# Barbara Chase-Riboud: Sculptor

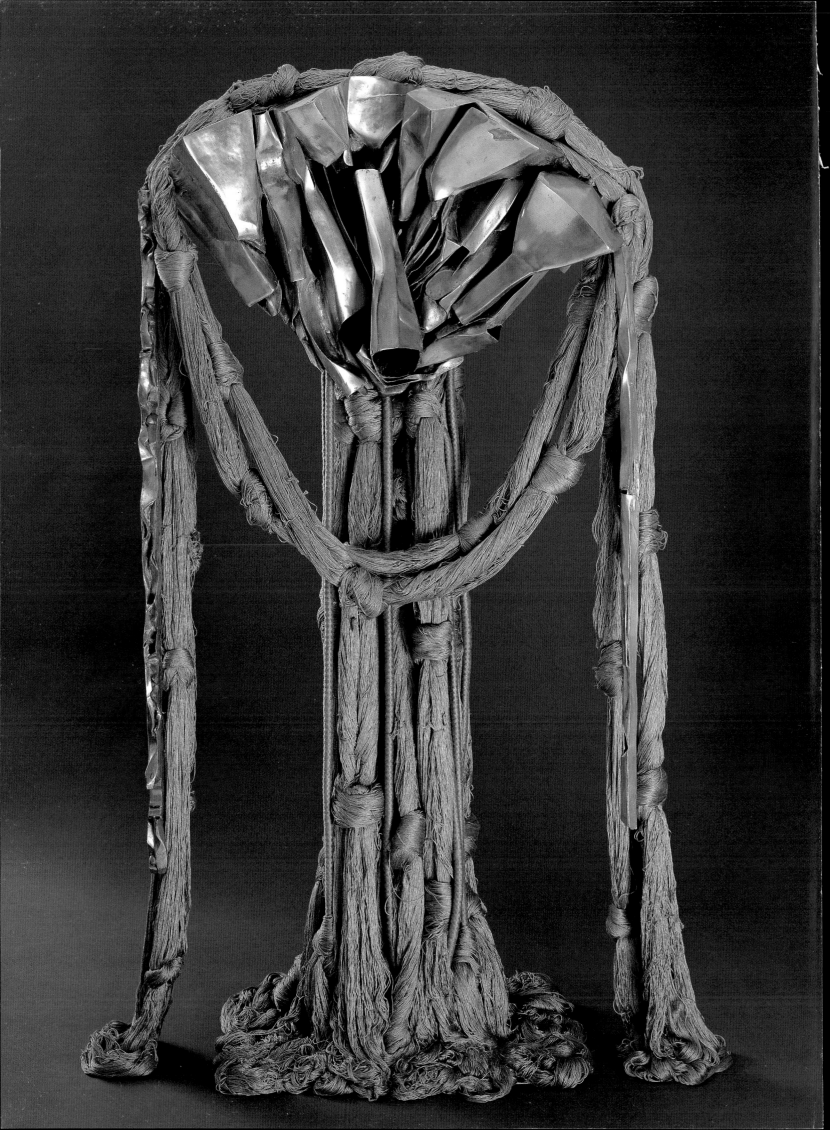

# Barbara Chase-Riboud
# Sculptor

Essays by Peter Selz and Anthony F. Janson

Harry N. Abrams, Inc., Publishers

EDITOR: HARRIET WHELCHEL
DESIGNER: JUDITH MICHAEL

FRONTISPIECE:
*Tantra I.* 1994. Polished bronze and silk,
82 ⅝ x 51 ⅛ x 15 ¾″ (210 x 130 x 40 cm).
Courtesy Achim Moeller Fine Art, New York

LIBRARY OF CONGRESS CATALOGING-IN-PUBLICATION DATA

Selz, Peter Howard, 1919–
Barbara Chase-Riboud, sculptor / essays by Peter Selz and Anthony F. Janson.
p.    cm.
Includes bibliographical references and index.
ISBN 0–8109–4107–4
1. Chase-Riboud, Barbara—Criticism and interpretation.
I. Janson, Anthony F.    II. Title.
NB237.C46S46  1999
730' . 92—dc21                        99–14101

Printed and bound in Japan

HARRY N. ABRAMS, INC.
100 FIFTH AVENUE
NEW YORK, N.Y. 10011
www.abramsbooks.com

# Contents

# All That Rises

*The most important thing to know is who you are and what you stand for, and to acknowledge this identity in your time. You cannot go back. Art cannot go back. The concepts in art are your history, there you start. The projection beyond your filial heritage is as vast as the past. The field for ideas is open and great, your heritage is universal, your position is equal to any in the world, except I can tell you no way to make a living at art . . . .*

*It is identity, and not that overrated quality called ability, which determines the artist's finished work. Ability is but one of the attributes and acts only in degree. Ability may produce a work but identity produces the works before and after. Ability may make the successful work in the eyes of the connoisseur, but identity can make the failures which are the most important to the artist. What the critics term the failures are apt to be unresolved but of greatest projection. They had to be done, they held the promise. The promise, the hint of new vista, the unresolved, the misty dream, the artist should love even more than the resolved, for here is the fluid force, the promise and the search.*

—David Smith, *Unauthorized Introduction* (Archives of American Art, 1947, RHF 0324, F0749.)

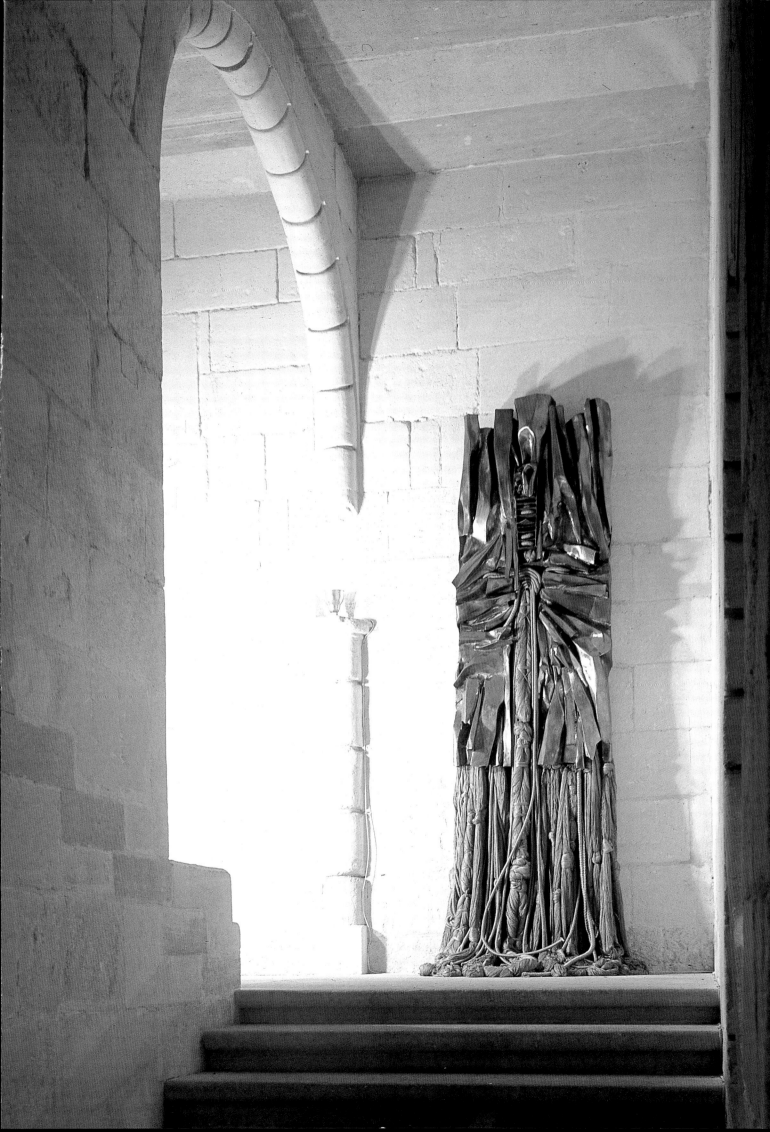

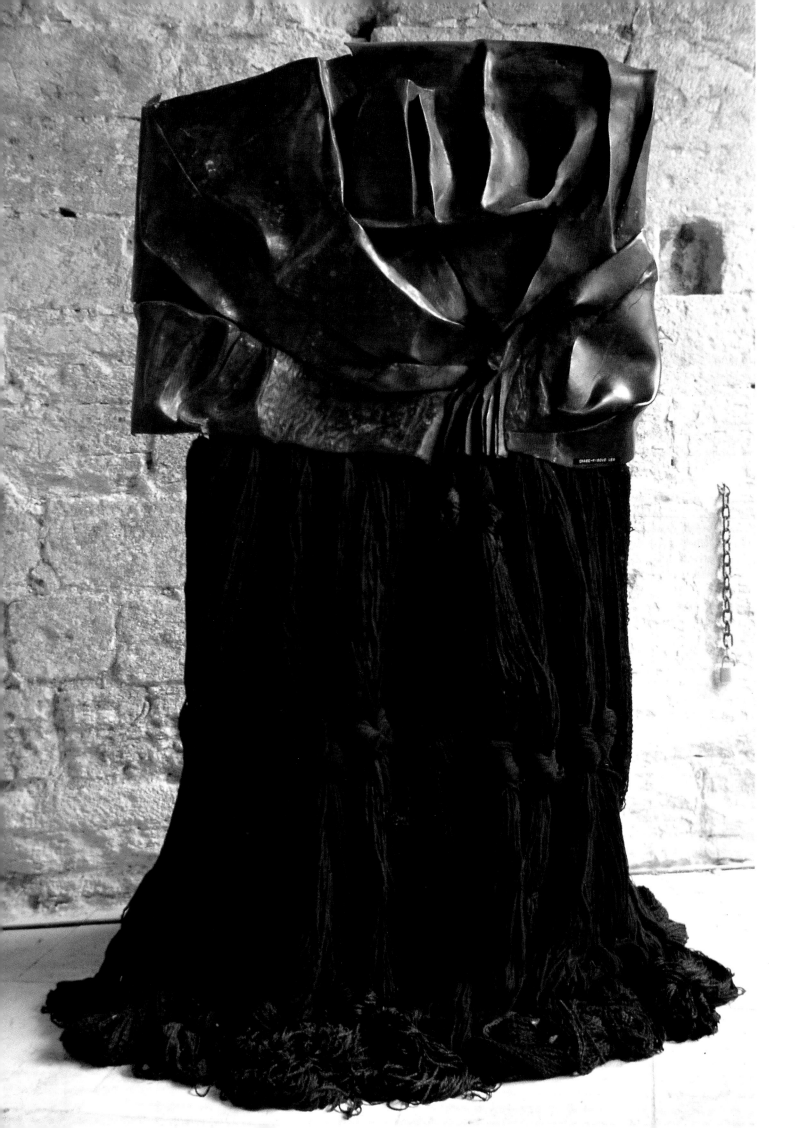

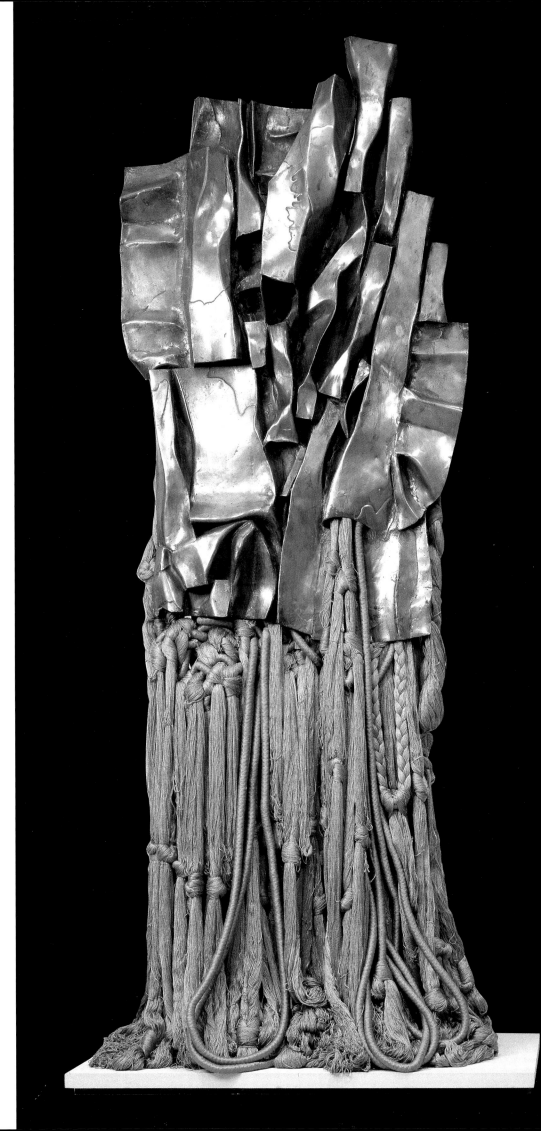

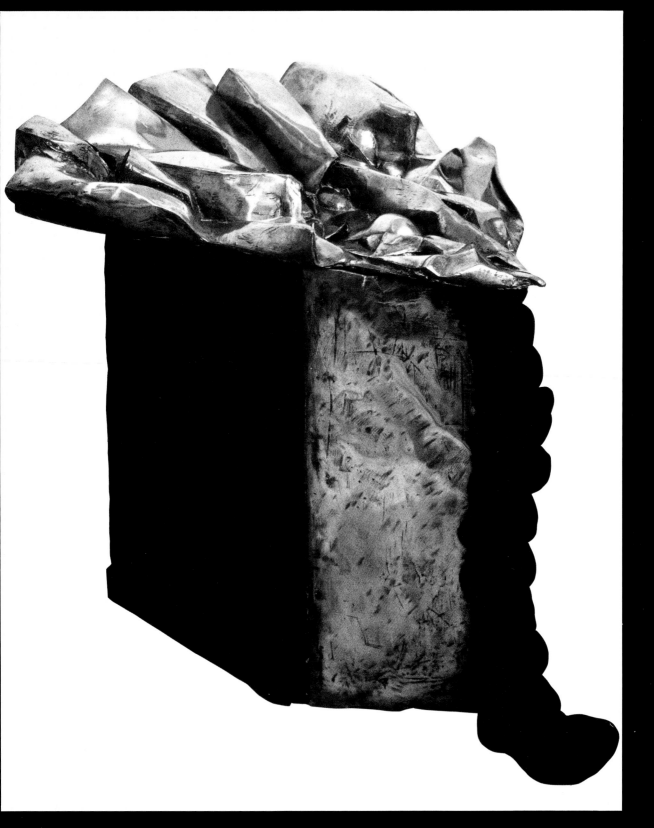

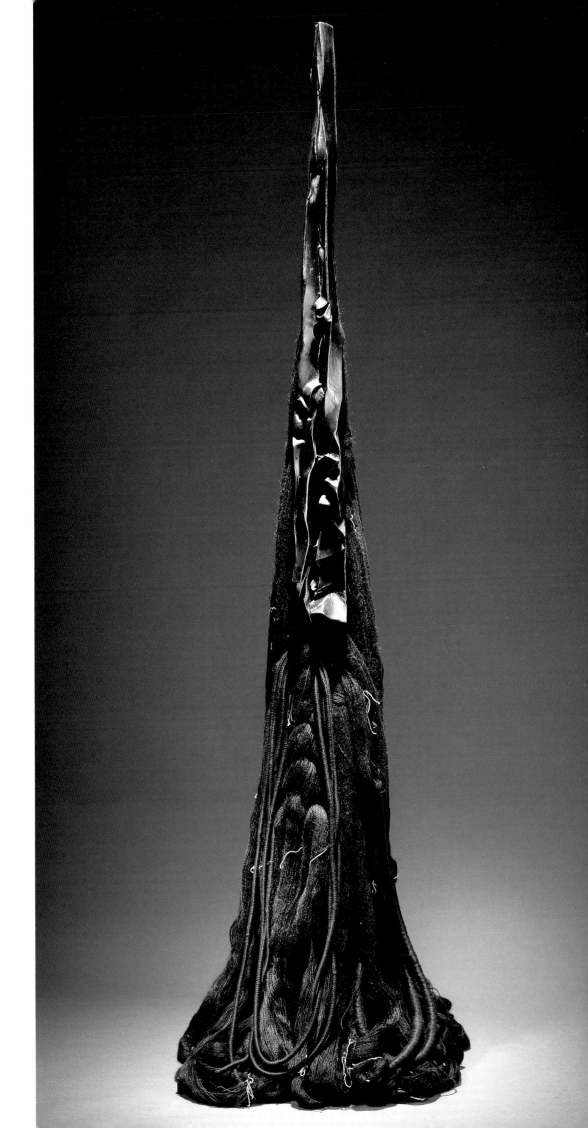

OPPOSITE:
*Malcolm X #4.* 1970.
Polished bronze, wool, wool
ribbon, 47 ¼ x 43 ¼ x 43 ¼″
(120 x 110 x 110 cm).
Private collection, Düsseldorf

RIGHT:
*Black Obelisk.* 1994.
Black bronze and wool,
78 ¾ x 19 ⅝ x 23 ⅝″
(200 x 50 x 60 cm).
Collection of the artist

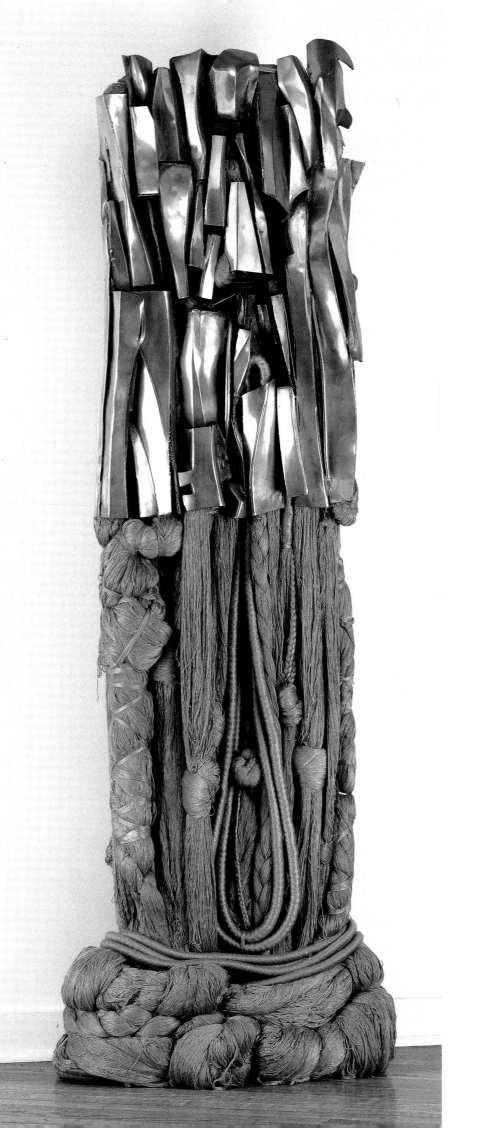

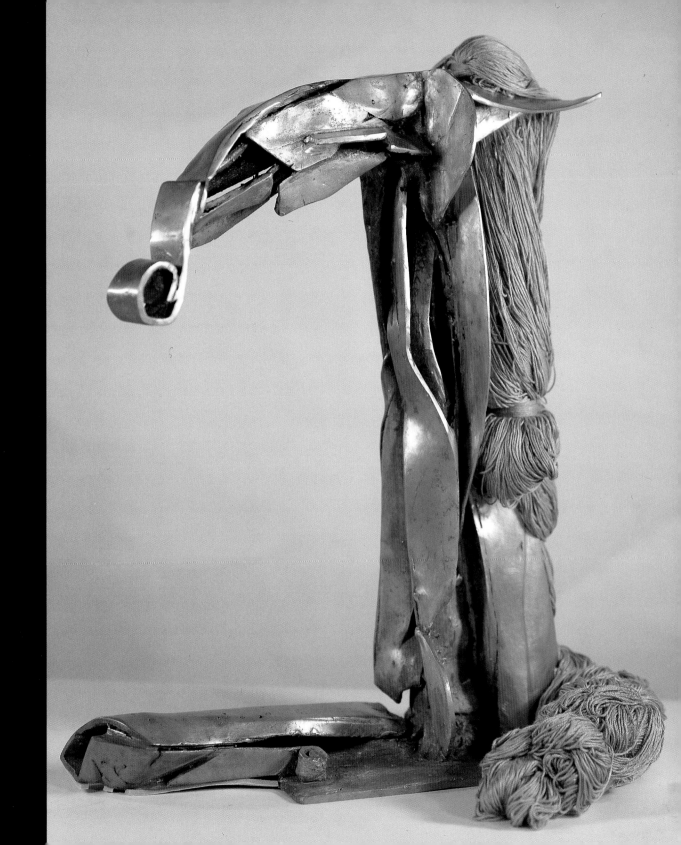

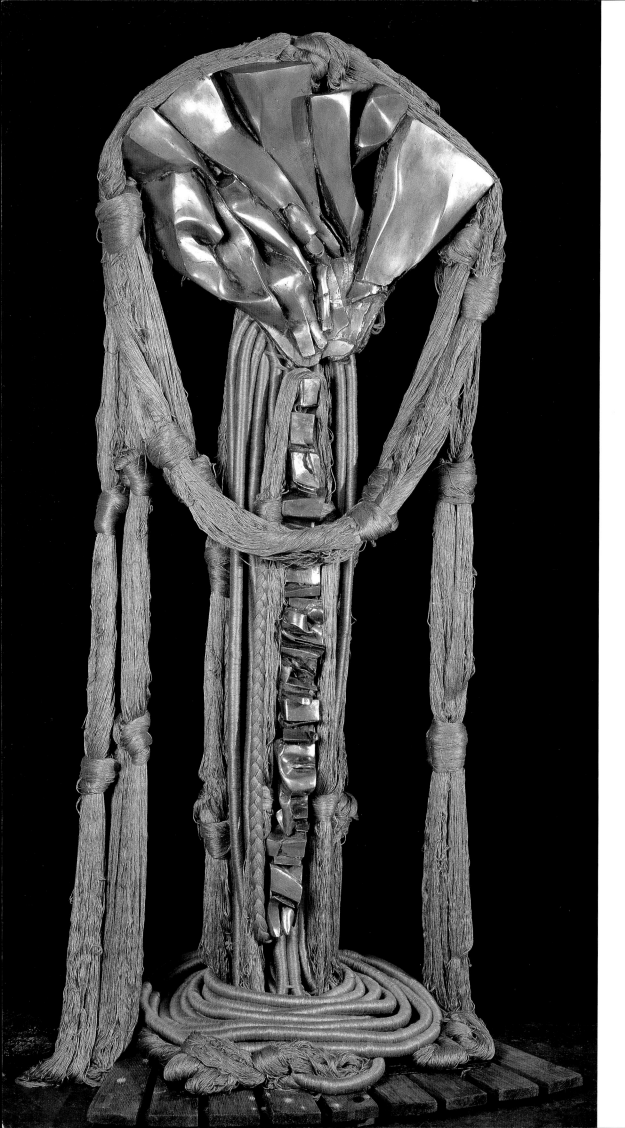

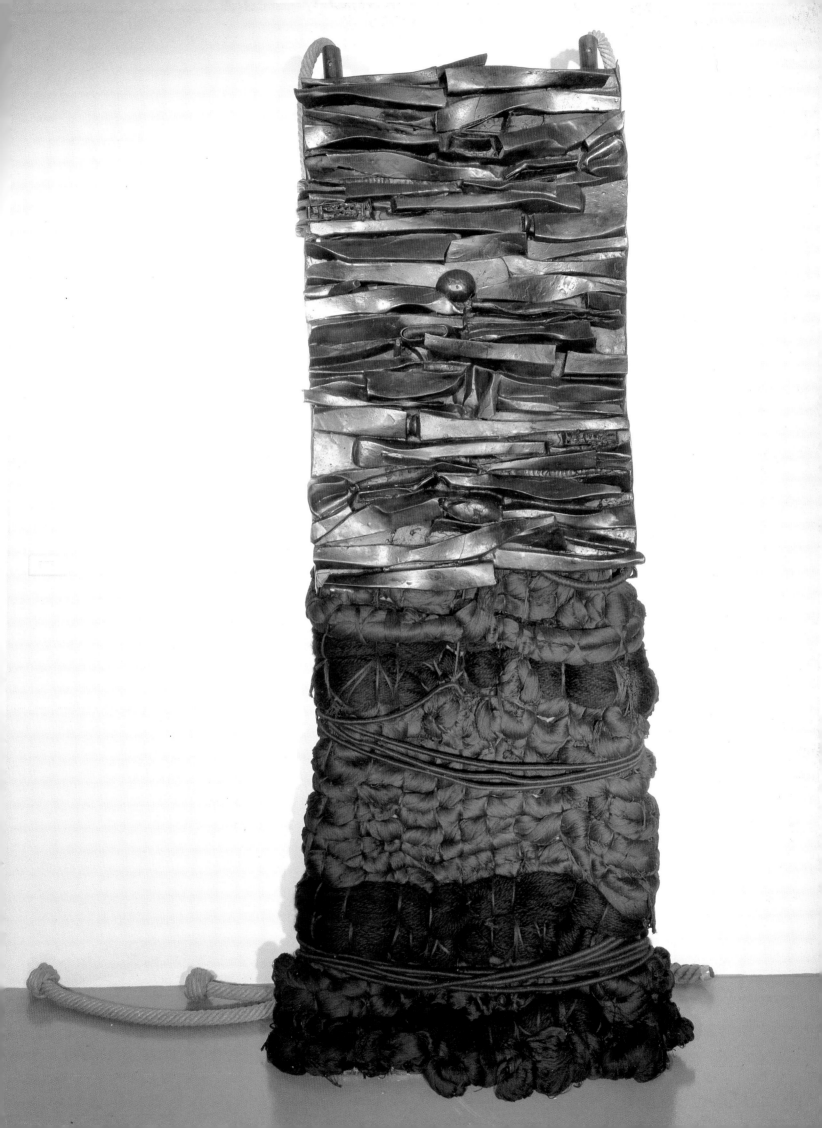

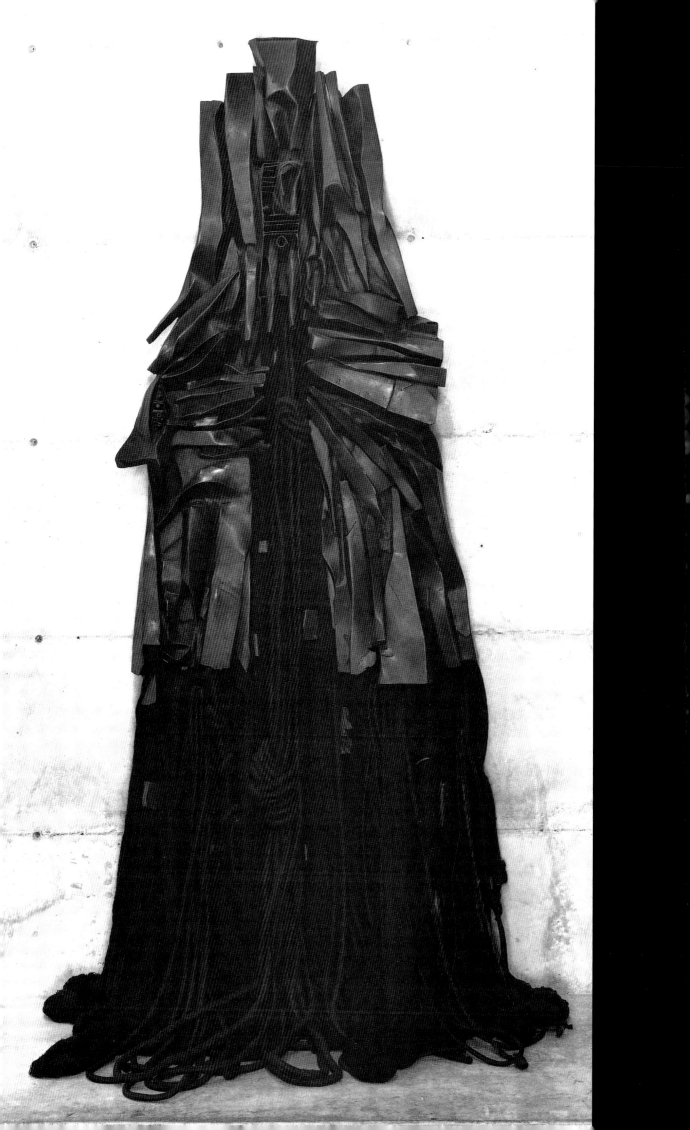

# Sculpture

**Peter Selz**

### *Preparation*

In 1954, when Barbara Chase was fifteen years old, The Museum of Modern Art acquired her woodcut *Reba* for its permanent collection. Since then, the artist has produced an amazing body of work in many different mediums and genres. The unique presence of her sculpture defies classification within the realm of modernist art. Although honored by many exhibitions and commissions in the United States and Europe, this highly individualistic artist was never part of the putative mainstream. At a time when cool distance in Minimal sculpture and bland adulation of popular culture or conceptual dematerialization seemed to occupy the attention of the art world, Chase-Riboud produced maximal sculpture that is passionately involved with the manual process of sculpturing. The ultimate purpose of her art is the creation of objects with inherent mystery and sensuous beauty. It is informed by ancient culture, by the art of Africa—especially Egypt—and imperial China, as well as by modernist sculptors such as Alberto Giacometti, David Smith, Isamu Noguchi, and Germaine Richier.

Encouraged by her artistically inclined parents and growing up in a home with lots of books, Barbara Chase began taking art classes at the Fletcher Memorial Art School and the Philadelphia Museum of Art when she was seven. Later, she enrolled at the Tyler School of Art and Design (Temple University), where she received strict academic training in painting (anatomy, perspective, glazing, etc.), the var-

ious graphic mediums, and the techniques of sculpture such as carving in wood and marble, modeling in clay and plaster, and welding in metal, which was a concession to the contemporary age. Upon graduation in 1957, she won a *Mademoiselle Magazine* contest and was recommended by Leo Leonni, the notable visual designer and art director, for a John Hay Whitney Fellowship to study at the American Academy in Rome. There she worked, saw Rome, and met older artists like Ben Shahn and Cy Twombly, as well as personalities like Ralph Ellison, Gian-Carlo Menotti, and Jerome Robbins, and also Ezra Pound, who "looked exactly like an illustration of God in his white suit, white beard, white hair, white eyebrows, white shoes, white socks, white shirt, white tie, sitting on a white wicker throne— a broken, demented old fascist genius."[1] Exposure to these creative writers, artists, and composers brought the young artist in close personal touch with contemporary culture.

The great and indelible impression of the Baroque city, of the sensual architecture by Borromini and Bernini, and especially, the latter's fountains and marble sculptures, found their echo in Chase-Riboud's work only after subsequent sojourns in Rome. It became most evident in her late majestic bronze *Africa Rising* (1998). The antiquities of Rome and a trip to Greece certainly were of importance to the young artist, and even more so was an unplanned journey. "As a dare at a Christmas Eve party," she told Eleanor Munro, "I left on the spot with friends on a trip to Egypt." She was left stranded but somehow managed to take control of her situation, remained in Egypt for three months, and recalled:

*I grew up that year. It was the first time I realized there was such a thing as non-European art. For someone exposed only to the Greco-Roman tradition, it was a revelation. I suddenly saw how insular the Western world was vis-à-vis the nonwhite, non-Christian world. The blast of Egyptian culture was irresistible. The sheer magnificence of it. The elegance and perfection, the timelessness, the depth. After that, Greek and Roman art looked like pastry to me. From an artistic point of view, that trip was historic for me. Though I didn't know it at the time, my own transformation was part of the historical transformation of the blacks that began in the '60's.*[2]

It was during the year in Rome that the young artist began her life-long method of direct-wax casting, a technique she first learned at a Roman bronze foundry. She produced a number of critical works such as *Adam and Eve*. Here, stretching the conventions of representational sculpture, two highly attenuated figures are depicted under the biblical Tree of Knowledge, which seems to protect the vulnerable couple. In the carefully worked pedestal, elements that might

OPPOSITE:
*Adam and Eve.* 1958.
Bronze, 90 ½ x 59 x 29 ½"
(230 x 150 x 75 cm).
Collection of the artist

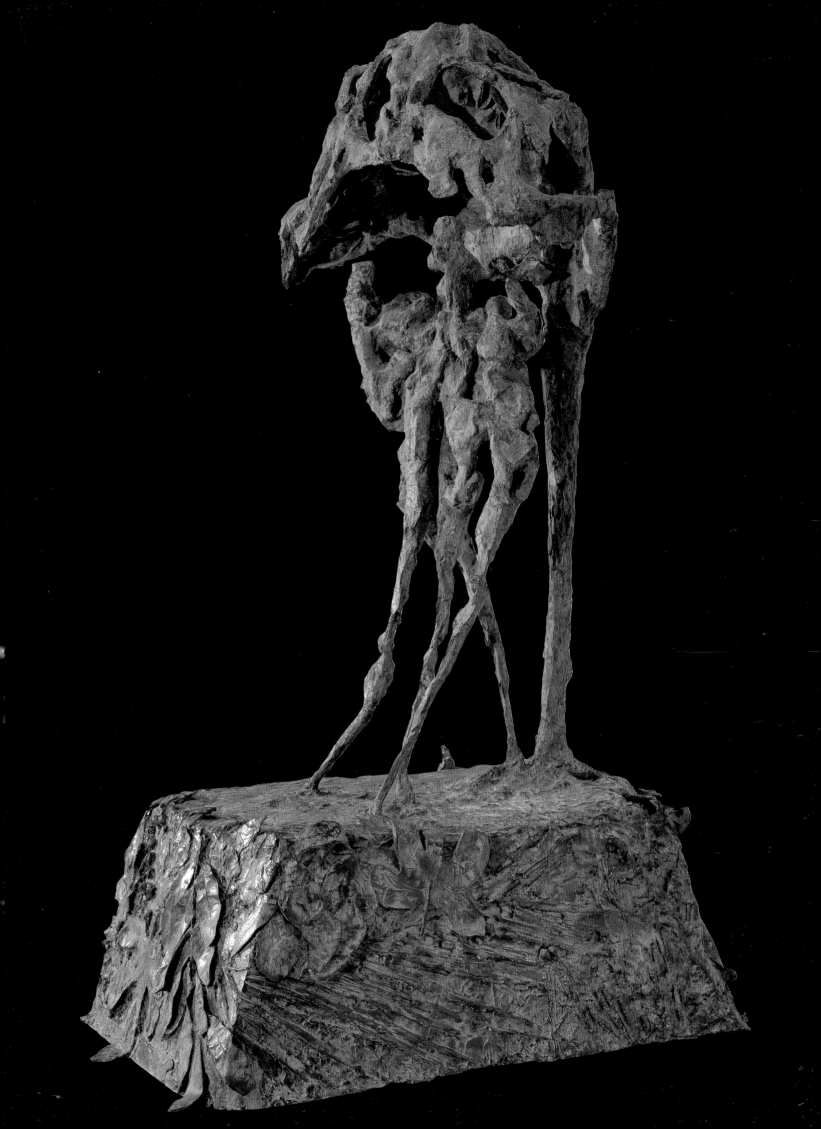

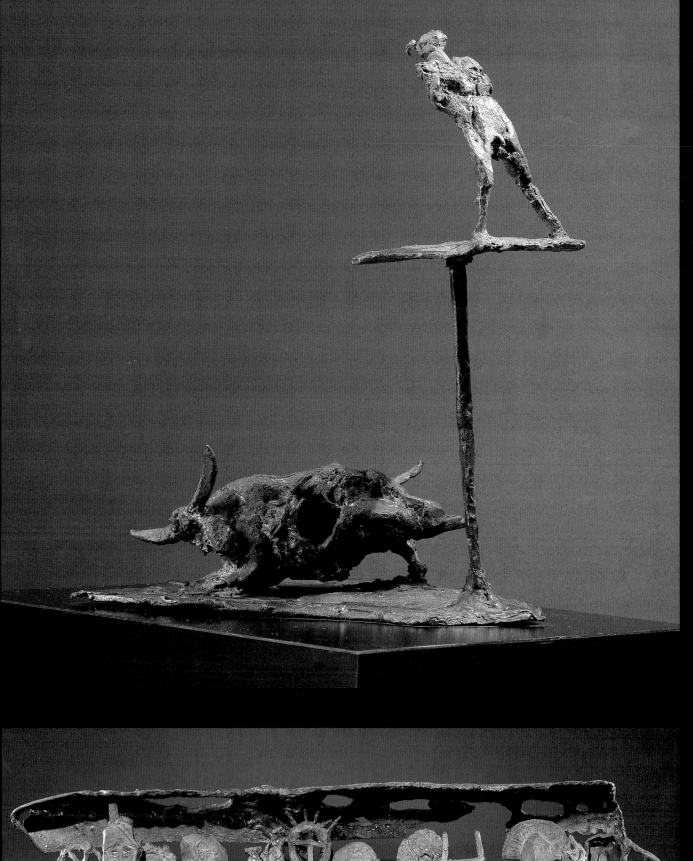

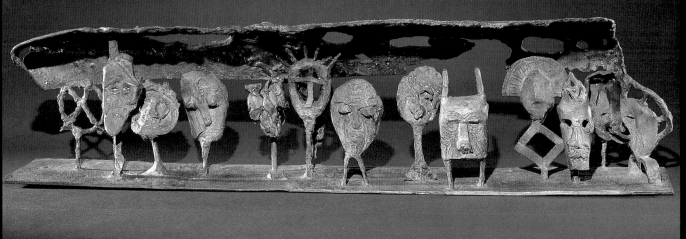

almost be cast directly from leaves are applied over a base of deep striations. This substantial ingot-shaped base accentuates the fragility of the emaciated limbs that rise from it. The skull-like crown of the tree may very well allude to the mushroom-type cloud of nuclear explosions, and the work appears to suggest the ever-present awareness of the world at risk.

During her time at the Academy, the student-artist also made some fine group compositions, such as *Portrait of the Artist on the Via Appia* (page 29), which consists of a random assemblage of nudes, heads, wings, and other fragments that relate to ancient Roman sculpture, shelved on a stepped platform with the artist herself, wearing a hat, contemplating the aggregate.

*The Last Supper* (1958) consists of twelve abstract figures on a flat base, protected by some sort of roof. Here the artist gave free reign to her almost playful imagination. The X on the far left seems to stand for Judas. Jesus is signified in the center by a cross in a halo and one of the abstract figures is done as a Bakota reliquary figure.

Ben Shahn bought this piece when it was shown at the first Spoleto Art Festival, and Chase-Riboud remained in contact with Shahn for many years. Shahn, like Rico Lebrun, whom she encountered while studying at Yale, "were both my humanist and affective mentors—they kept at least one of my feet in concrete reality, liberal socialism, humanism and emotional content when everything else was going toward cold abstraction."[3]

"Cold abstraction" was an important aspect of the attitude prevailing at Yale, where Barbara Chase was accepted as the only African-American woman at the School of Design and Architecture. There she studied with Josef Albers, as well as Vincent Scully, Paul Rand, Herbert Matter, Louis Kahn, and Philip Johnson. Many of the leading American artists of the succeeding decades received their professional training at Yale. Like many of Albers's students, she initially rebelled against his strict methodology, but later she realized that discipline frees talent.

*Albers himself had shaped the program. He was impossible and adorable, difficult, exigent, dogmatic, intimidating, brilliant and unforgiving. What he formulated was a methodology—a system. It involved a way of thinking about art. "Professional" implied a certain attitude toward one's work: that one was committed to a career.*

*The principle was: You can think any way you want, but your ideas must be clear. A logic has to be there as a grid to support your ideas. Your technical training has to be impeccable in regard to form, color, design and straight thinking. Engineers, doctors, scientists and lawyers think straight. Artists should, too. If you didn't master this idea, you would never do anything significant in your art, no matter how much talent you had or how hard you worked.*[4]

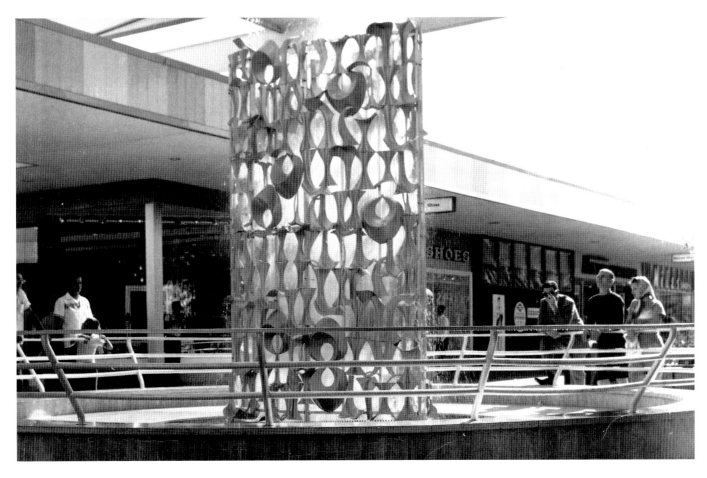

In 1959, during her first year as a graduate student at Yale, the young artist was commissioned to design a large fountain to serve as the focal point for a new shopping center at Wheaton Plaza in a Washington suburb in Maryland. The work consisted of two slightly curved pressed aluminum screens with the water pumped to rise to the top and then spill down on the elongated elliptical shapes. The fountain was fabricated in an airplane factory in New Haven and then assembled at the Wheaton site. The lightness of its color and structure combined with the lambent falling water made for a shimmering effect visible to the ends of the mall, and at night it was lit from the sides and bottom of the surrounding pool.[5] Although it was the beginning of her recurrent engagement with aluminum for her sculpture, she thought of this piece as architectural design. She submitted it as her master's thesis at Yale, but it was rejected, ostensibly because it was not done under faculty supervision. Then, turning to her more poetic inclination, Barbara Chase made a book of engravings to Arthur Rimbaud's proto-Surrealist poem, "A Season in Hell," for which the distinguished scholar Henri Peyre wrote the introduction.

While at Yale, she became engaged to James Stirling, the promising young British architect, and spent eight months in London after her graduation, where she became acquainted with England's leading sculptors, including Kenneth Armitage, Henry Moore, Reg Butler, Barbara Hepworth, and Eduardo Paolozzi. But London did not suit

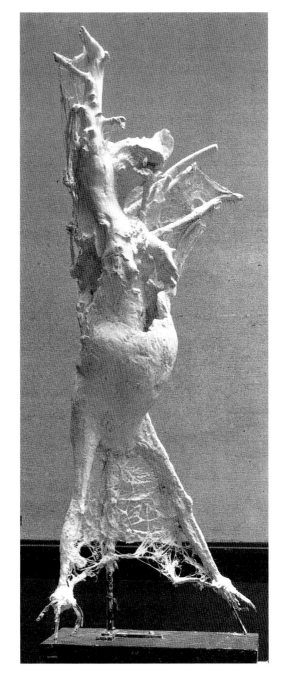

her inclinations, and, at the suggestion of the French painter Georges Mathieu, she went to Paris for a weekend, and there she still maintains a home.

Far from being outclassed by New York, Paris at the time was still an active center of the art world. André Malraux, then Charles de Gaulle's minister of culture, had recently published his *Musée Imaginaire*, which provided a wealth of art images from Asia, Africa, and pre-Columbian America on an aesthetic level equal to European art. Painters like Jean Dubuffet and Jean Fautrier, working with the heaviest impasto materials, created savage images on canvas. Mathieu, who had been Barbara's initial contact in Paris, was one of the original *art informel* painters and the individual who brought gestural abstraction, or Action Painting (so named by Harold Rosenberg in the United States), into public physical enactments on a grand scale. Chase-Riboud, however, became more interested in the sculpture by Giacometti and Germaine Richier, whose work was related to the Existentialist mentality—if not the doctrine—of Jean-Paul Sartre, the philosopher who felt that metamorphoses and ambiguity suggest the very uncertainties of human existence.

Richier's hybrid creatures have been seen as metaphors for humanity's survival against the impingement of nature and society. A student of Antoine Bourdelle, who himself had been Rodin's assistant, Richier started in the mainstream of modern sculpture. But, once she had mastered the craft, she responded to the anxieties of the time, creating figures of ravaged existence.

In the catalogue of *New Images of Man*, an exhibition this author organized at The Museum of Modern Art, I noted that,

*. . . using the traditional techniques of the sculptor, [Richier] has cast in bronze a race of hydras, spiders, bats, praying mantises, six-headed horses and other ogres. Her effigies affect by their strangeness, their existence on the frontiers of human-ness. . . . Like so many artists of this time, her work is concerned with transmutation, metamorphosis and organic interaction, relating to the patterns unraveled by the physical scientists in their discovery of a continuous process in which absolute time, space, and matter have been abolished.*[6]

An early sculpture by Chase-Riboud such as *Plant Lady* (1962) presents a grotesque and emaciated human body, bent on all fours, whose head has been replaced by a dozen rubbery aloe vera leaves. These stems seem either to grow organically from the too-wide opening at the neck, or to be inserted into that gaping orifice. In sculpting the hermaphroditic body, the artist contrasted a thick neck and torso with painfully thin arms and legs. The smooth and succulent character of the plant is in vivid contrast to the inorganic and metallic

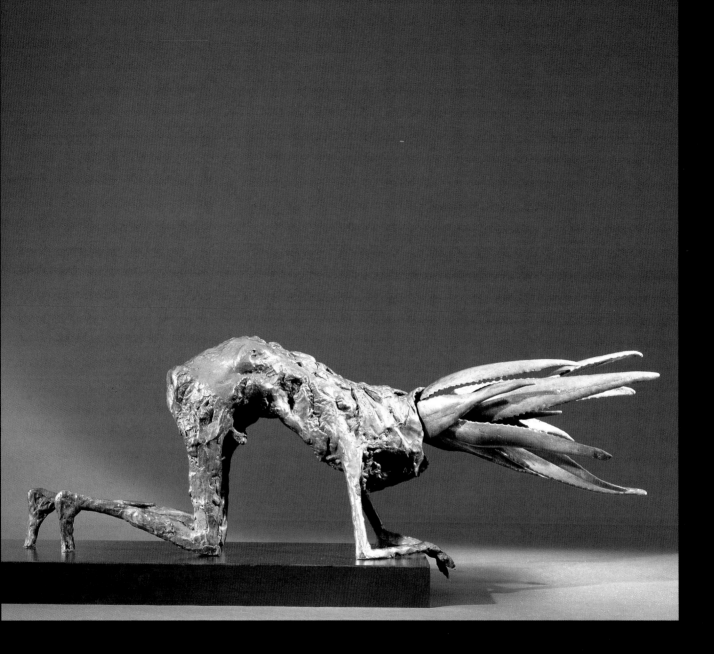

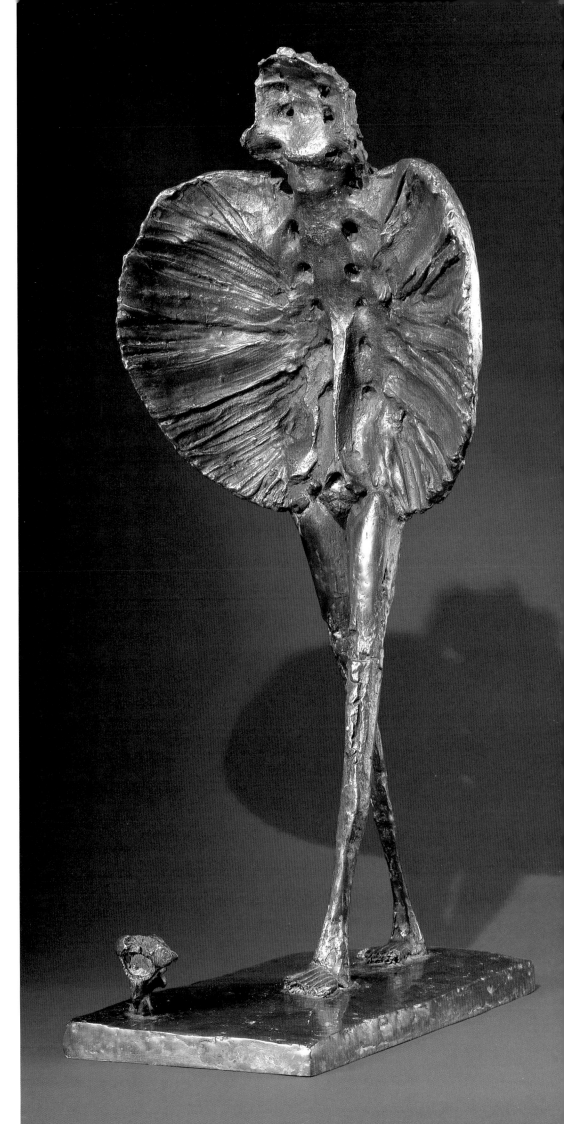

OPPOSITE:
*Plant Lady.* 1962. Bronze,
9 $\frac{1}{16}$ x 23 $\frac{1}{2}$ x 6 $\frac{1}{3}$″
(23 x 60 x 16 cm).
New Orleans Museum of Art

RIGHT:
*Walking Angel.* 1962. Bronze,
35 $\frac{1}{2}$ x 11 $\frac{3}{4}$ x 15 $\frac{3}{4}$″
(90 x 30 x 40 cm).
Private collection, Paris

OVERLEAF, LEFT:
*Vase Lady.* 1962. Bronze,
16 x 30 x 12″ (40.6 x 76.2 x 30.5 cm).
Collection of the artist

OVERLEAF, RIGHT (LEFT TO RIGHT):
*Le Couple.* 1963. Bronze,
68 $\frac{1}{8}$ x 63 x 29 $\frac{1}{2}$″
(173 x 160 x 75 cm).
Collection of the artist

*Tiberius's Leap.* 1965. Bronze,
61 x 11 $\frac{3}{4}$ x 11 $\frac{3}{4}$″
(155 x 30 x 30 cm).
Collection of the artist

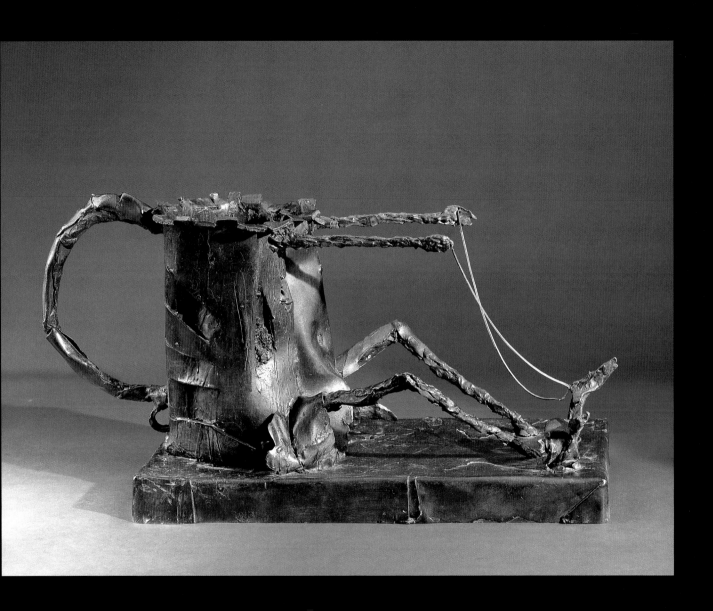

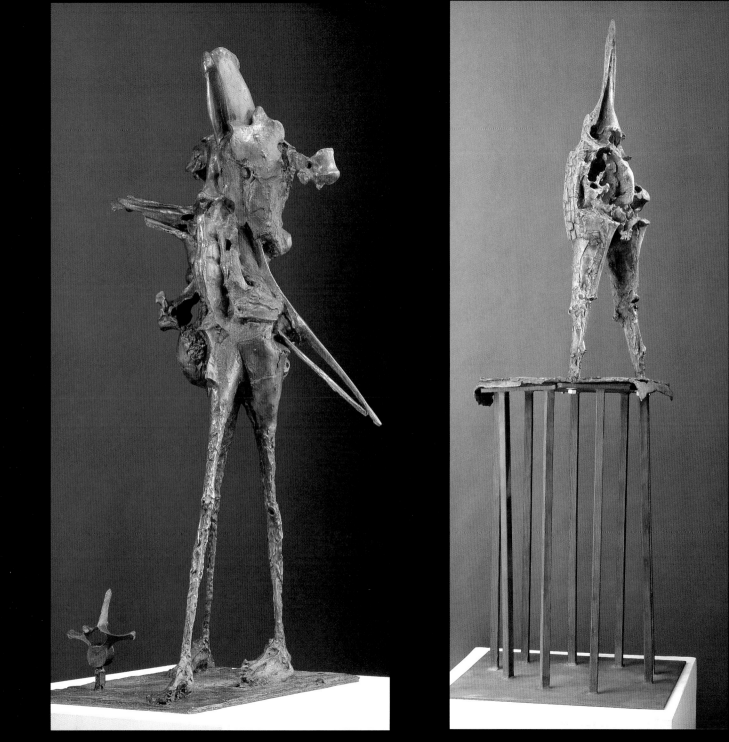

encrusted body. *Walking Angel,* done in the same year, is a forward-striding figure with great blossoming wings that resemble large leaves, but their rippling texture is also somewhat reminiscent of the guardian figures from Gabon in which curved faces were surrounded by large spadelike forms of polished brass. *Le Couple* (1963) appears like a large upright praying mantis with several legs. With its sharp angular protuberance, its roothold, and that vertebral segment situated at the feet of the figure, it is an image of ambiguity and dark humor. In *Tiberius's Leap* (1965), a pointed crown is substituted for the head of the second Roman emperor, who is placed on the precipitous edge of a high fence, about to plunge into the unknown.

Like other bronzes of 1966, the headless and immutably erect *Nostradamus* is cast from animal bones. The artist collected bones of birds, reptiles, tigers, and even elephants from a Paris taxidermist and would reconstruct these bones and cast them into bronze figures. This provoked her to make sculptures that no longer signified personages but were merely eloquent configurations of bones cast in bronze. These works were exhibited at Jeanne Amoore's gallery in Paris in 1966.

Many artists in Paris, as elsewhere, were engaged in what was to be defined as "the art of assemblage." Max Ernst, one of the first artists Barbara Chase met in Paris, juxtaposed unrelated entities into poetic Surrealist collages. Man Ray, whom she met at the same time and to whom she referred as "the most renowned Philadelphia artist of the previous epoch," made Dada assemblages such as *Indestructible Object,* in which he placed a cutout photograph of an eye on the pendulum of a metronome.

Jean Dubuffet used the term *assemblage* for his collages of predone paintings or butterfly wings and then extended its meaning into three dimensions, transmuting coal clinkers, sponges, charcoal, vine stalks, and roots into very curious "statues of the precarious life."[7] Jean Tinguely, whose studio was close to Chase-Riboud's, made useless but imposing and noisy haphazard-looking, anarchic "meta-machines," and his friend Arman collected everything from dolls to violins for his "accumulations." In this atmosphere of what the critic Pierre Restany called "Nouveau Realism," Chase-Riboud created sculptures out of "found" animal bones, directly converting a slice of nature into art. It is true that many cultures turned tusks of animals such as elephants and walruses into carved ivory, but rarely have the actual bones been assembled to make sculptures.

### Sculpture as Synthesis of Bronze and Fiber
In Paris, Barbara Chase had met the Magnum photographer Marc Riboud; they were married on Christmas Day 1961, at the ranch of Sheila Hicks in Talcapco, Mexico. Hicks, who in 1959 had arrived

ABOVE:
*Malcolm X #1* (scale model). 1969–70. Bronze and silk, height approximately 7″ (17.8 cm). Whereabouts unknown

OPPOSITE:
*Portrait of the Artist on the Via Appia.* 1958. Bronze, 7⅞ x 27½ x 8⅝″ (20 x 70 x 22 cm). Collection of the artist

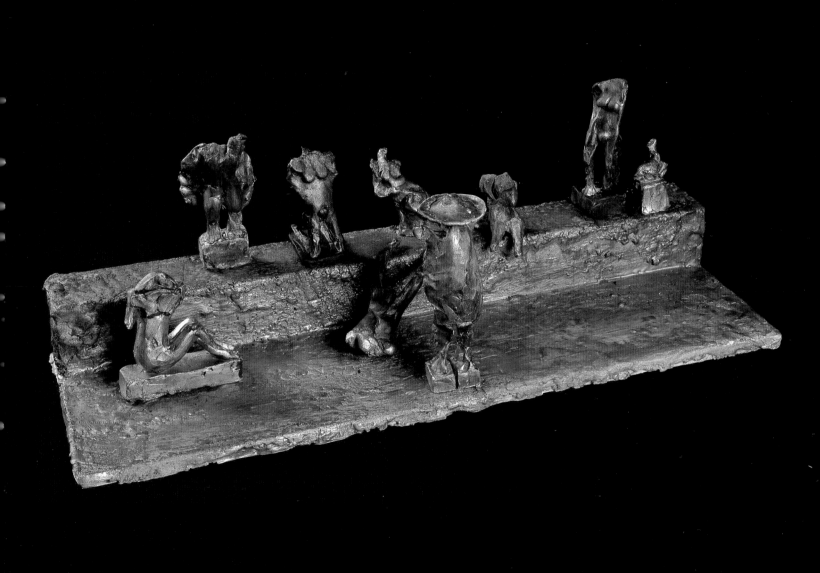

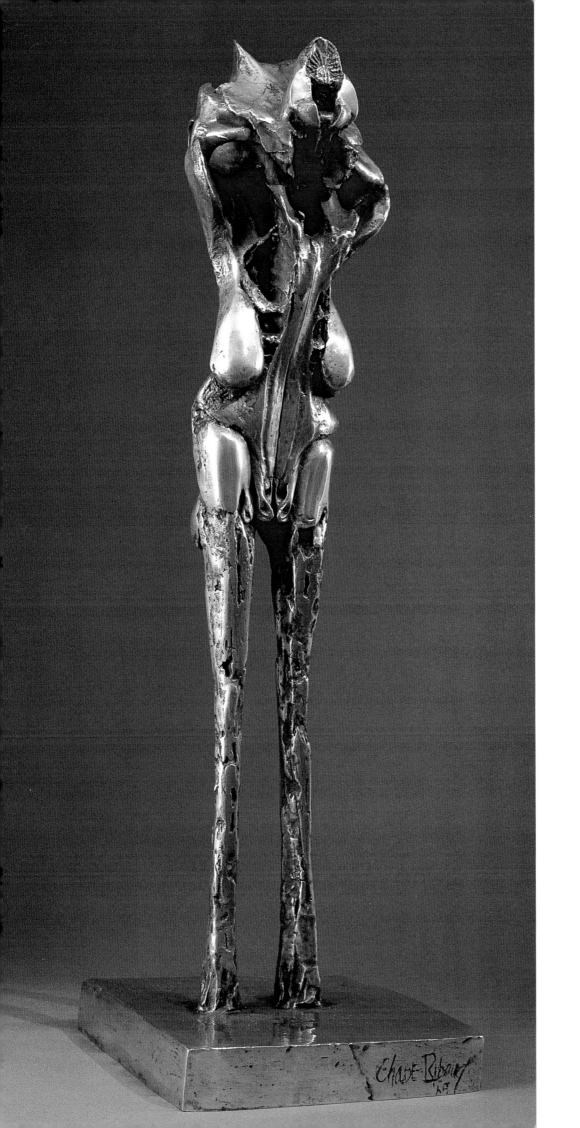

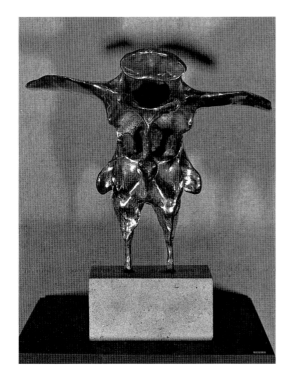

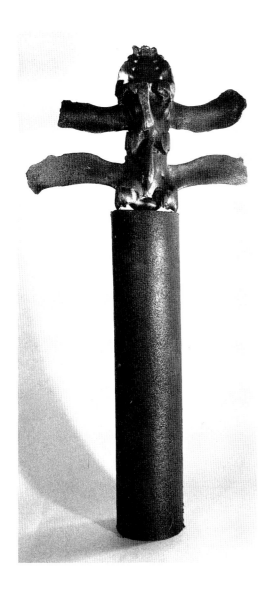

at Yale from a Fulbright Fellowship in Chile, had been Barbara's closest university friend. An important fiber artist, Hicks suggested the use of ropes instead of legs for her friend's sculptural work. This enabled Chase-Riboud to discard what she called "the tyranny of the base."

The idea of using fabric in sculpture was certainly not new to an artist who was familiar with African dance masks, but it is also related to a renaissance in fiber art during this period. Earlier, when the Surrealists made use of draped cloth, it was largely for the purpose of concealment, and Kurt Schwitters's application of bits of discarded cloth to his Merz collages seems almost incidental. It can well be argued that fiber really entered the fine arts context when Robert Rauschenberg exhibited his *Bed* in 1955. Soon thereafter, Christo presented his wrapped packages, artists like Colette and Hicks created fabric environments, and Sam Gilliam took his canvas off the stretcher, painted it, and hung it freely in the gallery space. Yayoy Kusama made beds of cotton phalluses, and Eva Hesse used rubberized cheesecloth for her expandable post-Minimal wall hangings. Robert Morris exhibited random heaps of felt strips, changing their configurations during the show. Most significant of all for Chase-Riboud, Magdalena Abakanowicz placed coarsely woven or stuffed burlap humanoid forms to stand freely in the space they defined. The hierarchies of art were challenged, and fiber, like clay, became accepted as an art medium: the oldest art materials assumed the most contemporary functions.

Before Chase-Riboud made her first sculptures combining fiber with bronze, she made a pivotal journey, which became as significant for her artistic development as the Egyptian trip undertaken during her student years. During the height of the Vietnam War in 1965, she accompanied Marc Riboud on a voyage to the People's Republic of China as the first American woman to visit post-revolutionary China. They traveled by train into the interior of China, saw the ancient Buddhist caves near Hsian, and went on to Inner Mongolia as well as to Tibet. In China, the artist witnessed directly a magnificent ancient culture that provided her with another non-European way to look at the world and its art.

The effect of this experience resonated in her work, in the luxuriant presence of her later sculpture, such as the Tantra and the Cleopatra series, in the white silences of spaces in her drawings, and, certainly, in her poems. After her return to Paris, she wrote twelve poems about China, which were published later in her poetry collection *From Memphis & Peking.*[8] The vivid and very visual language and the sensory detail of her poetic description recalls the evocative verse of the French Symbolists, who believed in parallels and correspondences between art forms:

## ON THE TERRACE AT 11 NANCHIHTZE STREET

Standing

On somebody's terrace,

Feeling foreign,

Gazing at a city more like a Universe Forbidden,

Rising over Peking like flamingo wings, a

Hovering which is neither float nor flight

But a murmuring static in the still air,

The roofs of palaces and pavilions catching the last

Light as if the sun were their own reflection.

Corner towers rise to meet the descending mist

Which becomes a pale and smoky screen

Between the red walls of the city and my avid Western eyes,

Like the veils the emperor's valets wore

So as not to contaminate him with their breath.

A breeze sweeps the moat as a Chinese character brush

Correctly poised, dips expertly into ink.

The Eastern Gate bangs with a hollow ring and a cry.

Hawk sparrows maneuver in the dusk.

Pale lights snap on, girding the yellow mall in a beaded belt,

Flattening passing navy figures into relief-less shadows.

Half hidden by willows, breeze-bent in oriental kowtow, the

Western Wind blows off the Gobi desert, bringing sand

And lifting clouds of ever-present Peking dust that scuttles by.

Chinese conversation, soft and dissonant, lies below and about.

Scraped dishes echo off tiled walls like keys rattling,

And here and there a stubborn child lingers outside

Savoring the last swooning daylight before bed, while I,

Standing

On somebody's terrace,

Feeling foreign,

Gazing at a city more like a Universe Forbidden,

Resist until the light leaps away.

The year following the trip to China, the artist attended the First Pan-African Festival, which was held in recent post-colonial Algiers. There she met Black Panther members Eldridge and Kathleen Cleaver and Huey Newton, and she recalled that:

*I found myself there with all the freedom fighters and liberation groups—the Algerians, the South Africans, the Black Panthers from America. A kind of historical current brought all these people together in a context that was not only political but artistic.*[9]

OPPOSITE:
*Zanzibar/Gold.* 1972.
Polished bronze and silk,
98 ½ x 35 ½ x 11 ¾″
(250 x 90 x 30 cm).
National Collections of France,
The Ministry of Culture

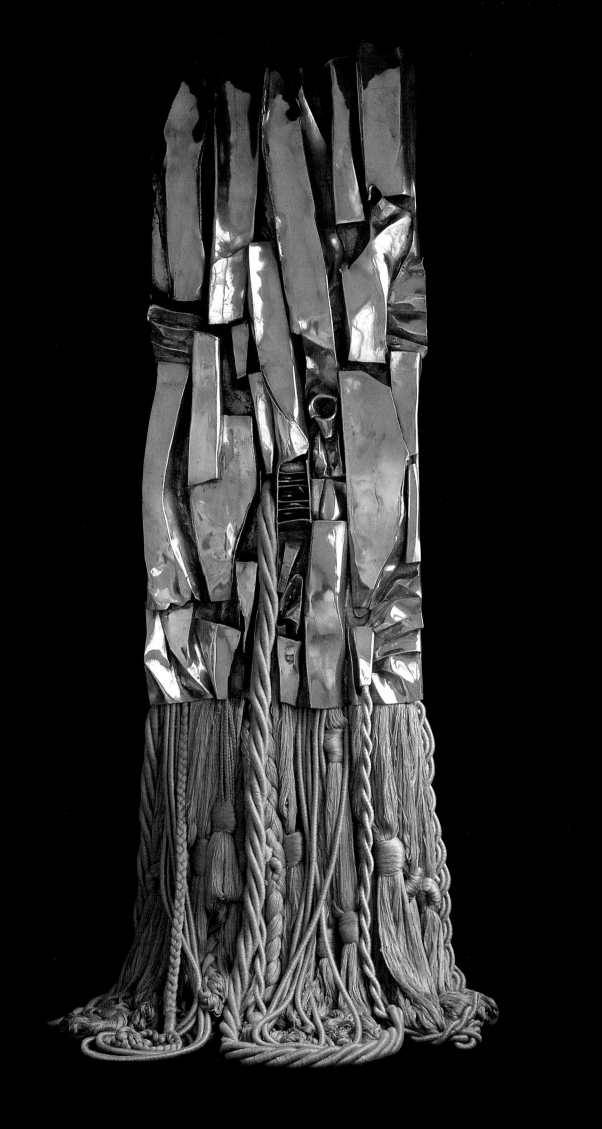

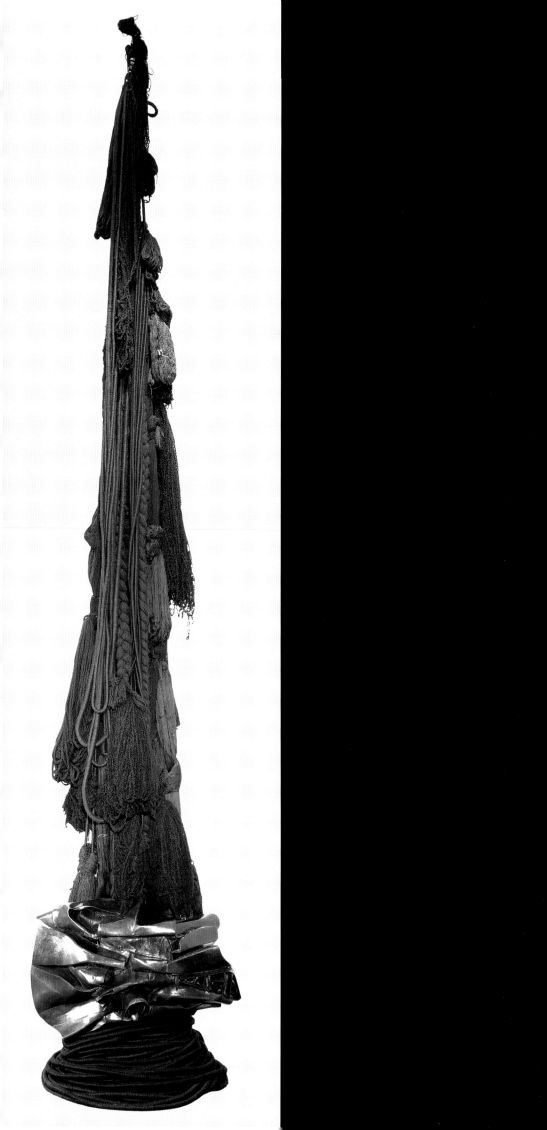

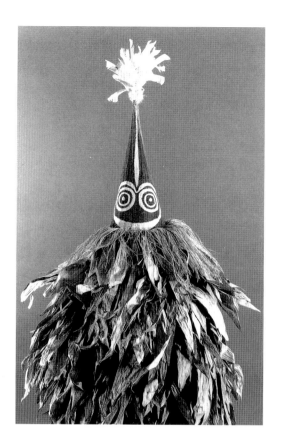

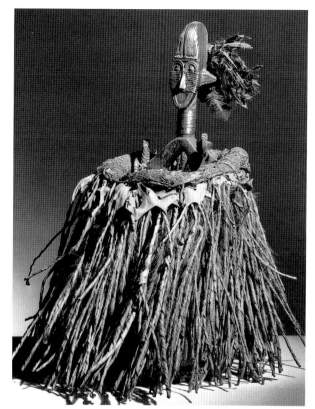

She exhibited her work in Dakar, Senegal. In 1969 she returned to Africa for the Pan-African Festival in Nigeria and then, in 1975, she accompanied her exhibitions in Senegal, Mali, Ghana, Sierra Leone, Tunisia, and Morocco as a representative of the U.S. State Department.

Her visits to Africa certainly had a great impact on her future work. The fascination of so many modern European and American artists with the art of Africa was by no means a matter of appropriation, as has been asserted by misguided observers. It was, rather, a feeling that these objects—not considered Art by their makers—had a shamanist or magical power, which was very much what many modernist artists were in search of. It must also be remembered that much of African or Oceanic art is what we have come to call Performance Art: it is an interplay of sculpture, costume, dance, and dream. Many Oceanic and African masks are surrounded by raffia fringes, by hemp, shredded cloths, cords, or feathers that come to life during the dance, which may be performed for purposes such as counteracting witchcraft. Robert Farris Thompson, the eminent art historian of African art, describes a dance he witnessed in upper Kenya:

*The dance begins, the feet of the dancer in the mask are completely hidden. The dancer moves very rapidly, taking short steps. The swooping, gliding character of the motion of the mask stems from unseen means of locomotion. Bensinjom circles through dust he himself has raised by force and speed of wheeling. He moves in fleeting circles with a speed so fluent the weight and density of his mask and gown seem to*

*dissolve in gyrating patterns. He wheels and wheels, taking on quali-*
*ties of bird-like grace and suspended balance. . . . The point of this*
*impassioned happening was precisely its embodiment within the*
*assuaging genius of art and motion.*[10]

The raffia, cord, netting, and fringing that we often see as parts of African masks—usually below the head—finds an echo in some of Barbara Chase-Riboud's signature sculptures. We might also think of Ashanti combs in which head and ringed necks appear above rhythmic repetitions of the teeth of the combs—a configuration which can also be related to Chase-Riboud's wall pieces. These elements had probably as much of an impact on the artist's work as the Baroque sculpture of Gianlorenzo Bernini.

In 1970 the artist exhibited a number of her new sculptures at the Bertha Schaefer Gallery in New York. The show was then taken to the Hayden Gallery at M.I.T., whose director at the time, Wayne Andersen, was impressed by this "interesting work by a highly intel-ligent artist." These pieces reinterpreted the traditions of ethnic sculpture of Africa and Oceania as well as the sumptuous glory of Baroque sculpture—all in a contemporary syntax. They were dedicated to the militant black leader and Muslim minister who, after his pilgrimage to Mecca, eloquently advocated the brotherhood of black and white, and was assassinated in New York in 1965. Her Malcolm X pieces are to be seen as tribute and celebration, not in any sense as polemical interpretations or as icons of mourning. Also, while always aware of her African-American identity, Chase-Riboud never overstressed this fact. To the contrary, she likes to quote her grandmother's dictum: "Make things look easy as a matter of good breeding. Letting people know you are carrying a load is a Third World attitude toward life."[11]

*Malcolm X #1* (page 60) consists solely of polished bronze, pati-nated into a golden hue, and does not have the fabric used in the other works of the series. *Malcolm X #3,* (page 9) the largest of the group, is slender, its cording is silk instead of wool, and both bronze and fiber are again finished in a golden hue. This is also the color of *Malcolm X #4,* (page 10), in which the polished bronze segment is placed in an angled bronze socle with a black wool ribbon serving as the link between the upper unit and the floor.

*Malcolm X #2 (page 8),* now in the Newark Museum, is more than six feet high and faces the viewer head-on with a powerful presence. The top is black polished bronze, the lower part consists of heavy wool cord—also dyed black. The dialectic of the hard, "masculine" bronze with the soft "feminine" skirts results in the synthesis of a coherent work, affecting a response of astonishment in the viewer.

The detailing of the interplay of forms in the bronze, the cracks

and tears, the openings and closings, the continuous vibrant ripple of the metal was achieved by the lost wax process: the sculptor first constructed large thin sheets of wax, which were then bent, slashed, and twisted, knotted, pleated, and carved. Wooden or copper pins were then used to connect different parts before the wax model was encased in plaster and clay molds to make the negative mold. The molten metal was then poured to melt the wax. After this, the investment mold was broken away and the cooled bronze removed from its casing. Only a single, unique cast can be made by this process, but the result has a precision not obtainable in other casting processes.

What, we may ask, was the critical response to these innovative works? The Schaefer exhibition, together with a Romare Bearden show at the Knoedler Gallery, was reviewed patronizingly in the *New York Times* by its conservative art critic Hilton Kramer in an article called, "Black Experience in Modern Art." Kramer suggests that these artists "raise some interesting questions about the relation of the black experience to modernist forms of painting and sculpture," but he neglects to suggest what these questions might be. Dismissing the original innovations and the unique affirmations of the human spirit in Bearden's collages, Mr. Kramer finds that Bearden's often delicate imagery "calls for stronger form and robust expressions than is usually given." And he faults Chase-Riboud for a "very French refinement especially evident in the four *Monuments to Malcolm X*— wall-hanging sculptures of considerable elegance that unfortunately suggest the ambience of high fashion rather more than they suggest the theme of heroic sufferance and social conflict."[12]

Hilton Kramer's rather myopic, indeed insidious, review was answered in a subsequent issue of the *Times* by the curator Henri Ghent, who had organized a number of African-American exhibitions, and also by the New York painter Alvin Smith. Ghent points out that Mr. Kramer seems to have a "stereotype idea that the work of black artists must by nature be crude, lacking in craftsmanship, and totally devoid of sophistication." Addressing the Malcolm X pieces, he writes that:

*One strongly suspects that the real motive behind Kramer's severe criticism of Mrs. Riboud's work stems from the fact that she chose to create tasteful and dignified sculptures in memory of Malcolm X. She, like millions of blacks, has come to see the memory of the civil rights activist as an eloquent and beautiful human being, one who has played a towering role in helping America's black population to think better of itself.*[13]

Alvin Smith takes issue with Kramer's lumping two black artists together instead of seeing them as the individual artists they are, as

well as his antediluvian notion that the best esthetic expression of any aspect of the black experience calls for raw, aggressive, hostile forms, which is the reason for his view that the late Malcolm X is undeserving of the magnificent monuments Chase-Riboud created in his honor.

This controversy about the criticism of Chase-Riboud's Malcolm X series proved paradigmatic for the more erudite polemic regarding the major exhibition "Primitivism in Twentieth Century Art: Affinity of the Tribal and the Modern," mounted at The Museum of Modern Art in 1984. Thomas McEvilley, arguing from an advanced anthropological perspective in a discussion of past and present art, questioned the dogma of a universal and absolutist aesthetic of formalism as advanced in the museum's blockbuster exhibition. McEvilley takes issue with Kirk Varnedoe, the codirector of the exhibition, who was responsible for its section "Contemporary Explorations": Varnedoe's "dread of the primitive, of the dangerous beauty that attracted Matisse and Picasso and that continues to attract some contemporary artists today, [which] results in an attempt to exorcise them and to deny the presence, or anyway, the appropriateness, of such feelings in Western humans."[14] Varnedoe and William Rubin, the exhibition's other director, claimed that in many instances coincidental "affinities" rather than direct influences accounted for similarities in ethnic and modern objects due to "some universal will to form." By taking the ethnic object out of its broader cultural context, however, the ritual meaning with which it was endowed was ignored. Many of these so-called primitive works were meant to be seen in motion, often at night by torchlight. Their original magic power is distorted when displaced into the white box of the museum, when form is substituted for content.

Actually, in our epoch, arts are transmitted globally with instant speed, and artificial borders have lost their meaning. True "multiculturalism" prevails in works of artists like Bearden, Chase-Riboud, and many others, who are influenced by innumerable traditions that are then filtered through the artists' personal experiences. Ethnocentricity and its concomitant belief in higher "universal" values as privileged by critics like Kramer and Rubin, is being replaced by a nonhierarchical pluralism that is, above all, aware of cultural interaction. Only this can lead to a fuller understanding of works like Chase-Riboud's celebration of Malcolm X, with their sources in African and Oceanic objects, in Bernini's sculptures, and in modernist art. In fact, an essentially sensual style like Chase-Riboud's can assimilate many influences to blend into its own authoritative fluidity.

The early 1970s were an immensely productive period for the sculptor. She continued to make an impressive number of bronze

38

and silk pieces, created in Paris and cast at her foundry in Verona. The meticulous and powerful manipulation by her hands is largely responsible for the intricate undercuts, the deep and the shallow openings in large pieces such as *All That Rises Must Converge/Gold* (1972) in The Metropolitan Museum of Art (page 7), or *Confessions for Myself* (1972) in the Berkeley Art Museum (page 16), or *Time Womb*, in which the aluminum is silvered to a very light hue and placed above pale gray silk cordings. These wall sculptures, with light mysteriously appearing to emerge from inside the bronze folds, direct the viewer to see them frontally. Placed in niches, the best way of installing them, they evoke a sense of the spiritual in the viewer associated with altars or votive shrines.

The implied movement in these works is vertical, both downward along the cascading silk strands and simultaneously ascending toward the bronze crown. In *Gold Column* (1973), which rises to a height of thirteen feet, patches of bronze are placed toward the bottom as well as on top, while the silken cords hug the floor at the base of the pole. In pieces such as this, a fascinating reversal of textural constitution has taken place as the hard metal appears flexible and the soft fabric seems to be inflexible and hard. The male component, as it were, takes on the characteristic of the female element and vice versa.

Although there is no reference to the human body in these vertical pieces, they evoke associations with the human figure. The critic Donald Kuspit observed correctly that "when a sculpture—even an abstract sculpture—carries a kind of conviction we call 'presence,' we are unconsciously reading it as a metaphoric symbolisation of the body's emotional meaning. . . . It may renounce the overt illusion of the body, but covertly it represents the most intimate conception of the body."[15]

In 1970, the artist also began a series of powerful sculptures, which she named *Zanzibar* after the East African island in the Indian Ocean that was an early center of the Muslim slave trade. Discussing the Zanzibar group, Chase-Riboud wrote in an autobiographical note for the encyclopedia *Contemporary Artists*, "If 'beauty' can be called 'black' in the same way that humor can be called 'black,' then *Zanzibar* can be described as such." The note concludes with, "Sculpture as a created object in space should enrich, not reflect, and it should be beautiful. Beauty is its function."[16] This was not the general attitude taken toward art in the 1970s, when "beauty" was hardly de rigueur. It is all the better, therefore, to read an artist saying so. We might even carry it a step further, to the precept of St. Augustine, who affirmed that "beauty is the radiance of truth."

*Zanzibar/Black* (1974–75) is endowed with a mysterious beauty,

OPPOSITE:
*Dream Column.* 1976.
Black bronze,
72 ¾ x 15 ¾ x 15 ¾"
(185 x 40 x 40 cm).
Collection New York State
Office Building, New York

OVERLEAF, LEFT:
*Zanzibar/Gold #2.* 1977.
Polished bronze and silk,
47¼ x 23¼ x 3⅞"
(120 x 59 x 10 cm).
Private collection, Brussels

OVERLEAF, RIGHT:
*Gold Column.* 1973.
Polished bronze and silk,
13' 1" x 1' 5 ¾" x 1' 1 ¾"
(4 x .45 x .35 m).
Private collection, Paris

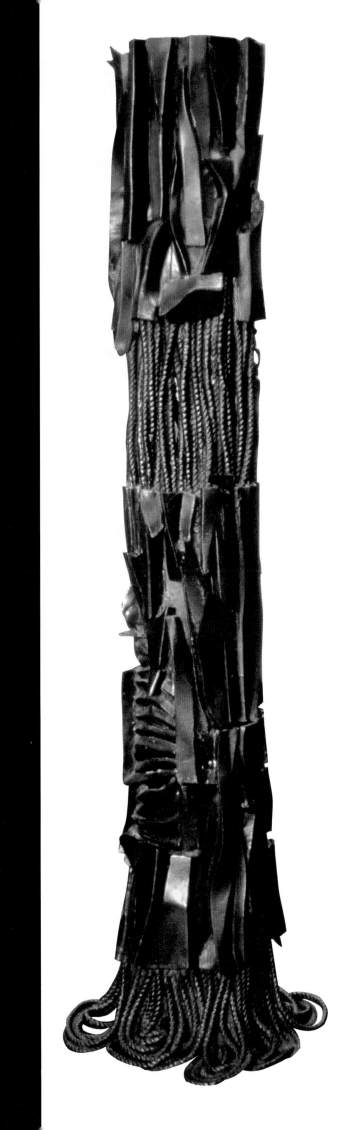

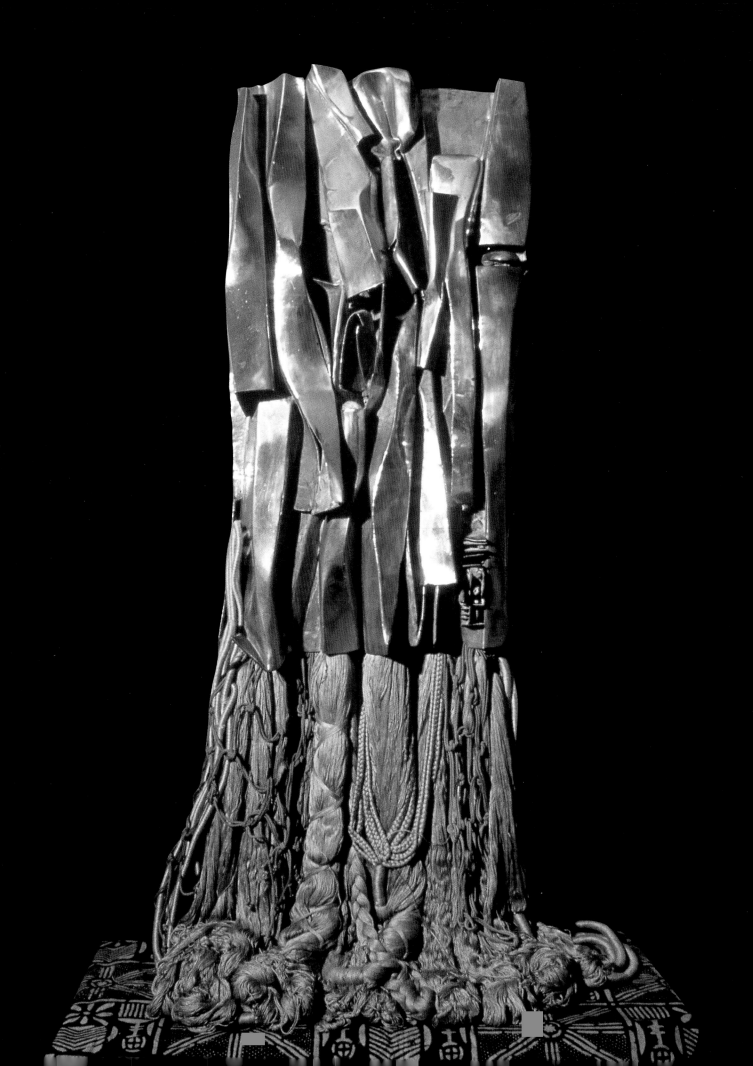

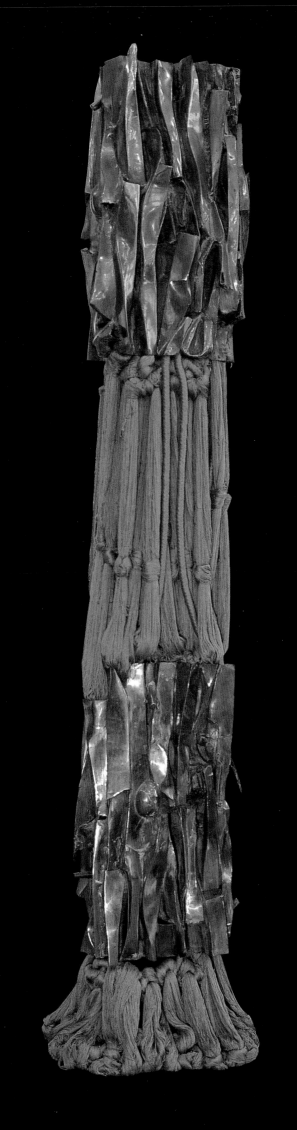

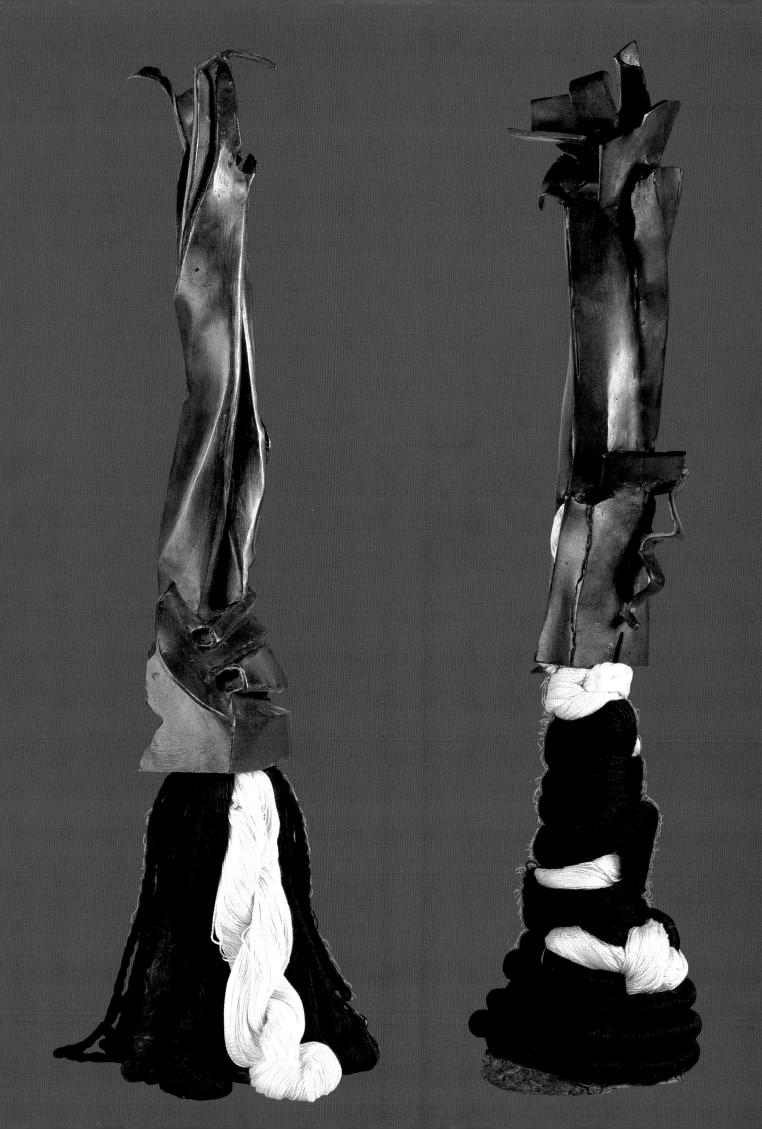

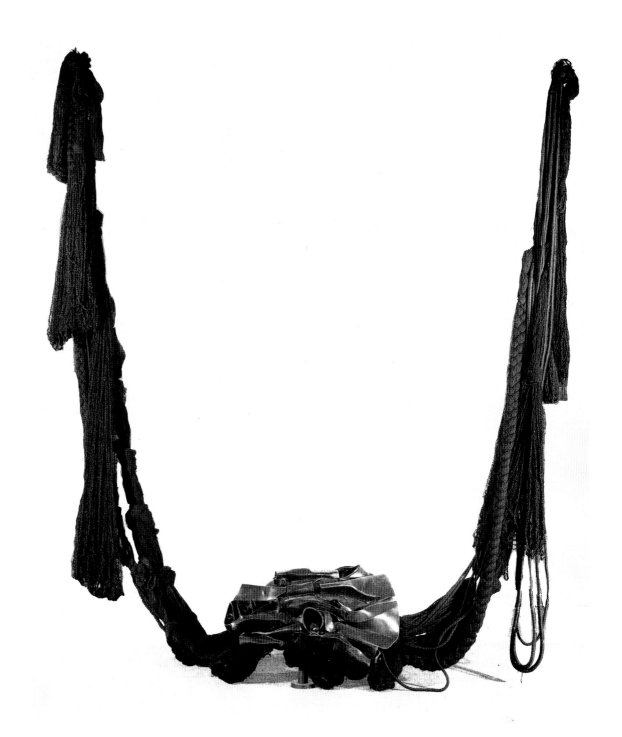

which we also find in some of Chase-Riboud's exquisite charcoal drawings of this period. The same discipline required in making the drawings is related to the ordered structure of her poetry. Her incisive poem, "Why Did We Leave Zanzibar?," was actually written in 1969–70, a few years prior to the sculptures of that name. The poem, like the metal and fiber sculptures, fuses sensual celebration with passionate indignation into an epic work. Her deliberations on the history, life, and emotion of the African American—the "dark haloed sister"—does not plead a cause, but transforms this awareness into a delineation of human experience. Her ardent poems and sculptures are, in spite of their rich sensuality, carefully restrained in their basic formal structure. They were, after all, made by the hand of an erstwhile student of architecture.

## WHY DID WE LEAVE ZANZIBAR?

Dark haloed sister,

Penumbric jewel

Burning in dry tobacco leaf beauty,

Brittle and flaking discontent,

Eyes damned with the silt of disappointment,

Lodged and sheltered in Public Housing,

Celled there tapping in Morse code on the bars of the mind:

The landscape of your nerve ends like orgasm.

The landscape of your nerve ends like orgasm.

Long-fingered, long-necked

Delicate wristed and ankled sister,

Wide-hipped and smelling of honey,

Eyes echoing hollow words and unremembered places,

Fingers stuttering, tearing

And wrapping themselves around

The essential question:

> *Why did we leave Zanzibar?*

Something in the line of the back spells

The irredeemable exhaustion of trying to make ends meet;

Those two butt ends of our amputated history,

Cauterized on the hot iron of self-hate,

Lusting after self-destruction

That we find in split vaginas,

Smeared with the muck of barbarians,

Birthing a race of orphans and madmen

when we could have stayed on the beach,

Heads severed and wombs filled with sand,

Clutching our ancestors,

Rejoicing in sterility,

Reveling in abortion,

Resplendent with infanticide,

Cursing the living with the last breath of strangled children.

You say we had no choice:

> *There is always one alternative to rape and every woman knows it*

Dark-breathed sister

Sinister survival worshiper,

Ready with the sword to smite the suicides,

Jailer for our prison-makers,

Grinding down our men with religion-pocked

Grins of satisfaction (Jesus Saves),

Crushing our defenseless sons with the jawbone of that Jew's cross,

Dazed and concussed, they stumble into the street to play stickball

Driving their fathers mad with grief and shame

So that their rage is spent in our bodies

(Or better still, the wives and daughters of the enemy);

And how we both glory in it,

Smack our lips in rutting satisfaction,

Tasting curdled blood and milk

Left standing in the sun too long

By absent-minded missionaries:

> *Benedictus qui venit in nomine Domini.*

Sassy, sweet-voiced sister,

Moon-browed and night-mouthed

In deepest song,

Lying on your back in cathedrals,

Content that another night has passed

Without murder,

Lying on your back in cathedrals,

Masturbating with the true cross (Sweet Jesus)

While black men thrash around with white flesh,

Listening for your hysterical screams resounding in the tabernacle,

And over all, Cleopatra's asp hovers:

Sliding between legs,

That perpetually open route to power,

Posing the essential question on split tongue:

> *Why did we leave Zanzibar?*
> *Sweet fragrant mango-stenched beach,*
> *Breasts pressed flat against steamed sand,*
> *Seeping through sieve-like flesh,*
> *Carrying carats of ancestor dust,*
> *Rattling like pearls in oyster shells.*

Sleek, earth-dyed sister,

Madness glistening at your throat,

We could have stayed on the beach,

Clinging to the rocks like bats,

REFUSING TO MOVE OUR WOMBS,

Scraping them with flint,

Soaking the continent with the holy blood of martyrs.

Plum-lipped sister,

Sad and wild-eyed with my reflection,

I touch one apricot breast

As you touch one brassy one,

And we gaze into each other's eyes

Like the criminals that we are,

Dark brown gall rising to the surface like oil on water,

Casting up that bottle-wrapped question

Flung into the sea by some desperate hand so many murders ago:

> *Why did we leave Zanzibar?*

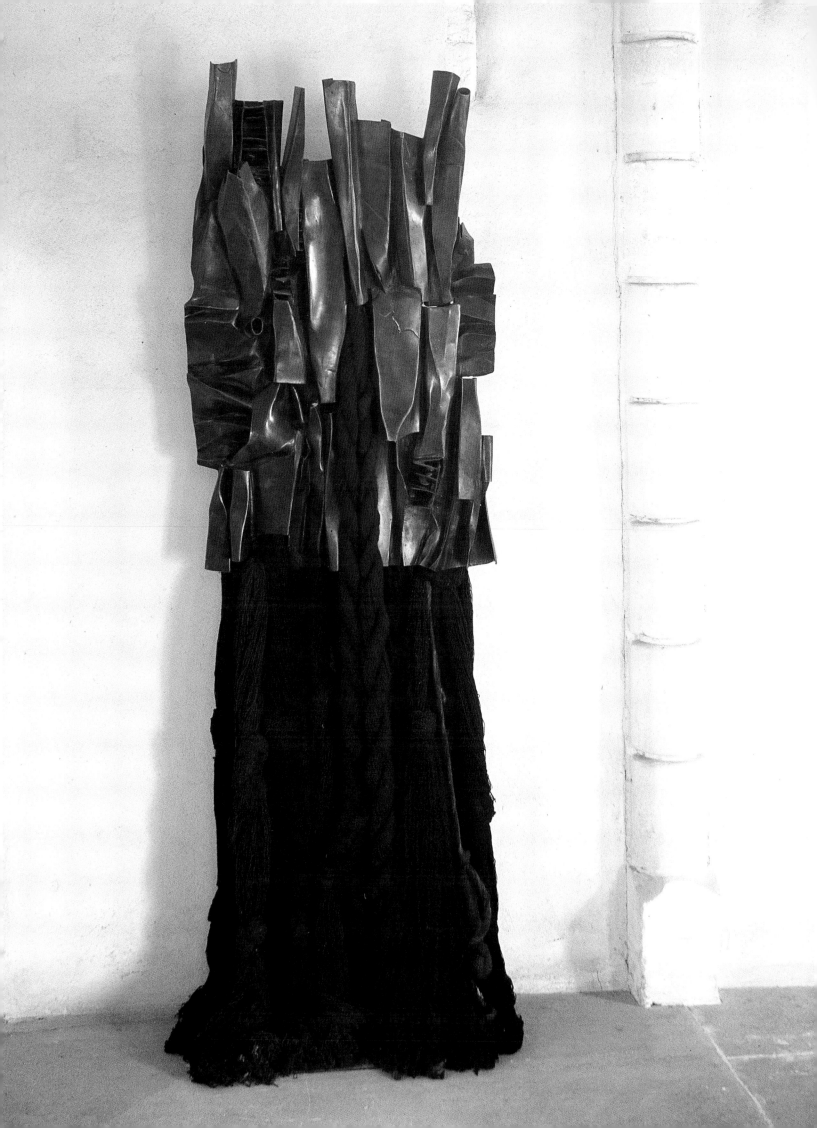

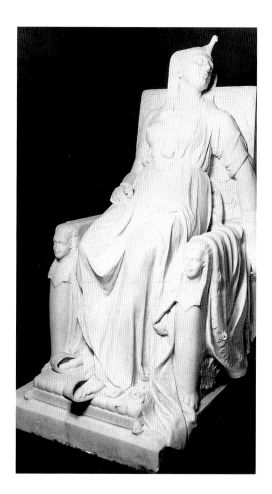

When this author, director of the University Art Museum at Berkeley at the time, saw works like *Zanzibar/Gold* and *Confessions for Myself*, he decided to curate a one-man exhibition of Barbara Chase-Riboud, which, it turned out, was one of the earliest major museum exhibitions of a woman artist in America.[17]

At this time the artist also commenced her series relating to Cleopatra, in which she transformed objects relating to the alluring Ptolemaic heroine into luxurious pieces of sculpture. The pharaoh's daughter with hereditary claims to divinity, Caesar's mistress, Marc Antony's wife, Cleopatra became an archetypal figure in world literature and in popular myth. In the preface to her book of verse, *Portrait of a Nude Woman as Cleopatra*, which was published in 1988 and was awarded the prestigious Carl Sandburg Poetry Prize, Chase-Riboud recalled seeing Rembrandt's *Study of a Nude as Cleopatra*, a simple but masterful drawing of a nude sitting on her bed. Cleopatra had also been the subject of one of Chase-Riboud's precursors: in 1876 Edmonia Lewis, the first African-American sculptor of note, was living and working in Rome, where she carved a large and majestic white marble statue, *The Death of Cleopatra*. It is a powerful work showing the queen seated on a throne, holding a snake, which, according to Plutarch, was her suicidal medium—in her right hand. In Lewis's Neoclassical marble statue, a work of great emotional impact, the queen is dying with a sense of pride. This work was shown to critical and popular acclaim in the 1876 Centennial Exposition in Philadelphia, the occasion in which the young Auguste Rodin exhibited for the first time in America. Large as it is, *The Death of Cleopatra* vanished from view for more than a century; it was acquired by the National Museum of American Art in Washington in 1994.

In the Cleopatra series (see pages 77–80), Chase-Riboud merges her early fascination with the power of Egyptian art with the experience of seeing the antiquities of China during her trip to the People's Republic of China in 1972, when Marc Riboud photographed the sarcophagi of Prince Liu Sheng and Princess Dou Wan, which had been unearthed from their rock-cut tombs in 1968.[18] These Han dynasty sarcophagi were covered with sheaths made up of thin rectangular pieces of jade that were pierced with tiny holes and fitted together with gold wire. *Cleopatra's Cape* (1973) consists of a structure over six feet in height that is covered by 3,500 multicolored bronze squares of varying sizes. These are engraved with thirteen different designs, varying from square to oblong configurations. The hard, metallic arched form of the cape and the heavy hemp rope extending from the armature appears to rest softly on the ground.

The artist was undoubtedly informed by Plutarch's description of Cleopatra. The Greek traveler tells us that when Cleopatra first appeared before Antony, "she lay under a canopy of gold, dressed as

OPPOSITE:
*Zanzibar/Black.* 1974–75.
Black bronze and wool,
9′ 6″ x 4′ 3″ x 1′ 1″
(2.9 x 1.3 x .33 m).
Private collection, Paris

ABOVE:
Edmonia Lewis.
*The Death of Cleopatra.* 1876.
Italian marble.
National Museum of American Art,
Washington, D.C.

Venus," and that later "that evening Antony was astounded by the magnificence of her preparations and the spectacular illuminations she had contrived for his entertainment, with many chandeliers lighted at once in patterns of squares and circles."[19]

Although she did not necessarily identify herself with the Egyptian queen, Barbara Chase-Riboud continued to be preoccupied with her history. In succeeding years she built imposing structures for her: a marriage contract, a door, a chair, and a bed.

*Cleopatra's Door* (1984), an imposing royal gate, consists of oak posts partially covered with multicolored bronze, and a swath suspended from the center, also sheathed with phosphorescent bits of bronze. It is symmetrically balanced and, rising to a height of eleven feet, an impressive and noble structure. Again the viewer is faced with the paradox of the hard bronze, which is formed to appear like soft fabric. Similarly, *Cleopatra's Chair* (1994) and *Cleopatra's Bed* (1997) seem to be made of flexible armor.

Thousands of interlocking bronze tesserae in gold, bluish, greenish, and pinkish hues were made to interlock on carefully prepared armatures. In the *Bed*, the chain mail was placed on top of a silk mattress, and the fiber is visible through the spaces between the metallic squares. The *Chair*, which is three feet high and four feet across, is commanding by its sheer size and glimmer and is indeed both regal and architectural. All these phantom works evoke desire, yet, at the same time, they are tangible objects. Plutarch reported that after the queen's death, "when they opened the doors, they found Cleopatra stark dead, laid upon a bed of gold, attired and arranged in royal robes."[20]

In her Cleopatra poems, which seem as palpable as the sculptures, the direct sensuality of the language takes the place of the opulent objects.

## CLEOPATRA XXVII

Beneath the weight of angry pride
My Pharaohian breasts glisten through Sidonian fabric
Wrought in fine texture by the sley of the Chinese
My bridal gown warped by Egyptian needles.

Which have separated the warp-web of the legally Wedded,
Touching your map of the world with a peacock feather,
Murmuring quietly this . . . and this . . . and this . . .
Sinai, Arabia, Cyprus, Jericho, Galilee, Lebanon, Crete.

You're not the only man to pay for my Egyptian Nights.
My Royal Prostitution mortgaged the lives of other men:
Death at dawn was the price of phallic rapture

So don't wonder that my Tariff is your Territory
Shimmering through Nile-dyed muslin
Murmuring and this . . . and this . . . and this . . .

During much of the time when she was working on these pieces, Chase-Riboud was living and working in the Via Giulia in Rome, in a building (Palazzo Ricci) once occupied by the famed Renaissance sculptor and goldsmith Benvenuto Cellini. Again, "place" seems to have played a role as muse. She lived not far from the basilica of Saint Peter's with Bernini's great *Cathedra Petri* as the focal point of the nave. *The Chair of Saint Peter* is a fantastic conglomerate of stone, bronze, stucco, and glass, an icon of pomp and circumstance that signified the papacy's claim to apostolic succession.

The work of Gianlorenzo Bernini was indeed of great importance to Barbara Chase-Riboud: the tossed, twisted, and convoluted sheets of cast bronze, intermingled with malleable braids of silk by this twentieth-century artist certainly suggest an affinity to the agitation in the drapery in Bernini's marbles. There is also a related attitude toward materials. Bernini "regarded some of his greatest achievements to have marble made as flexible wax."[21] Similarly, Chase-Riboud made bronzes as flexible as silk. Bernini also meant for even his freestanding sculpture to be seen from a specific one-point aspect. Chase-Riboud also admired Bernini's flicker of light to imply transitory movement and the immaterial floating quality of his work. In his great late sculpture of *The Ecstasy of Saint Theresa* (1645–52) at Santa Maria della Vittoria in Rome, he "used drapery as abstraction and its surface modeling is a prominent fact in supporting the work's emotional power."[22] Furthermore, Bernini stepped across the borderline between sculpture and architecture, as does Chase-Riboud, who strives toward a similar unification of the arts in our time, as evidenced by her architectural sculpture, her drawings, poems, and fiction.

In addition to working in bronze and fabric, the artist continued her work in cast aluminum, which had begun with the Wheaton Foundation in 1960. Thirteen years later came *Bathers*, related in formal concept to the Malcolm X series. In a discerning article, Françoise Nora, then curator of the Musée National d'Art Moderne in Paris—now the director of the National Museums of France—described *Bathers* as a

. . . *low relief of aluminum squares, placed on the floor next to each other, a little like typographic blocks of faded archaic Chinese calligraphy. Hunks and tendrils of grey silk push through and are trapped in cracks. The mood here, even more than in the wall pieces, is a kind of poetic science fiction of the past, evoking a world one supposes is either a lost civilization, an Atlantis which has left us undecipherable artifacts, or an announcement of our own death and destructions.*[23]

Periodically, Chase-Riboud returned to work in aluminum, and in 1994 she designed a large and impressive indoor fountain in the

OVERLEAF, LEFT (TOP TO BOTTOM):
Gianlorenzo Bernini.
*Cathedra Petri*. 1657–66.
Gilded bronze, stucco, marble, glass.
Saint Peter's, Rome

Gianlorenzo Bernini.
*The Ecstasy of Saint Theresa*. 1645–52.
Marble and bronze. Cornaro Chapel,
Santa Maria della Vittoria, Rome

OVERLEAF, RIGHT:
*Ecstasy of Saint Theresa*. 1994.
Bronze, Cor-Ten steel, chalk,
35 ½ x 47 ¼ x 9 ¾″ (90 x 120 x 25 cm).
Private collection

PAGE 54:
*Bathers*. 1973. Created in an edition
of three (only one shown): each composed
of 16 modules of aluminum and silk,
3 ½ x 90 ½ x 72 ⅞″ (9 x 230 x 185 cm).
Collections: Centre Georges Pompidou,
Paris; Saint John's University, New York;
Private collection

PAGE 55:
*Astrological Fountain: Sagittarius/Kiron*
(full view: ABOVE; detail: BELOW).
Polished aluminum-bronze, black granite,
and water, 3′ 6″ x 18′ (106.7 x 548.6 cm).
Palladium Collection, Espace Kiron, Paris

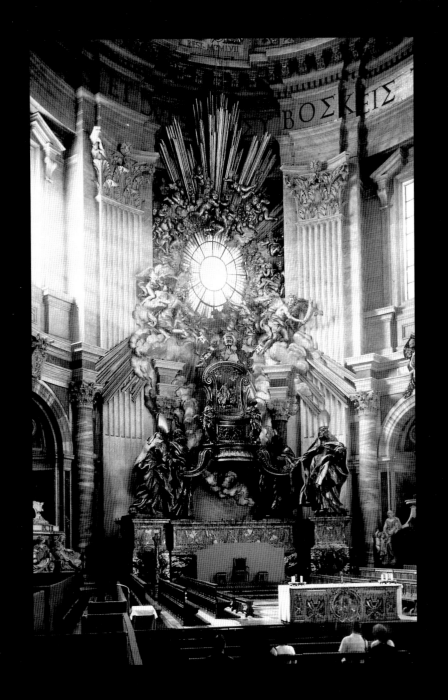

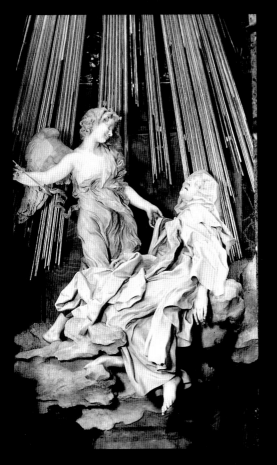

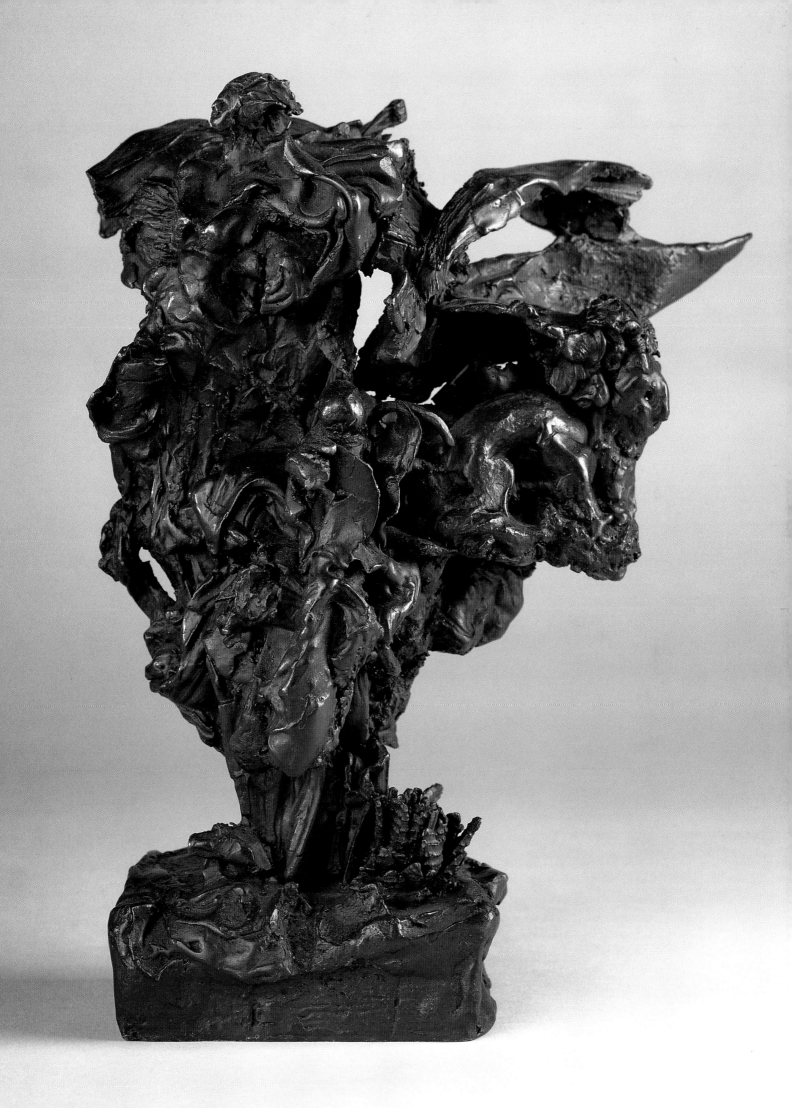

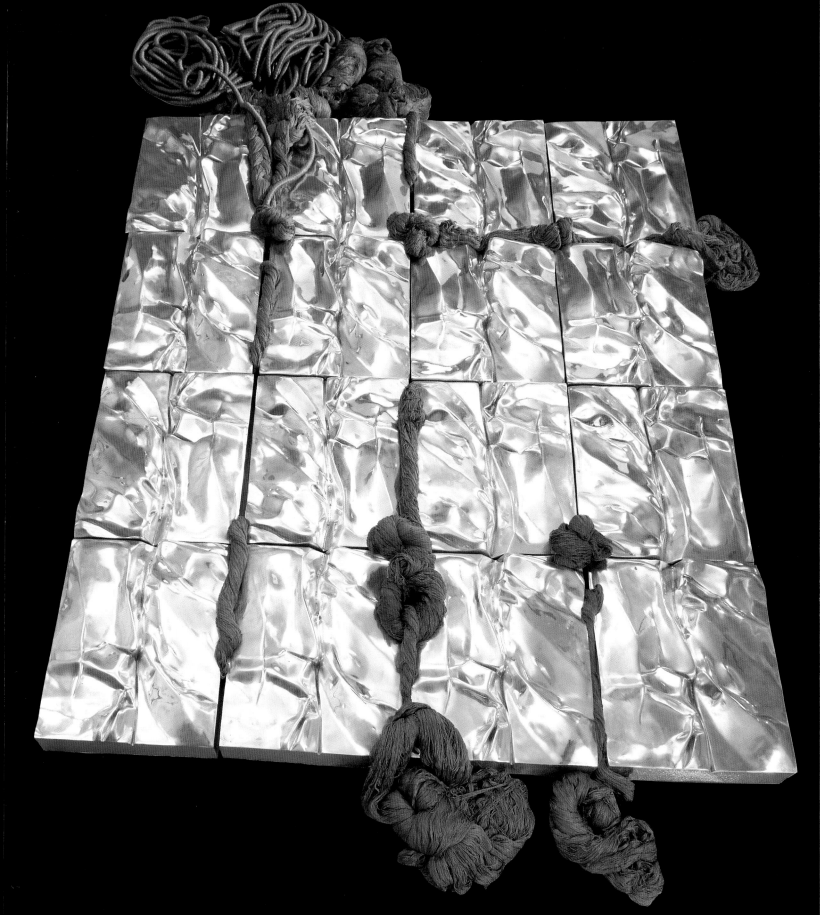

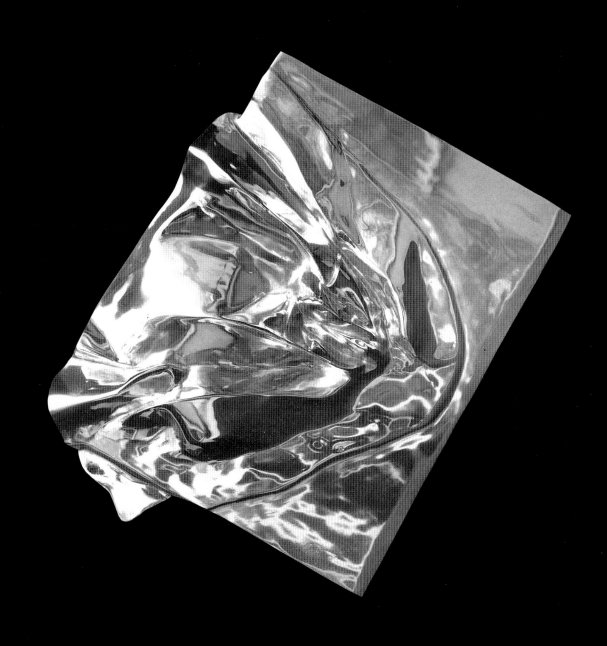

Espace Kiron in Paris, where she also installed an important exhibition.

She also continued working on sculpture that juxtaposes bronze and fiber. In 1994 she fashioned the elegant *Black Obelisk* (page 11), which is lean and spare, growing from a tangle of woolen threads to a slender spire. Halfway up the tower, a segment of black bronze imitates the irregular crumpled skeins of the woolen strands in a vivid interchange between the two substances. The *Matisse's Back in Twins* (1994) refers to Matisse's sculpture series of backs (1909–30) and is also a severely frontal view of a figure. But here a polished gold bronze interweave is set in the place of the older master's shoulder, arm, and head. All these works are signified by silent conversation of binary opposites:

metal/fiber
heavy/light
masculine/feminine
earth/spirit

Referring to ancient Hindu and Buddhist esoteric tradition, the artist completed three works entitled *Tantra* in the 1990s. Tantra refers to the power and energy of Shakti, female consort to a Hindu god, and to the occult rituals and practices of copulation, all leading to a sense of oneness with the universe. *Tantra I* (page 2) is a stately sculpture of lustrous appearance. We see a work almost seven feet high and more than four feet across standing on an armature to which bronze sheets and silk strands have been attached. The interlocking and tangled fall of the silk lends complexity to a work that is otherwise characterized by geometric simplicity of form and line. The elaborate skeins of silk both respond to the fall of gravity and act as visual pedestals supporting the massive fan that makes us think of a head or, rather, a mask. *Tantra III* (page 64) evokes the Tantric *mandala*, the sacred circle of divinity. The circular fiber forms can be seen as emerging from the mandala and returning to this symbol of totality. Using the language of abstract sculpture and nontraditional materials, Chase-Riboud has created in this series not only atavistic or primordial images, but also illusions of regal personages, or phantom objects of ritual and magic. They do not seem to resemble any sculpture we have ever seen, even though they can be related to the imperial sculpture of Egypt or to African masks.

### Narrative Sculpture

As early as 1973, the artist actually started on her Cleopatra series when she conceived *Cleopatra's Marriage Contract* (page 84), which was also the first of her narrative paper sculptures. *Cleopatra's Marriage Contract* is a work of heavy handmade paper, hung with

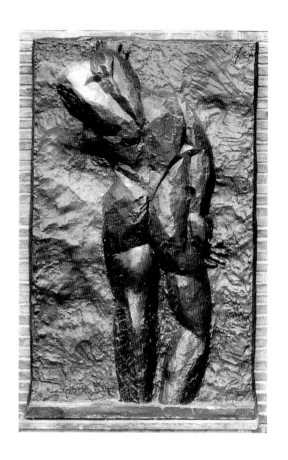

ABOVE:
Henri Matisse. *Back II*. 1913.
Bronze relief, 74 ½ x 45 x 7″
(189.2 x 114.3 x 17.8 cm).
Hirshhorn Museum and Sculpture
Garden, Washington, D.C.

OPPOSITE:
*Matisse's Back in Twins*. 1994.
Aluminum, bronze, and silk,
82 ⅞ x 21 ⅞ x 11″ (210 x 55 x 28 cm).
Collection of the artist

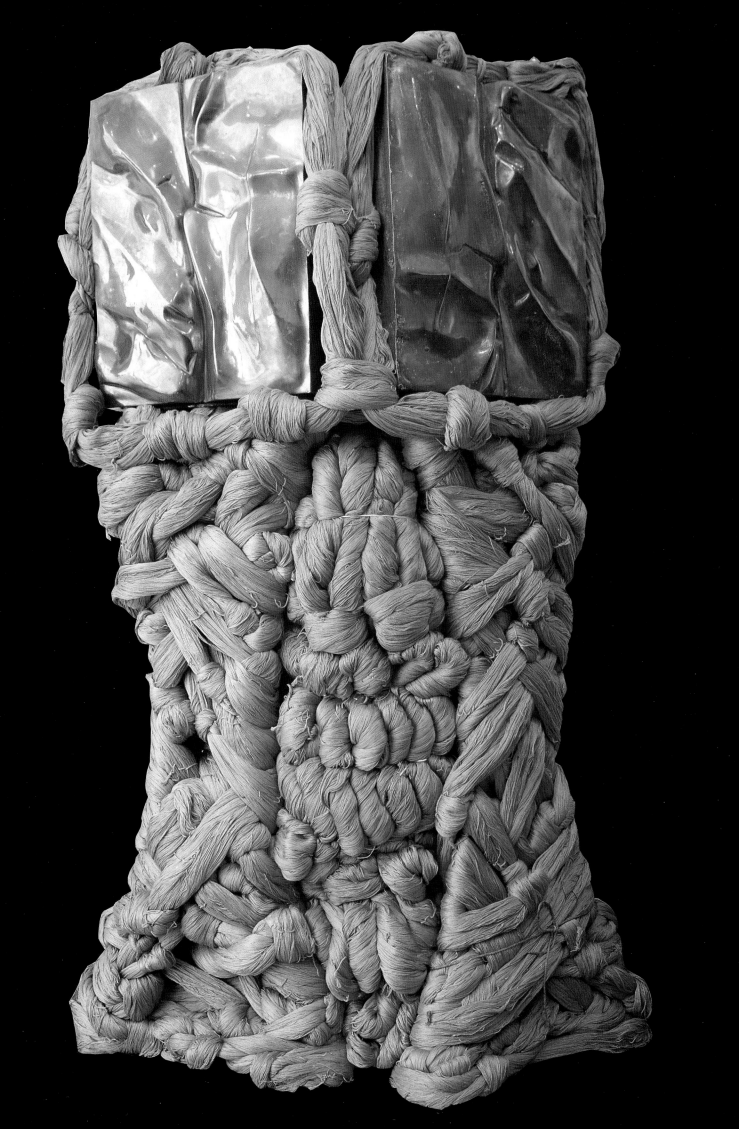

numerous seals and scribbled with automatic writing—a Surrealist technique based on the subconscious vitality of the creative hand. Living in Paris, the artist was familiar with Max Ernst's *frottages*, which had liberated this Surrealist artist from relying on received imagery, and she admired the work of the Belgian painter and poet Henri Michaux, who had experimented with invented pictorial signs, with scribbles, which can be seen as body signatures. It is worth noting that Chase-Riboud's novels, *Sally Hemings* (1979), *Valide* (1986), and *The President's Daughter* (1995) were all written in longhand. She points out that she writes by hand, with the pen as her writing instrument, because it is most congenial to the hand. The human hand is a prodigious instrument, capable of far greater control and precision than electronic machines. We must remember that the etymology of the word *surgery* comes from the Greek *cheirourgian*, meaning "hand work." There is an intimate connection between touch and intellectual and sensory motor activity. The hand, a primary source of creativity, is a means of spontaneous expression of the body, used by this artist both for her sculpture and her writing.

These novels, as well as poetry, form an integral part of the oeuvre of this polymath. After publishing her first book of verse, *From Memphis & Peking*, in 1974, she came across Fawn Brodie's biography of Thomas Jefferson, which affirms the president's love affair with his slave Sally Hemings.[24] She found this tale of miscegenation, the interlocking relationship between black and white in American history and its long concealment, of great importance. She asked her friend Toni Morrison to write about it, but Morrison, who had edited *From Memphis & Peking* at Random House, in turn urged Chase-Riboud to do so herself. Walking on the very same streets in Paris where Jefferson and Hemings had been in pre-Revolutionary France facilitated her doing so, and in 1979 her highly acclaimed nonfiction novel combining history with psychological speculation was published.[25]

In the mid-1990s she returned to automatic writing in *Isabella's Contract with Columbus* (page 84). Here the handmade paper is attached with red seals that are impregnated with crosses. It has the signature of Her Most Catholic Majesty, the queen who was largely responsible for the institution of the Inquisition and the expulsion of the Jews, as well as the patron of Christopher Columbus during his journey westward to "discover" America, which, incidentally, was decisive in the creation of the "peculiar institution" of slavery in the New World.

Very different in feeling is *Poet Walking His Dog* of 1994 (page 83). It consists of a Cor-Ten steel shelf on which a bronze figure of an emaciated man, wearing a large sombrero, is trailing behind a squirming little dog. On both sides are "columns" or sheets of paper

OPPOSITE:
*Artemisia*. 1995.
Bronze,
19 ⅜ x 5 ⅞ x 8 ⅝″
(50 x 15 x 22 cm).
Collection of the artist

58

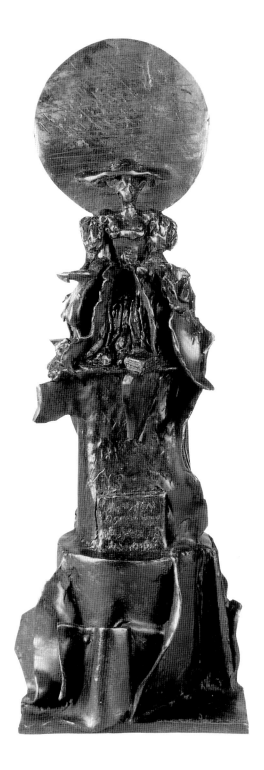

with anatomical and botanical engravings. On a large sheet behind the bronze figures of man and dog are again the artist's automatic scribbles, but we are able to read an inscription: "Poet en train de promenade son chien, dédier a St. Tomasi di Lampedusa." In another miniature tableau, *Poet Walking by Rainbow (Poet Walking His Dog #2)*, the bronze man, somehow reminiscent of the free handling of the material in Honoré Daumier's satirical sculptures, holds his dog on a long leash that is curved to complete the circle of a bright rainbow painted on the Cor-Ten steel sheet. Another piece, *Poet's Mistress's Shoulder #2* (page 82), is again equipped with paper scrolls of drawings from a Baroque anatomical treatise, assembled on the Cor-Ten sheet with a disembodied bronze arm intruding on the composition of the documents.

This was the period in which the artist allowed free flow of fantasy and intuition to direct much of her work. There is *Sculpture Garden* (1995), with its pointed and rounded triangular and circling shapes emerging from a whirl of rope, apparently put together at random. *La Musica*, from 1997 (page 13), is a highly eccentric piece that continues the tradition of Surrealist sculpture: a double column of bronze and bundled silk seems to hold a bronze appurtenance shaped like a violin, which could also be seen as the conductor's held-out baton and repeats the horizontal shape (a foot?) at the bottom. There is the stately bronze of *Artemisia* (1995), with its large disk or halo encircling the figure's head. This work was done in honor of the Baroque painter Artemisia Gentileschi (1593–c. 1642), who depicted historical subjects, such as the darkly dramatic painting of *Judith and Maidservant with the Head of Holofernes*, from a woman's point of view. Artemisia was also the protagonist of a controversial contemporary film about the artist.

These objects are radically different from the work done by Chase-Riboud's American contemporaries. From the beginning of her career, she had been open to ethnic cultures of the past, and she had always felt a close connection to America's indigenous music. In an earlier autobiographical note, she wrote:

*Although I feel isolated from current trends in American art, this is not true of current trends in American music. The fascination with African and Oriental music which began in the early sixties with John Cage and John Coltrane, to name only two, founded a strong underground movement in avant-garde music. The dense, complex and primary music of Steve Reich, Terry Riley and Alice Coltrane are much closer to what I'm after than the funk or super-realism of post-pop. Pop did have an influence on my work. Not only in my revolt against it, but in the freedom it gave me to explore the possibilities of materials other than the classic ones for sculpture.*[26]

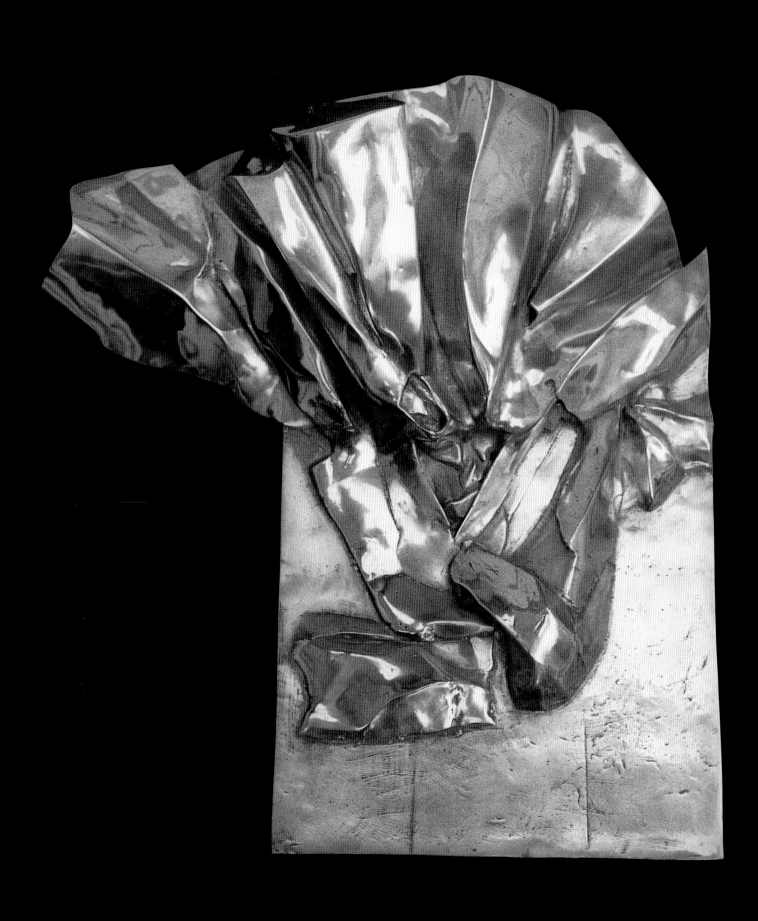

## Sculpture in the Public Domain

During the mid-1990s, Barbara Chase-Riboud began working on maquettes and scale models for a commissioned monument to an African graveyard that had been uncovered during construction for an office building in lower Manhattan. *Africa Rising* (pages 123–27, 133), installed on lower Broadway in New York in 1998, can be seen as a compelling milestone in monumental public sculpture at the fin-de-siècle. Until the end of the nineteenth century, and even extending into our own, the principal purpose of public sculpture was to educate and ennoble the citizenry, to inspire lofty sentiments and, above all, to legitimize, if not celebrate, the nation's institutions and its military heroes and civic luminaries. The former were represented riding victoriously on horseback; the latter, often engaged in oration, appeared in formal garb. If a sculptor hoped for public commissions, he—rarely was it a she—had little freedom to follow his own artistic impulse. He was trained in the academy to meet the demand for patriotic and elevating statuary, an attitude that has been carried into the very recent past with the Iwo Jima monument at the edge of Arlington National Cemetery and the three soldiers in full battle dress that were, regrettably, placed next to Maya Ying Lin's incomparable Vietnam Veterans Memorial.

Our attitude toward public sculpture, however, has undergone a consequential change: witness the numerous effectively anonymous equestrian statues that today attract more pigeons than people. Two outstanding twentieth-century thinkers did not look hopefully for meaningful sculpture in the public domain to emerge in our time. The preeminent art historian Erwin Panofsky concluded his monograph on funerary sculpture by saying:

*All those who came after Bernini were caught in a dilemma—or, rather, a trilemma—between pomposity, sentimentality, and deliberate archaism. He who attempts to write the history of eighteenth, nineteenth, and twentieth century art must look for his material outside the churches and outside the graveyards.*[27]

So, we must look in the public square. But, as the erudite social philosopher Lewis Mumford warned: "If it is a monument, it is not modern, and if it is modern, it is not a monument."[28]

By and large these opinions are certainly justified by the kind of "plop art" or corporate baubles that we find in shopping malls and corporate office buildings. Professor W. J. Mitchell, editor of *Critical Inquiry* and author of *Art and the Public Sphere*, deplores "the liquification of the public sphere by publicity, the final destruction of the possibility of free public discussion . . . by a new culture of military and state management, and the emergence of a new world order in

OPPOSITE:
*Malcolm X #1* (viewed from above).
1970. Polished bronze,
16 ⅛ x 29 ½ x 29 ½"
(41 x 75 x 75 cm).
Private collection, Krefeld, Germany

which public art will be the province of 'spin doctors' and propagandists." But he also suggests that "the internationalization of global culture" might "provide opportunities for new forms of public solidarity to emerge, and leave openings for the intrusion of new forms of public resistance to homogenization and domination."[29]

There have actually been, and continue to be, exceptional monuments of commemoration as far back as the end of the nineteenth century. In the *Burghers of Calais* (1885–95), Auguste Rodin changed the idea of the public monument unalterably. The French master broke with noble idealization and chose to present the viewer with an uncompromising vision of six voluntary victims with rough-hewn faces and extraordinarily expressive hands. Instead of imposing legendary heroes, Rodin created suffering human beings.

The finest public monuments of the century have tended to be more abstract, such as Tatlin's model for a *Monument to the Third International* (1919–20), whose whole design is based on the dynamics of the spiral, a concept that, fifty years later, was also essential to Robert Smithson's *Spiral Jetty* (1969–70), an earthwork now submerged below the water level of the Great Salt Lake.

World War II, Auschwitz, Hiroshima, and Vietnam have given rise to public sculpture that no longer glorifies the violence of war. Consider Ossip Zadkine's agonized figure symbolizing the *Destroyed City of Rotterdam* (1954) or Isamu Noguchi's maquette for a *Memorial to the Dead* (1952) in Hiroshima. Never realized, the latter was conceived as a monument about birth and death. Its portentous dome, like that of Henry Moore's *Nuclear Energy* (1965) at the University of Chicago, evokes the ominous nuclear mushroom while simultaneously signifying a sense of protection and solace. In Paris, under the supervision of the architect C. H. Pingusson, a crypt was hollowed out on the Île de la Cité for the compelling *Memorial to the Martyrs of Deportation*, and, among the plethora of Holocaust monuments, the *Monument Against Fascism* (1989) by Jochen Gerz and Esther Shalev-Gerz in Hamburg deserves special attention. Conceived as a critique against traditional memory places, it is designed to sink and eventually disappear totally into the ground as more names are added to its lead surface by signatory visitors. No doubt the most moving commemorative monument to the American men and women killed in the Vietnam War is the Vietnam Veterans Memorial (1982). Informed by Minimal sculpture as well as medieval funerary monuments, Maya Lin slashed the earth to build a wall of names and planted the top of the gap with grass as a gesture of healing. But none of these memorials were sculptures of buoyant affirmation, which is the theme of Barbara Chase-Riboud's *Africa Rising*. Standing above the African Burial Ground, it is a monument of both national mourning and reconciliation.

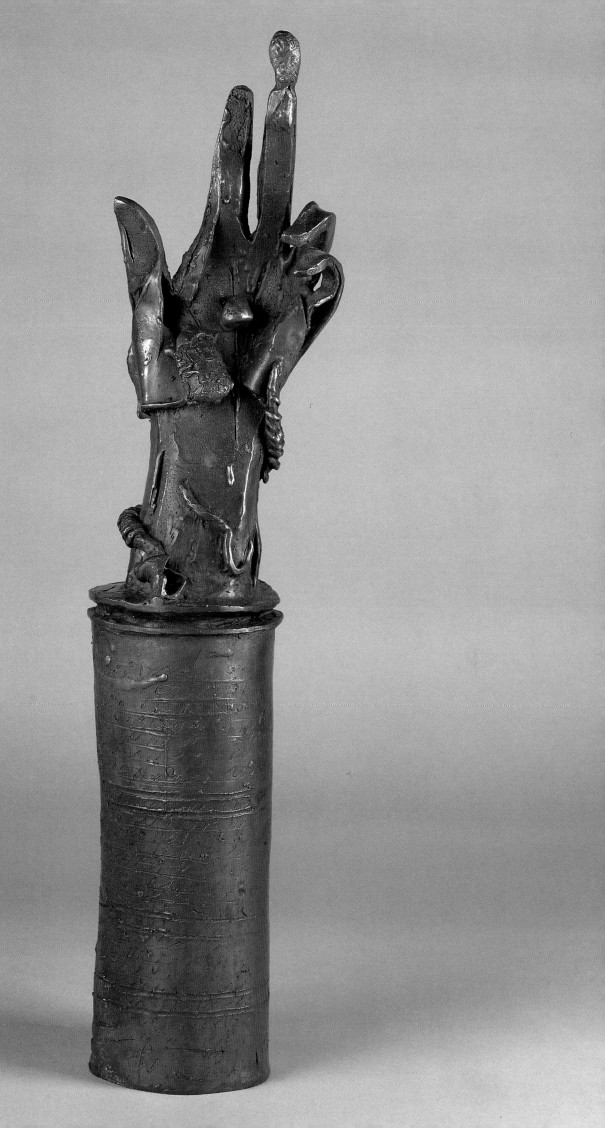

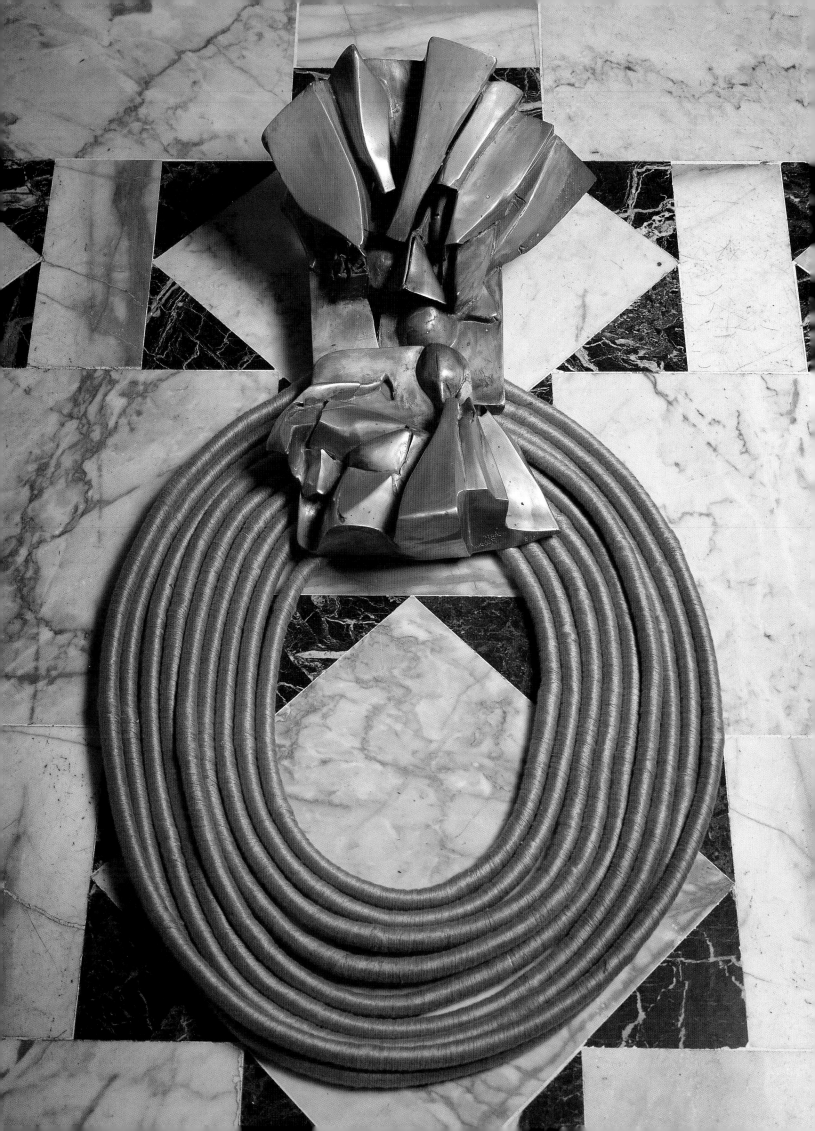

The site of this nearly twenty-foot-high sculpture is the lobby of a new federal building at 290 Broadway, near Foley Square in downtown New York. The building was erected on top of the nation's earliest (believed to date back to the seventeenth century) and largest African burial ground, which extended from Duane Street to what is now City Hall Park. In keeping with colonial practices toward blacks, this graveyard—located north of Wall Street—was originally declared to be outside the city limits. It began to be built upon in the late eighteenth century and was neglected and forgotten thereafter. It was rediscovered in 1991 during the excavations for the present building, an event that had "global and universal implications which transcend urban archaeology, physical anthropology, or the concerns of any one group."[30] In Dutch New Amsterdam, almost 40 percent of the population was African; in British colonial and early American New York, almost 20 percent of the population was African. Many of these Africans were enslaved, and it was only in 1827 that slavery was outlawed in the Empire State. The investigation of the bodies also confirmed the brutal treatment imposed on the slaves and brought about new reflection on our history, discourse on the interaction of black and white populations, as well as the realization of the importance of historic preservation. The idea of constructing a tall office building on top of the burial grounds created a storm of controversy, and the excavations were stopped when a broad community of concerned citizens objected to the threat to the ancestral remains and to the opportunity for valuable anthropological research into "the origins of the African population, the physical quality of their lives and the biological and cultural transition from African to African-American identities."[31]

*Indeed, New York's African Burial Ground was a vivid example of the omission of the colonial Africans' presence and contribution to the building of the city and the nation. The African-American public could at once turn to the abundance and tangible physical remains of the people omitted from the city's deficient school curricula. By omission, northern slavery and racism had been denied.[32]*

Construction of the building was stopped in 1992, partly due to the direct intervention of Gus Savage, a black Congressman from New York, and the city's mayor, David Dinkins. The building was modified and an area of grassy land to the east of the building was retained as permanent open space; a postage-stamp series to commemorate the African Burial Ground is to be issued. The site was designated as a National Historic Landmark, and a competition for a work of art to memorialize the site was announced in 1994 by the United States General Services Administration (GSA). Five hundred

OPPOSITE:
*Tantra III.* 1984–98.
Polished bronze and silk cord,
68 ⅞ x 59 x 4 ¾″ (175 x 150 x 12 cm).
Collection of the artist

OVERLEAF, LEFT (TOP TO BOTTOM):
*Nike of Samothrace.* c. 190 B.C. Marble,
height with base approximately 16′ (4.9 m).
Musée du Louvre, Paris

Umberto Boccioni.
*Unique Forms of Continuity in Space.* 1913.
Bronze, 43 ⅞ x 34 ⅞ x 15 ¾″
(111.4 x 88.6 x 40 cm). Collection,
The Museum of Modern Art, New York.
Acquired through Lillie P. Bliss Bequest

OVERLEAF, RIGHT:
*Untitled (Africa Rising).* 1997–99.
Chalk on Arches paper, 20 x 28″
(50.8 x 71.1 cm). Collection of the artist

thirty-seven sculptors, including Chase-Riboud, came forth as candidates, and "on June 21, 1995, I received a letter from the commission of the GSA informing me that I had been selected 'to design, execute and install an artwork for the Memorialization of the African Burial Ground.'"[33]

Chase-Riboud had explored racism, the meaning of slavery and its effect of total disempowerment on human beings, as well as its impact on the owner-victimizer, in her historic novels and many of her poems. In response to this new challenge, these issues were now to be considered in her sculpture. *Africa Rising* was her first explicitly political work of art, as well as her first major commissioned public sculpture. In the winter of 1995, the artist set to work, making a total of twelve scale models, of which four were submitted to the commission. Some of them, such as *Scale Model #10*, rather abstract and very baroque, indicated her continuing affinity to Bernini. Certain motifs, such as the winged Nike figure and the ship's prow, were present from the beginning and were retained throughout. After *Model #7* was accepted, the artist created the final sculpture at her foundry in Milan, where it was cast, in direct wax, in three full-size parts, an awesome challenge for the foundry masters, as failure of any part meant failure of the whole.

African tradition, non-European art, and the sculptor's lifelong involvement in the history of European sculpture all found their apogee in *Africa Rising*. Apart from the continuing inspiration Chase-Riboud derived from Bernini's work, she also built upon the contribution Medardo Rosso made to early modernist sculpture by the "flickering throbbing surfaces which seem to merge with the viewer's space and environment."[34] Rosso was admired by the commanding Futurist sculptor Umberto Boccioni, who, in his "Technical Manifesto of Futurist Sculpture" (1912), referred to Rosso as "the only great modern sculptor who has attempted to open up a larger field to sculpture, rendering plastically the influence of an ambience and the atmosphere that binds it to the subject."[35] And Boccioni went on to proclaim "that sculpture is based on the abstract reconstruction of planes and volumes"[36]—the essential precept of the modernist sculptor.

The freely moving surface planes, giving vitality to the sculptural mass that we find in Boccioni's sculpture, is comparable to the manner in which Chase-Riboud used her bronze forms in many of her earlier metal and fiber pieces. Now a similar effect is produced without the fiber in the baroque cascades of the two lower zones in *Africa Rising*. In the nether segment, the artist actually replicated textile cording for the two large sides of the work, while more flattened piles are employed for the narrow prow. The viewer's eye moves from the low convex arch upward to the next level, with its more expansive

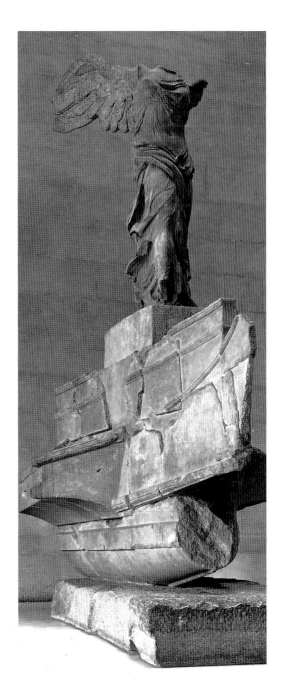

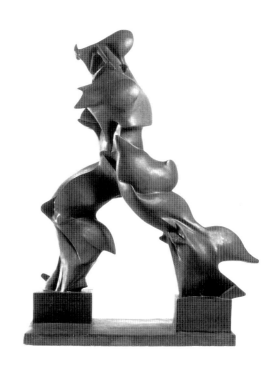

concave arch that rhymes with the lower arch but curves in the opposite direction. This arch, whose crescent shape recalls Egyptian or Ashanti headrests as well as East African stools, serves as the base for the towering Nike figure. The curved bow, however, can also be interpreted as an ark or, perhaps, a ship commemorating the transatlantic journey, called the Middle Passage, endured by Africans on their way to slavery in the New World. In another reading, the two lower levels of this large work can be seen as a great portal, a part of a palace, perhaps a later version of *Cleopatra's Door,* used here as the substructure supporting the windswept figure.

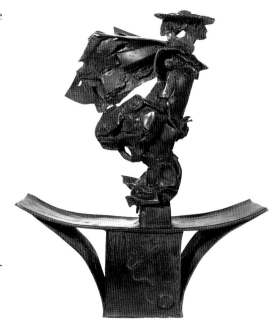

The whole work, in fact, is extremely architectural in the construction of its planes and masses. The great surmounting figure, which measures almost half of the total structure, is that of an abstracted female figure. It recalls, and indeed is meant to refer to, the great Hellenistic *Nike of Samothrace.* In Chase-Riboud's bronze, a clanging and fluttering mantilla takes the place of the widespread wings of the marble Greek goddess of victory. There is a similar sense of airiness and strong movement by the figure against the implicit winds. In both Nike figures, matter—marble or bronze—has been transformed into salient energy. Another precursor for *Africa Rising* is Boccioni's forward-striding figure that he named *Unique Forms of Continuity in Space* (1913), which cuts through its environment with dynamic velocity. Chase-Riboud's *Africa Rising,* like these two predecessors of her work, takes possession of the surrounding space with kinetic energy. But her Nike is also an African figure, whose extended buttocks relate to Sarah Bartmann, the so-called Hottentot Venus from South Africa who was exhibited at the Museum of Natural History in Paris as an exotic curiosity in 1815.

Chase-Riboud's African Nike is rendered in bronze, its surface treated to a silvery patina, which adds significantly to the vivacious quality of this figure. This black Nike appears to forge ahead toward light, and some unseen objective, with a compelling sense of triumph in which the physical sweep is lifted into a transcendental realm.

The sculpture is housed in the lobby of a thirty-four-story office building in proximity to the site where Richard Serra's *Tilted Arc* (1981) once stood between loathsome buildings at Federal Plaza, impinging on people's movement. Serra's huge minimalist and abstract form seemed precarious, menacing, cold, and depersonalized. The work, fine by itself, was disastrous in this site, and eventually it was removed, though by improper channels. In keeping with recent trends toward public art that addresses social concerns, especially of previously marginalized groups, rather than dealing with purely formal considerations, *Africa Rising* may prove to be less controversial precisely due to its discursive controversial content. It is a memorial that deals with human history and uses the human figure to transmit universal human concerns.

During the years preceding *Africa Rising,* Barbara Chase-Riboud

ABOVE:
*Sarah Bartmann/Africa Rising*
(scale model #6). 1996. Bronze,
35 ½ x 29 ½ x 8″ (90 x 75 x 20 cm).
Collection of the artist

OPPOSITE:
*Woman's Monument* (scale model).
1998. Bronze, 5⅛ x 4¾ x 3⅛″
(13 x 12 x 8 cm).
Collection of the artist

composed her historic novels dealing with the indescribable ordeal of slavery; it was also during this time that she began working on another major project, the *Middle Passage Monument*, in memory of the 11 million Africans who died on the journey to America to be sold into slavery. It is to be a massive cross-beamed structure with a great chain wrapped around a huge bronze wheel suspended between two towers or obelisks. The bronze obelisks, which are to rise almost 60 feet high, will be engraved with the names of every place on the African continent from which the victims were taken. The conjoining of the Egyptian (African) obelisk and the Roman triumphal arch formed by the H-shaped structure signifies the union of African and Euro-American heritage. The work is conceived as a memorial to one of the greatest tragedies in human history, but, at the same time, it is also meant to be a monument of reconciliation. Designed to stand on Theodore Roosevelt Island in the Potomac River, sited along an axis with the nearby Lincoln Memorial and the Jefferson Memorial, it would signal national reconciliation of racial divisions during the 130 years since Lincoln's Emancipation Proclamation. It will be a momentous monument whose time has long been coming. The artist's own voice, in the form of an appeal to President Clinton and accompanying proposal, eloquently describe the multiple elements of this project—its form, meaning, and purpose (see pages 128–32).

## An Artist in This World

*Work is the weapon of honor, and who lacks a weapon will never triumph.*
—I. K. Marvel, *Rêveries*, 1852

During the development of her proposal for a memorial to the Middle Passage, Chase-Riboud composed a lyrically moving poem that she titled "Harrar." When she received the commission for the African Burial Ground memorial, she reconceived the poem as "Harrar/Africa Rising." As of this writing, she still awaits acceptance of her Middle Passage proposal.

In the meantime, Barbara Chase-Riboud continues her stance of "being-in-this-world," to use Martin Heidegger's phrase, this time focusing on the empowerment of women. Working in the space between abstraction and figuration, the artist plans a large *Woman's Monument*, a sculpture that will consist of a large 30-foot-high mirror of polished bronze accompanied by a tall, abstract female figure. The figure will be rather amorphous, with a long skirt, coherent with the rippled textures in the artist's corded forms. Her large arched arm will touch the mirror's surface. This project calls for a collaboration between the artist and an architect so that the bronze mirror will be suitably attached to the building's wall. The large work means to commemorate women

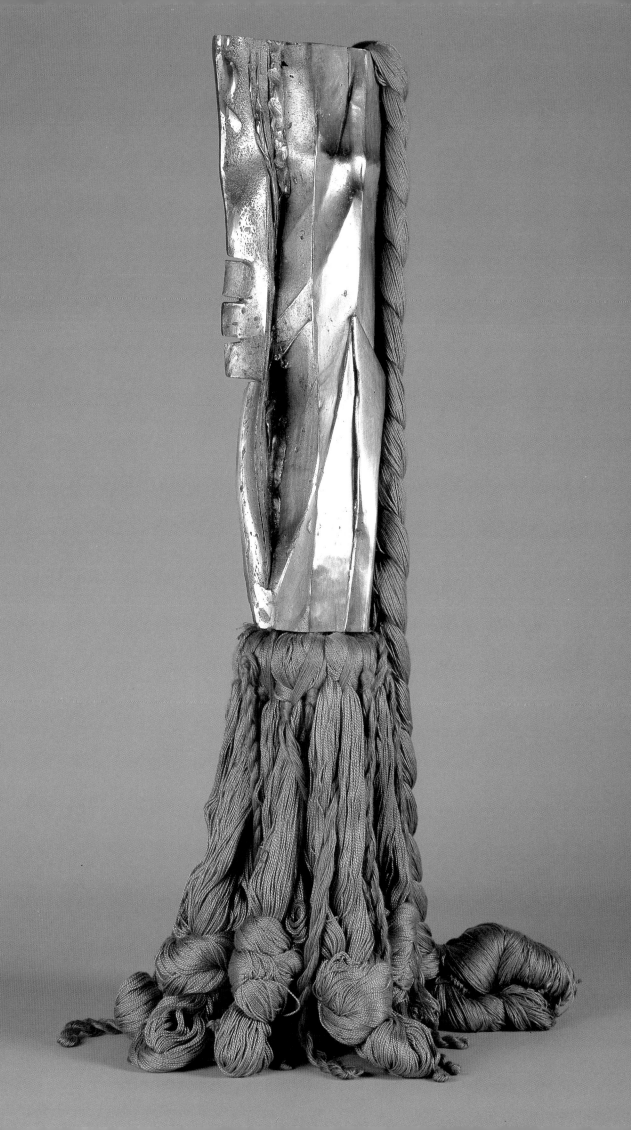

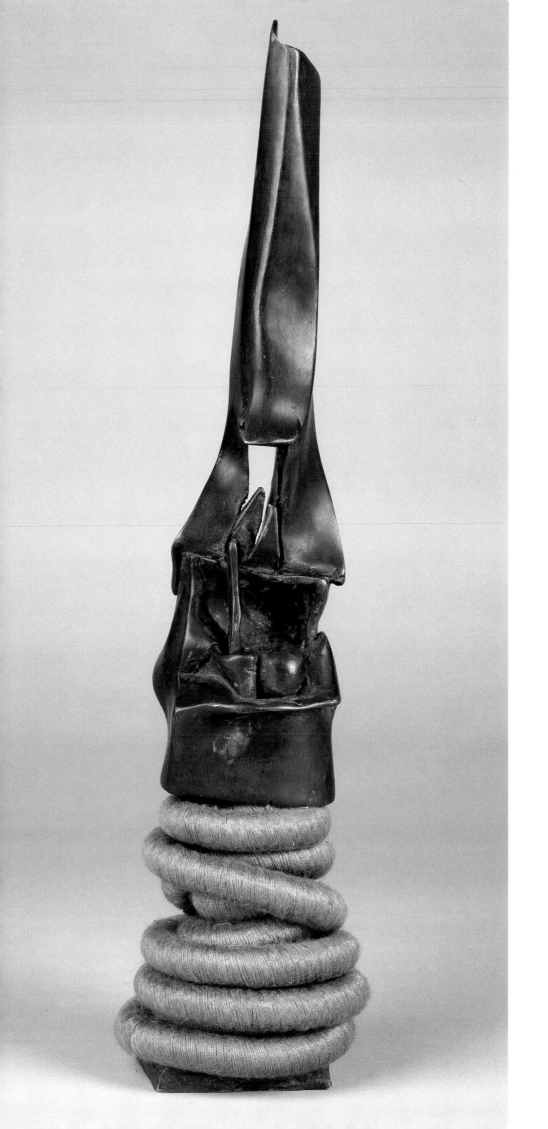

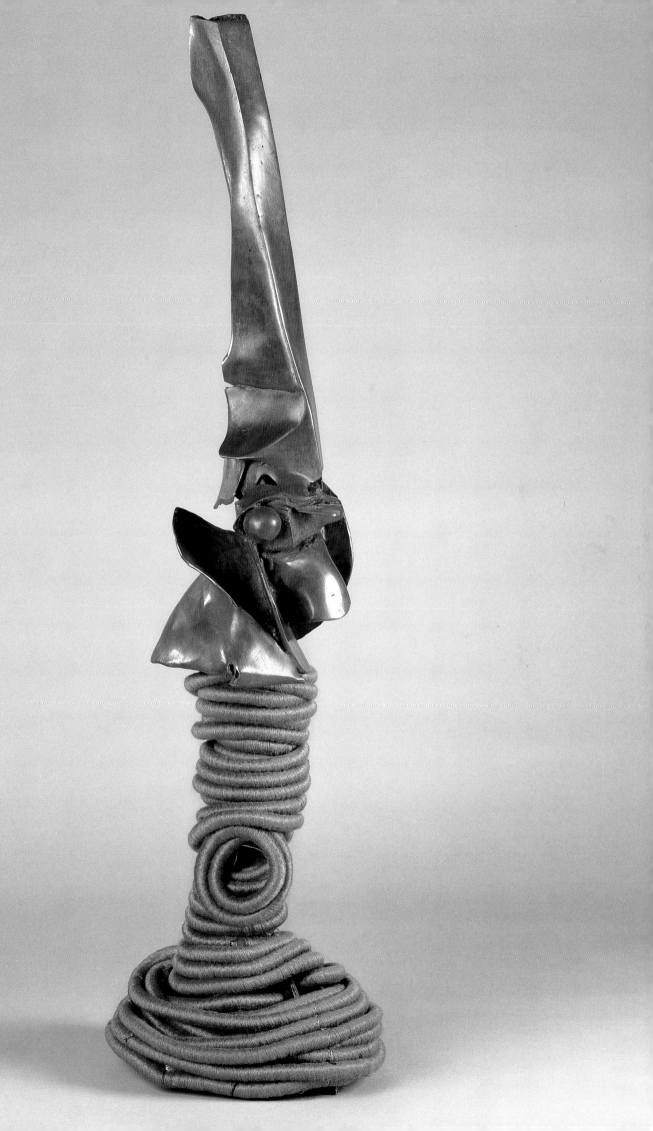

throughout history without resorting to banal propagandistic devices. It is to be placed in an urban center where it will reflect surrounding buildings as well as crowds of people. The mirrored surface will change consistent with the change of light, weather, population, traffic, even noise level. A text, as well as the names of significant women—some famous, some not—of the past two or three thousand years, is to be part of the monument. The use of the mirror can be seen as referring to the use of mirrors in "vanitas" still lifes, as a *memento mori*, reminiscent of several of Chase-Riboud's earlier narrative works set on Cor-Ten shelves, as well as her 1961 work *Artist in the Mirror*.

Ever since Pop art entered the art world, appropriation has taken the place of aesthetic originality. Aesthetic originality—an essential aspect of modernism—is based on modification and transformation of an ever-changing tradition—not replication and mindless quotation. We are in a place now where art has increasingly become a matter of fashion, of chic and trendy exhibitions. Yet there is, in spite of all the media that deliver artworks via the Internet and CD-ROM, still some serious art being produced. In fact, its marginal location makes it all the more important. In this age of the sound byte, there is still, or perhaps, again, art that requires time to contemplate and art that is based on ethical commitment. Barbara Chase-Riboud's new sculpture integrates sociopolitical and formal aspects of art and continues her concern with the multiple aspects of the artist's identity, which Harold Rosenberg felt was the primary issue of modern art.

## Notes

1. Barbara Chase-Riboud, fax to the author, August 4, 1998. Barbara Chase-Riboud likes to tell the story of the black G.I. who built Ezra Pound a writing table and a stool out of orange crates when Pound was being held under arrest by U.S. military authorities at the end of World War II. He had been imprisoned in a cage, open to the elements, suspended, where he could not stand upright and where he was allowed no books, no writing materials, no desk or chair. Yet this young man, in compassion for someone he knew to be a great poet, took pity and showed respect not for his treason but for his genius.
2. Chase-Riboud in Eleanor Munro, *Originals: American Women Artists* (New York: Viking Press, 1988), p. 372.
3. Chase-Riboud, fax to the author, July 26, 1998.
4. Chase-Riboud in Munro, op. cit., p. 373.
5. This work by a Yale graduate student was reviewed in the journal *Architectural Design* 31:1 (January 1961) in the same issue that first reviewed Le Corbusier's "Convent de la Tourette" in Eveux-sur-Arbresie, France.

ABOVE:
*Artist in the Mirror*. 1961.
Wax, 4 x 3 x 2″ (10 x 8 x 5 cm).
Collection of the artist

6. Peter Selz, *New Images of Man* (New York: The Museum of Modern Art, 1959), p. 131.

7. Prompted by Dubuffet's naming of specific pieces by himself as *assemblages*, William C. Seitz broadened the meaning of the word and introduced it as a generic term for collages, *papier-collées*, Readymades, found objects, paste-ups, Surrealist objects, and Combine paintings for his 1961 exhibition at The Museum of Modern Art called "The Art of Assemblage."

8. Chase-Riboud, *From Memphis & Peking* (New York: Random House, 1974).

9. Chase-Riboud, Interview with Susan McHenry, *Ms.* (October 1980), p. 40.

10. Robert Farris Thompson, *African Art in Motion* (Berkeley: University of California Press, 1974), pp. 214–216.

11. Barbara Chase-Riboud, fax to Harriet Whelchel, December 12, 1998.

12. Hilton Kramer, "Black Experience in Modern Art," *New York Times* (February 14, 1970), p. 23.

13. "Art Mailbag," *New York Times* (April 19, 1970).

14. Thomas McEvilley, "Doctor, Lawyer, Indian Chief," in *McEvilley, Art and Otherness, Crisis in Cultural Identity* (Kingston, N.Y.: McPherson and Co., 1992), p. 34.

15. Donald Kuspit, "Material as Sculptural Metaphor," in *Individuals: A Selected History of Contemporary Art*, ed. Howard Singerman (New York: Abbeville Press, 1986), p. 106.

16. "Barbara Chase-Riboud" in *Contemporary Artists* (London: St. James Press, 1977), p. 185.

17. University Art Museum at Berkeley, *Chase-Riboud* (Berkeley, 1973). Acknowledgments by Peter Selz, Essays by F. W. Heckmanns and Françoise Nora-Cahin. Since the time of this publication, the museum has changed its name to Berkeley Art Museum.

18. By coincidence, Marc Riboud's photographs of the Han dynasty jade sarcophagi appeared on the cover of *ArtNews* 71:1 (March 1972), in which Françoise Nora's review of Barbara Chase-Riboud's exhibition at the Betty Parsons gallery was published.

19. John W. McFarland, Pleasant and Audrey Graves, *Lives from Plutarch* (New York: Random House, 1966), p. 270.

20. Ibid.

21. Rudolf Wittkower, *Sculpture: Process and Principles* (New York: Harper & Row, 1977), p. 200.

22. Chase-Riboud, fax to the author, July 30, 1998.

23. Françoise Nora, "From Another Country," *ArtNews* 71:1 (March 1972), p. 28. "Bathers" is now in the collection of the Centre Georges Pompidou in Paris.

24. Fawn Brodie, *Thomas Jefferson: An Intimate History* (New York: W. W. Norton, 1974). Brodie's assertions were derided at the time, but she and Chase-Riboud have since been vindicated by DNA test results published in October 1998, by pathologist Eugene A. Foster, Charlottesville, Virginia.

25. Chase-Riboud, *Sally Hemings* (New York: Viking Press, 1979). In 1979, this book received the Janet Heininger Kafka Award for the best novel written by an American woman. It is scheduled to be reissued by St. Martin's Press, with a new introduction by the author, in September 1999.

26. Chase-Riboud in *Contemporary Artists* (op. cit.), p. 185.

27. Erwin Panofsky, *Tomb Sculpture* (New York: Harry N. Abrams, Inc., 1964), p. 96.

28. Lewis Mumford, *The Culture of Cities* (New York: Harcourt, Brace & Co., 1938), p. 438.

29. W. J. Mitchell, *Art and the Public Sphere* (Chicago: University of Chicago Press, 1990), p. 2.

30. Cheryl J. La Roche and Michael L. Blakey, "Seizing Intellectual Power: The Dialogue at the New York African Burial Ground," *Historical Archaeology* 31:3 (1997), p. 84.

31. Ibid., p. 84.

32. Ibid., p. 90.

33. Chase-Riboud, fax to the author, September 1, 1998.

34. Chase-Riboud, fax to the author, July 30, 1998.

35. Umberto Boccioni, "Technical Manifesto of Futurist Sculpture," in Joshua C. Taylor, *Futurism* (New York: The Museum of Modern Art, 1961), p. 13.

36. Ibid., p. 132.

# Cleopatra

"*Claude Lévi-Strauss has stated that 'art is the only proof that anything has ever happened in the past.' This is one of the most provocative—and one of the truest—comments on the role of art I've ever read or heard. Everything else is hearsay.*"

—Barbara Chase-Riboud

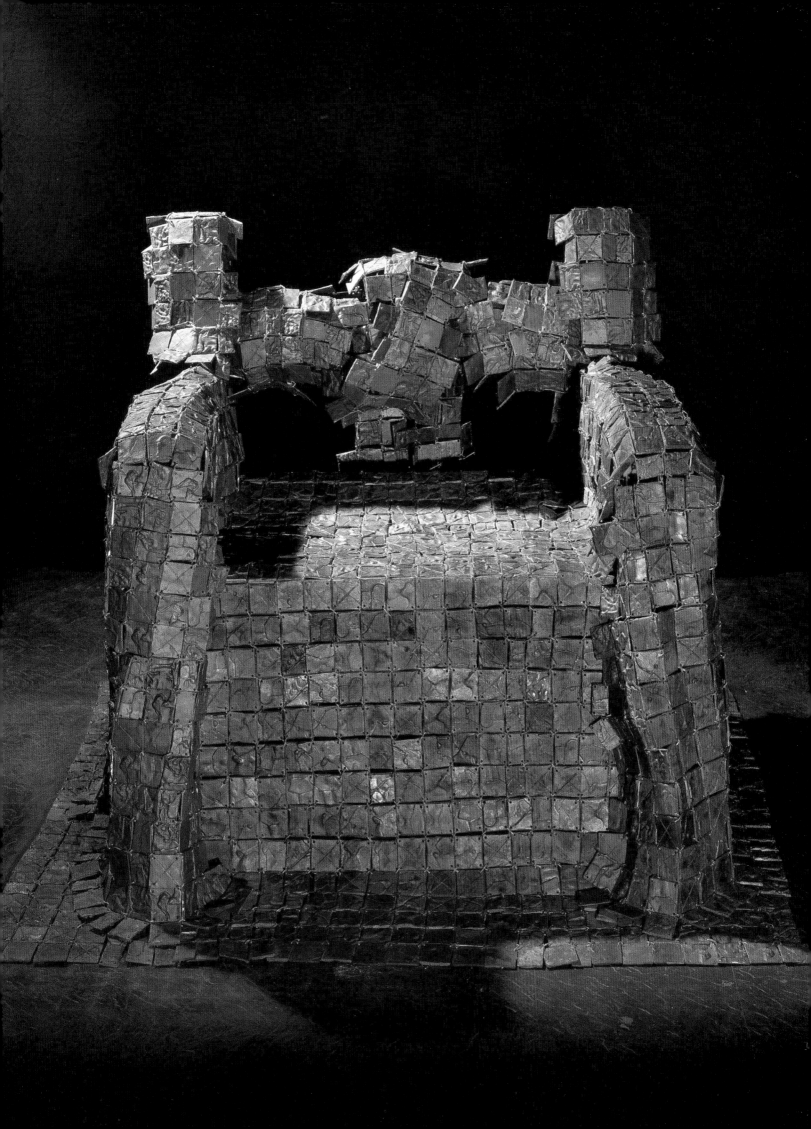

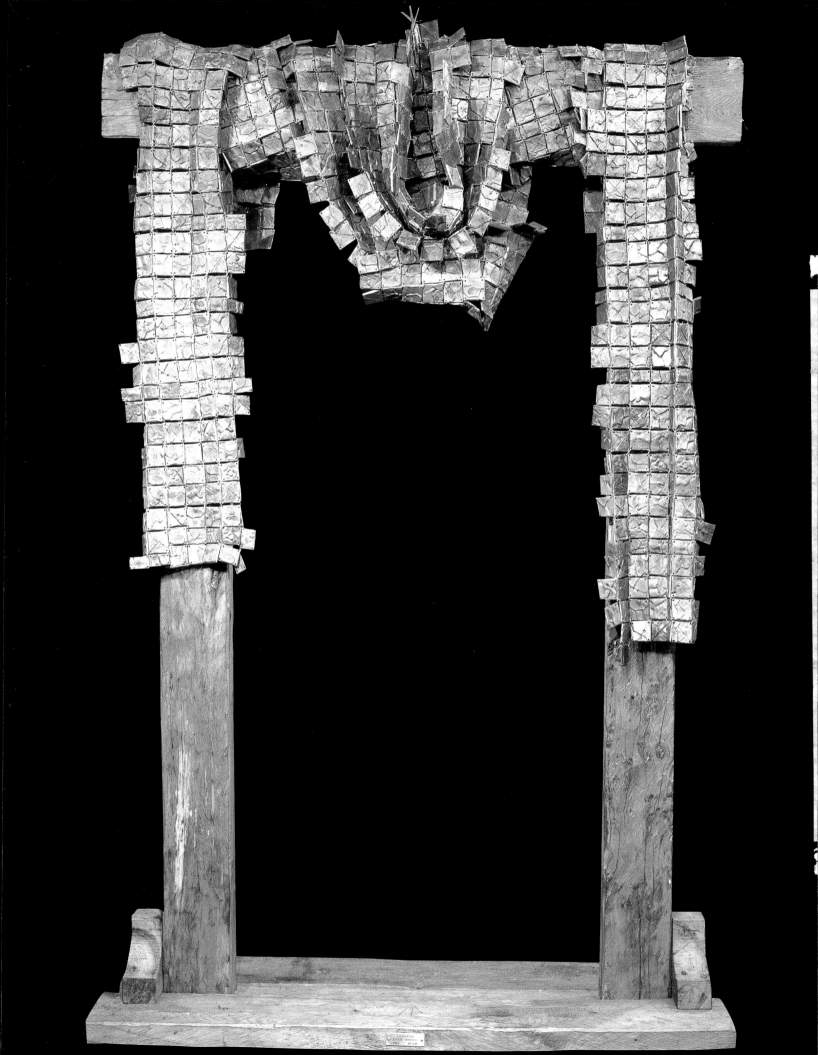

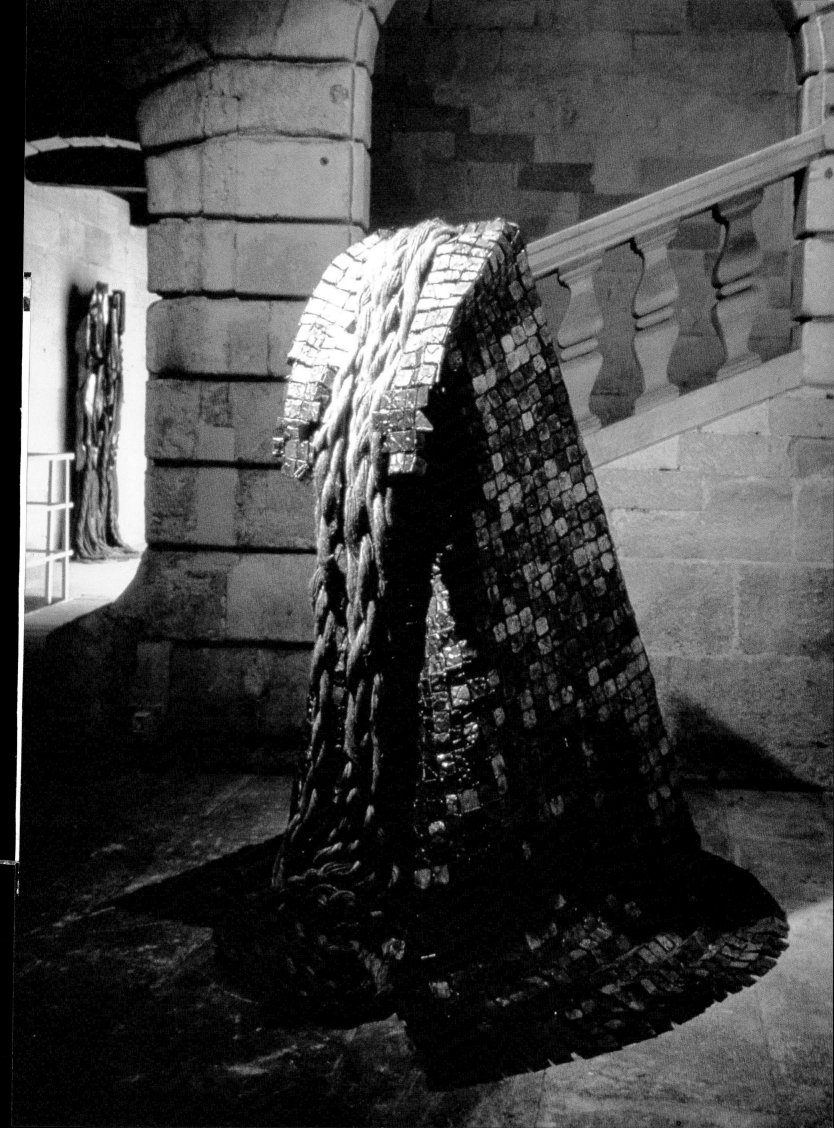

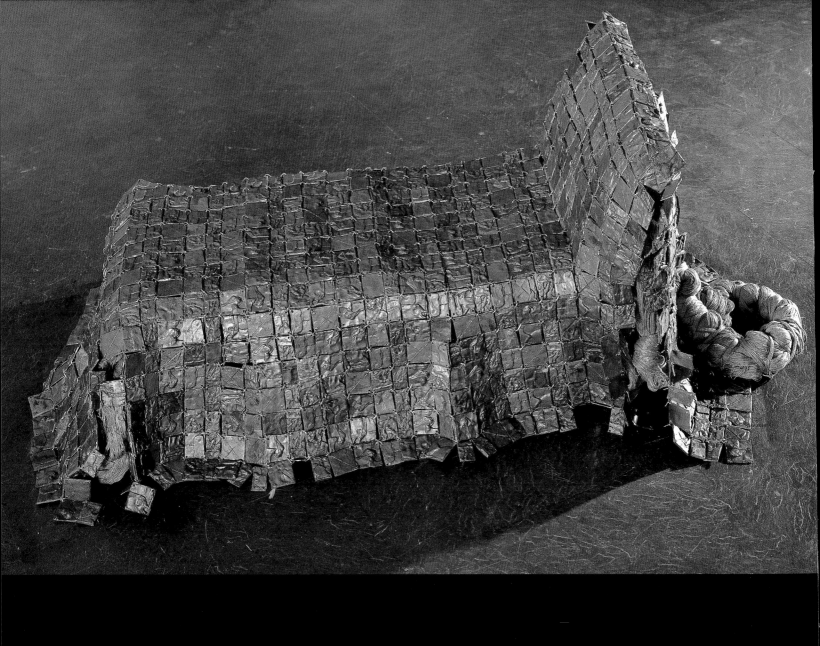

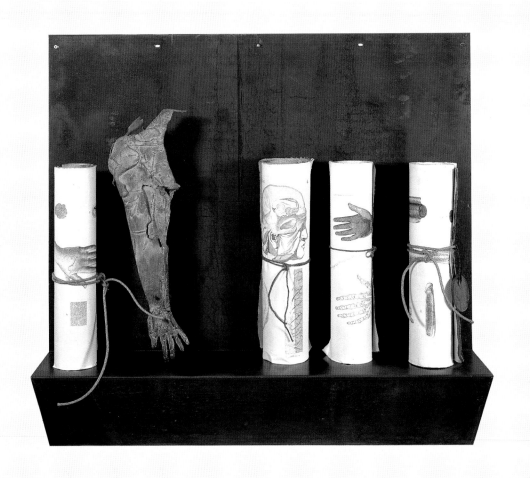

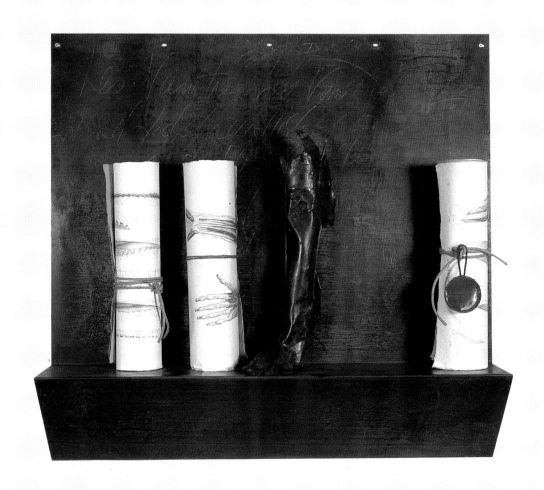

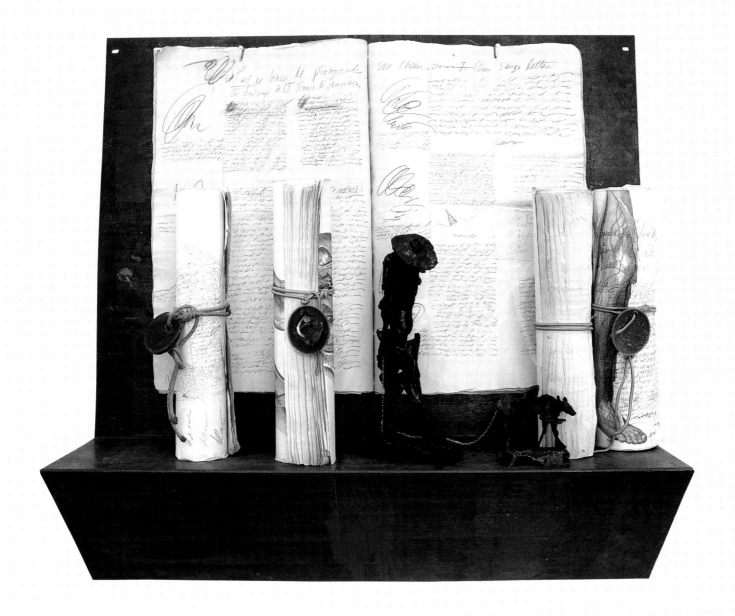

*Poet's Mistress's Shoulder #2*. 1994.
Colored bronze, paper, Cor-Ten steel,
45 ½ x 49 x 10″ (116 x 125 x 25 cm).
Collection of the artist

*Poet's Leg #2*. 1993.
Colored bronze, paper, Cor-Ten steel,
45 ⅝ x 49 ¼ x 9 ⅞″ (116 x 125 x 25 cm).
Collection of the artist

*Poet Walking His Dog*. 1994.
Bronze, paper, Cor-Ten steel, cord,
45 ⅝ x 49 ¼ x 9 ⅞″ (116 x 125 x 25 cm).
Private collection, Paris

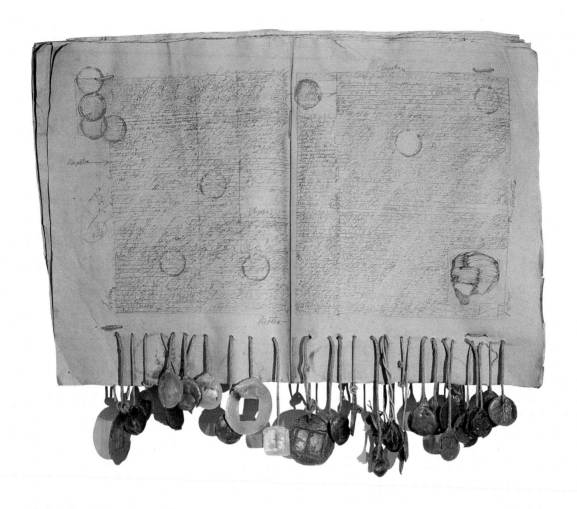

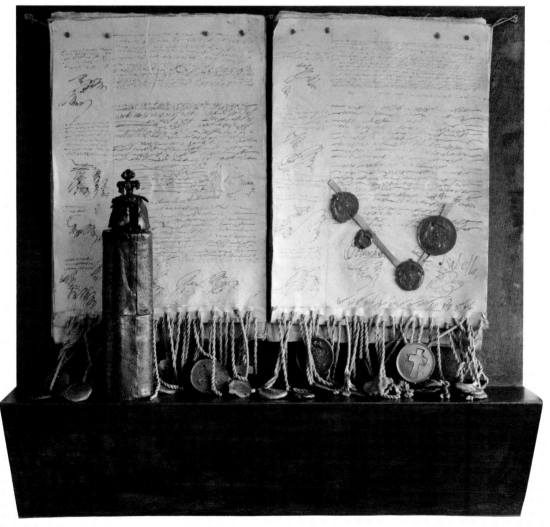

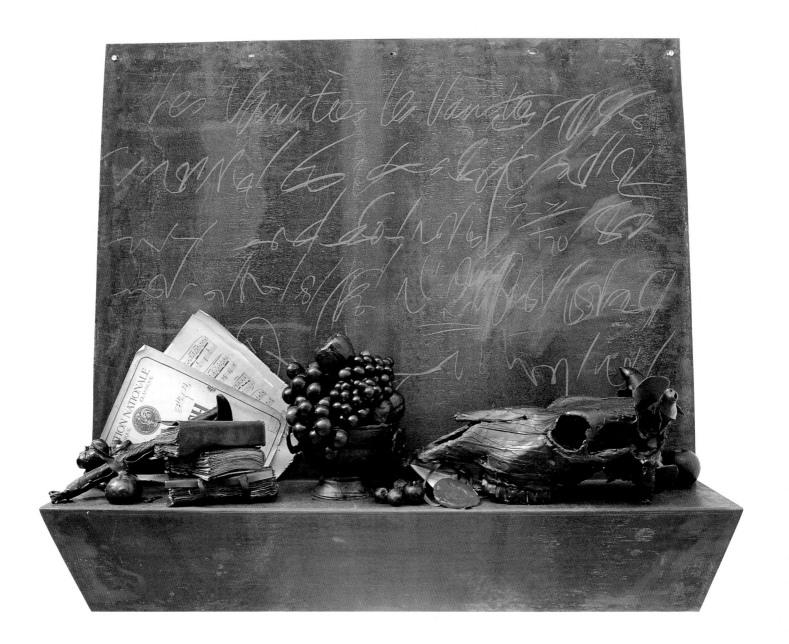

OPPOSITE, ABOVE:

*Cleopatra's Marriage Contract.* 1973.
Handmade paper, pencil, wax, cord, ink,
29 ½ x 47 ¼″ (75 x 120 cm).
Palladium Collection, Paris

OPPOSITE, BELOW:

*Isabella's Contract with Columbus.* 1995.
Handmade paper, pencil, wax, cord, ink, bronze,
45 ⅜ x 49 ¼ x 9 ⅞″ (116 x 125 x 25 cm).
Private collection, Paris

ABOVE:

*Vanitas.* 1994. Wax, bone, paper, chalk, pastel,
Cor-Ten steel, 43 ¼ x 47 ¼ x 9 ⅞″
(110 x 120 x 25 cm). Collection of the artist

# The Monument Drawings

## Anthony F. Janson

Barbara Chase-Riboud's drawings have been exhibited to critical acclaim in the United States, Europe, and Canada, and are represented in the collections of The Metropolitan Museum of Art and The Museum of Modern Art in New York. Yet the Monument drawings occupy a unique place in Chase-Riboud's oeuvre. They are aptly named: not only are they of unprecedented size for this artist, but they have a bold presence and vigorous execution surpassing anything she has done previously in this vein. The Monument drawings bear an intimate relationship to the sculpture and writing on which Chase-Riboud's reputation rests. While consistent with the new direction her recent work has taken, they must be understood in the context of her career as a whole, for they are the outgrowth of more than thirty years' experience as an international artist.

### The Artist as Persona Non

Barbara Chase-Riboud began her formal art studies at the age of seven at the Fletcher Memorial Art School and the Philadelphia Museum of Art, where it soon became evident that she was a prodigy. Although she was always the only black child in her classes, she never felt out of place. On the contrary, she felt that taking art lessons was a perfectly natural thing for her to do, thanks to her nurturing environment and unique personality. She appears at once pliant, yet determined—without character, yet possessed of an innate sense of unassailable rightness. In consequence, she almost always gets her way while seeming to bend to the wishes of others.

Chase-Riboud continued her training at the Philadelphia High School for Girls, where she transferred after being falsely accused of plagiarizing a poem she had written. She then attended the Tyler School of Art and Design, from which she received a B.F.A. in 1957. The following year was spent at the American Academy in Rome on a John Hay Whitney Fellowship. The highlight of her stay was a solitary trip to Egypt. Much as Italy immersed her in the mainstream of Western art, so the confrontation with Egypt's ancient ruins abruptly changed her artistic perspective away from its totally Western orientation, although her interest eventually gravitated to the later Greek and Roman phase of Egyptian history, witness her fascination with Cleopatra. Thus began Chase-Riboud's quest for her artistic identity, which she has sought in

THROUGHOUT THIS ESSAY:
The Monument Drawings
Charcoal, ink, and engraving
on Arches paper,
31 ½ x 23 ⅝″ (80 x 60 cm).
Collection of the artist

OPPOSITE:
*Foley Square Monument,*
*New York,* 1996

both her art and her writing by unearthing history with the persistence of an archaeologist.

While in Rome, Chase-Riboud was offered a scholarship to pursue a master's degree in design and architecture at Yale University, which was unique among major art schools at the time for opening its doors to exceptional African-American artists. (The painter William T. Williams and sculptor Tyrone Mitchell later received their M.A.s from there as well.) At Yale she met the English architect James Stirling, then a visiting faculty member, with whom she formed a close bond. The description given of her by another visiting English architect, Ken Frampton, to Mark Girouard, who is working on a biography of Stirling, still applies today: "very tall, very beautiful, very reserved, very aristocratic, a lady not be trifled with."[1] Upon completing her studies in 1960, Chase-Riboud went to Europe with the intention of marrying Stirling, but, finding London stuffy, she settled in Paris, where she wed the photographer Marc Riboud a year later. Marriage and motherhood were to place on the artist heavy demands that often took her away from her studio for extended periods.

During her first years in France, Chase-Riboud came into contact with numerous artistic tendencies. The formative influences on her work included sculptors Germaine Richier, Alexander Calder, and Alberto Giacometti; painters Antonio Calderara, Wilfredo Lam, Matta, Viera da Silva, and Pierre Soulages; and photographers Henri Cartier-Bresson and George Rogers. They helped to shape Chase-Riboud's outlook without, however, determining her style. Indeed, a comparison with these crosscurrents reveals that her art remains intensely American, but with an international perspective gained from living abroad. The artist continues to divide her time between France and Italy as a matter of personal preference, but she hardly regards herself as an expatriate. On the contrary, she has adopted Gertrude Stein's credo: "I am an American, and my hometown is Paris."

As a photojournalist, Marc Riboud traveled around the globe. In 1965, Barbara joined him on assignment in China, which had a profound impact on her. There she encountered yet another civilization older than Europe's. The following year, she experienced the rise of African-American consciousness when she exhibited at the First African Festival of Arts, which was held in Dakar, Senegal. She also attended the Pan-African Festival in Algiers, where she met Eldridge and Kathleen Cleaver, Huey Newton, and other high-ranking members of the Black Panthers. Concurrently, she wrote one of her rare political poems, "Soledad." Chase-Riboud's mature art is a direct outgrowth of these diverse experiences. Yet she has integrated them into a unique approach that cuts across all boundaries of race, gender, time, and culture.

*Malcolm X*

In 1970, Chase-Riboud created the Malcolm X series (now divided among several collections). Exhibited later that year at MIT, they established her reputation as one of the leading African-American sculptors on the contemporary scene. As a result, she soon was represented by two major New York dealers: Bertha Schaeffer and Betty Parsons. The Malcolm X sculptures were followed two years later by *Confessions for Myself* (page 16), exhibited at the University Art Museum, Berkeley, which remains her most celebrated work. All were created by manipulating large sheets of wax as if they were panels of cloth to create sensuous shapes. These forms were then cast in bronze before receiving a meticulous patination of polished brass or matte black. Out of a need to disguise the pedestals of her sculptures, she devised a system of braiding silk yarn with the help of her friend the fabric artist Sheila Hicks. As a result, the sculptures appear to stand on invisible legs, while at other times they almost seem to hover mysteriously in midair.

The braided silk performs a vital function in Chase-Riboud's sculpture: "In the 'skirt' sculptures, you have the continuing process of the bronze 'becoming' silk and vice versa; i.e., the continuous relationship between the male and female elements as one takes on the characteristics of the other, or changes roles one with the other."[2] Françoise Cachin points out, "The relationship between the two materials and the two tactile experiences symbolizes an important objective to Chase-Riboud: to unite an art which is considered noble to one which is considered craft—bronze casting, traditionally virile, with weaving, traditionally feminine. But her principal aim is to reinterpret in contemporary terms the magical and poetic qualities of a 'primary' vision of the world."[3] The juxtaposition of materials, which became a hallmark of her work in the 1970s, further lends these pieces an astonishing appearance that is at once strangely human and eerily supernatural. Indeed, as Cachin observed, they have a "poetic science fiction [that] radiates the impression of . . . another planet."[4] If Chase-Riboud's floor piece *Bathers* (page 54) evokes "the mysterious black slab in the film *Space Odyssey 2001*" for Cachin, *Confessions for Myself* could be likened to Darth Vader in the movie *Star Wars:* both represent the dark side of the subconscious, with its hidden world of archetypes. In common with other wall reliefs by Chase-Riboud, *Confessions for Myself* brings to mind modern-day shamans, while their appearance suggests the confluence of bronze Benin figures and wood Senufu masks:

*The combination of two opposing materials: hard and soft, has African and Oceanic connotations. This is an aesthetic as well as a religious and symbolic function. My object in the wall hangings is to reinterpret the aesthetic function in abstract language using non-anthropological materials. . . . When it works (and it doesn't work all the time), the tension and*

*opposition between the two materials transfer some of the aspects of one to the other—metal becomes soft and silk becomes hard, as in the Malcolm X series of 1970* [see pages 8, 9, 10, 60], *to form a unity of opposites. In, for example, the dancing masks of New Caledonia, the braiding and cording in the skirts attached to the masks serve the same purpose as my braided skirts do: to hide the armature (the person wearing the mask) and to dissociate the mask from the ground and its surroundings so that it is no longer simply a piece of sculpture, but a personage: an object of ritual and magic.*[5]

### Portrait of a Nude Woman as Cleopatra

In the late 1970s, Chase-Riboud virtually abandoned the studio and turned to writing. Remarkably, she enjoyed even greater success in this second career. After reading a biography of Thomas Jefferson, she decided to write a biographical novel about his black mistress, Sally Hemings, when she could find no one else to tackle the subject. Undertaken with the encouragement of Jacqueline Kennedy Onassis, *Sally Hemings* created a sensation upon its publication in 1979 and won the Janet Heidinger Kafka Prize for the best novel by an American woman. In 1988, Chase-Riboud won the Carl Sandburg prize for her book of poetry, *Portrait of a Nude Woman as Cleopatra*, and she has continued to publish novels and poetry.

Chase-Riboud's writing is directly relevant to her art in general and her graphic work in particular. The artist has always considered sculpture and graphics as two separate mediums representing completely different facets of her creativity. Drawing and writing, however, were coupled in her mind, because they both involve working in pen or pencil on paper. And all three have been closely linked, as interrelated endeavors, almost from the beginning of her career. In fact, the poems and artworks sometimes bear similar or even identical titles.

The genesis of both *The Bathers* and the Malcolm X sculptures cited above can be found in a group of drawings of a couple in bed on rumpled sheets, which make their first sculptural appearance in *White Emperor City* of 1969; these in turn are counterparts to a number of Chase-Riboud's erotic poems. Indeed, the artist has wondered what title she would have given the three Malcolm X pieces had she not been caught up in the emotional turmoil following the black leader's assassination.

Even *Confessions for Myself* is connected in time and subject with the poem "Anna," dealing with Chase-Riboud's great-grandmother's family saga and, with it, an essential aspect of her own identity. The following is an excerpt from this long poem.

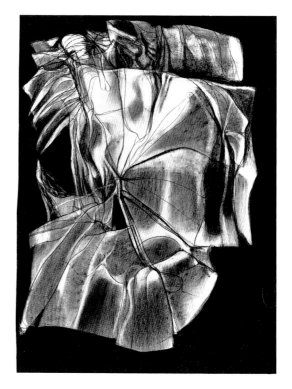

## LE LIT (THE BED)

Sullen blizzard of white linen
Lying rumpled
Under the morning sun,
Last night's pressed flesh
Still glowing like the flickering shadows
Of a silent movie,
Contours still raging like burnt-out onion skin
Dry and flaking with
Tiny ridges where a thousand drummed dreams
Swim like microbes.

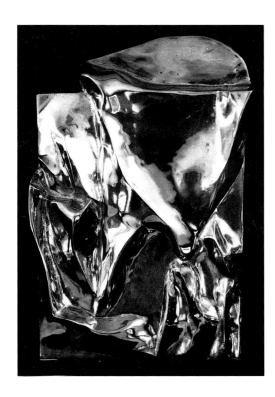

I remember
You,
Anna,
1945.
You must have been
Eighty-five or even older;
It hardly matters.
And I?
I was six.
Could I have known the word for
Empress?
Imperious old lady,
Amber-colored,
Chinese perfume bottle
Engraved with jewels,
(Beautiful jewels, I thought)
Set off by black crepe,
Hair straight as a song,
Disciplined
Into a silk cap,
You looked at me and murmured,
"Too dark.
She'll never be beautiful."
Oh Great-grandmother,
The blood
You let
With that
Offhand remark,
The absolute wound
That saw
My life flow
Out—
Sweet dreams of myself,
Shot free like stars spinning
From another galaxy!
Great-grandmother
Did you know?

### The Poet Walks Her Dog

In retrospect, it was the confluence of sculpture, drawing, and poetry
that transformed Chase-Riboud from a promising artist with a relatively
conventional approach embedded in the orthodoxy of the 1960s to one
of genuine stature with something entirely new and important to say.
Although, as we shall see, she explored related forms in her drawings of
the early 1970s, the artist continued to pursue them as largely indepen-

OPPOSITE:
*Le Lit.* 1966.
Charcoal on Arches paper,
29 ½ x 21⅞″ (75 x 55 cm).
Collection of the artist

ABOVE:
*White Emperor City.* 1969.
Aluminum,
31½ x 21⅞ x 1⁹⁄₁₆″ (80 x 55 x 4 cm).
Whereabouts unknown

dent from her sculptures. Until the mid-1990s the drawings themselves were very classical in style. Thanks to the thorough training she received at Tyler, which has always emphasized a traditional grounding in drawing, her superb technique brings to mind the style of Ingres and other Neoclassicists of the nineteenth century in its rigorous control and taut line. At the same time, her drawings have always shown a strong sense of design, the fruit of her studies at Yale under Josef Albers's disciplined methodology, which she later rebelled against but nevertheless remains indebted to. What led Chase-Riboud to integrate sculpture consciously in her drawings was the return to her studio in the late 1980s after a long hiatus.

The recent sculptures are very different from anything she has done before. Of particular interest is a group of shelf pieces. Measuring roughly three by four feet, these are small tableaux affixed to the wall that recall the miniature scenes done in the 1930s by the Surrealists, notably Alberto Giacometti. *Poet Walking His Dog* (p. 83) inevitably brings to mind the cover of the inaugural issue of *The Blind Man*, a Dadaist journal published by Marcel Duchamp, Man Ray, and others, in New York in 1917, though she was evidently unaware of the connection until it was pointed out to her. *Poet Walking His Dog* not only marks a significant departure in scale for Chase-Riboud, but also is important for including the human figure as well as scrolls of paper inscribed with a writing of the artist's own invention. In addition, Chase-Riboud has designed two enormous monuments. In 1995, she was awarded a major commission for the interior of the Foley Square Federal Building in lower Manhattan after the building was discovered to stand over a seventeenth- to eighteenth-century African-American burial ground. She also envisions a monument to the Middle Passage, which claimed the lives of more than 11 million Africans forcibly transported to this country throughout the nineteenth century.

### Enigmas: The Monument Drawings

These several strands—Surrealism, public monuments, graphic art, and writing—come together in the Monument drawings, which weave together a wide range of ideas, interests, and motifs to form a complex unity. The antecedents of this series can be found in a group of drawings by Chase-Riboud dating from the early 1970s, which incorporate many of the same devices but in a sparer style and less developed form. Thus, *Hopscotch-Column-Poem* contains the germ of the *Musil Monument* in its use of a wavy chord and squares with rocks or imaginary text. The chorded column is likewise found in *Column I* and *Column II*, while the tense wall of chords strung between two columns of rock can be seen in *Aperture I*. Nevertheless, most of Chase-Riboud's drawings, such as the two untitled sheets included here, are closer to her sculpture *Le Lit* (1972) in their almost sagging softness. More important, it is the recom-

bination of such elements into something infinitely richer and more complex that makes the Monument drawings so special.

All of the Monument drawings began with a column of cords and a crooked line printed from an etched plate, which served as a baseline on which to build her compositions. They also function like a bass line in jazz: a recurring leitmotif providing a solid foundation for her improvisations. This unusual device was suggested by Chase-Riboud's second husband, Sergio Tosi, an Italian archaeologist, art expert, and publisher whom she married in 1981. If male artists have their feminine muses, Chase-Riboud found her masculine "genius" in Tosi. While he prefers to remain discreetly in the background, he has become increasingly involved in her work and plays a major role in her artistic life as inspiration and collaborator. He had worked closely with such artists as Man Ray, Luciano Fontana, Yves Klein, and Cy Twombly on limited-edition books, so that collaboration with artists comes naturally to him. Tosi's involvement is in sharp contrast to that of Marc Riboud, whose own career took precedence over everything else. (Strangely enough, Riboud rarely photographed his wife and then only at her insistence, although her picture was taken by many other photographers. He later stated, "I hardly dare to photograph those who are closest to me and that I love.

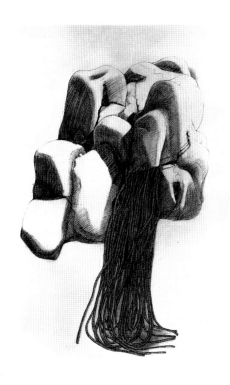

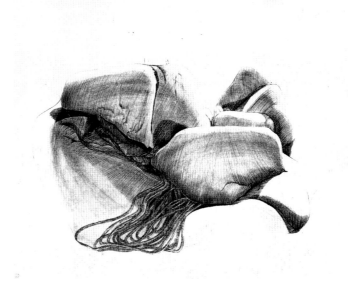

I don't know, timidity prevents me from doing this. I want to and I don't want to.")

Despite the fact that the monuments in these drawings are undeniably sculptural, they bear at best a loose relation to the sculpture Chase-Riboud has made to date. She is a modeler who works directly in wax. By contrast, the drawn sculptures in the Monument series appear carved from rough-hewn blocks of stone or rock, as if by some giant, for they are all envisioned on a vast scale. *Foley Square Monument* hardly resembles *Africa Rising*, the actual monument she executed for the Foley Square building. The post-and-lintel design in the drawing conjures up a gateway that is reiterated in altered form by a second entry

ABOVE:
*Untitled.* 1971.
Charcoal and graphite pencil
on Arches paper,
29 ⅞ x 22 ⅛″ (76 x 56.3 cm).
Collection, The Museum of
Modern Art, New York.
David Rockefeller Latin
American Fund, 280.72

RIGHT:
*Untitled.* 1970.
Charcoal on Arches paper,
19 ¾ x 25 ¾″ (50.2 x 65.4 cm).
The Metropolitan Museum of Art,
New York

not unlike those on Egyptian tombs. In this way, the monument alludes to the passage to death appropriate to a burial ground. The idea of passing through a gateway to death is found again in the *Middle Passage Monument* (page 111), which does follow the overall form of Chase-Riboud's maquette (page 131) for the monument she proposes in Washington, D.C. In the drawing, however, the wavy "base" line becomes an ironic faux barrier, like the guard ropes found in museums, to block the viewer's progress.

Like the shelf piece *Poet Walking His Dog*, the majority of these drawings incorporate Chase-Riboud's unique script as an essential aspect of their design. (*Foley Square* and *Middle Passage* are exceptions.) Here is an artist who is also a poet. Because it is indecipherable, the script carries no burden of meaning, yet it transforms these sheets into poetic objects that have far more to say than the text-laden images of the self-conscious wordsmiths currently so prominent. The characters evoke the lost languages of old that remain untranslatable. More specifically, they possess the mysterious quality of the runes used by the bards

ABOVE:

*Hopscotch-Column-Poem:*
*"My Sun Is in Your Moon."* 1978
Charcoal pencil on Arches paper,
29⅞″ x 22″ (76 x 56 cm).
Collection Toby Molenaar,
Sag Harbor

OPPOSITE:

*Musil Monument, Vienna.* 1996

in the pagan north before the advent of Christianity. Thus, these seemingly meaningless inscriptions link the artist-as-poet to an ancient and venerable tradition. In turn, they are connected to modern Surrealism.

The debt to Surrealism is manifested in *Monument to Man Ray's The Enigma of Isadore Ducasse*, which is one of only two drawings in the series done with a specific subject in mind. (The other is *Rubens's Mother*, discussed below.) It refers to a work, originally created in 1920 and replicated fifteen years later, identified as the first wrapped object: an iron bound in sackcloth with a rope. (The iron was derived from Ducasse's description of the "chance encounter of a sewing machine and an umbrella on a dissection table," which Man Ray depicted earlier in *The Enigma of Isadore Ducasse;* it became one of Man Ray's favorite objects and was utilized in his famous *Gift* of 1921, which now exists only in a later copy.) Ducasse (1846–1870) was a Uruguayan who moved in 1867 to Paris, where he wrote under the pseudonym the Count of Lautréamont. Rediscovered in the early 1920s by André Breton, the leader of the Surrealists, Ducasse's poetry featured the fortuitous juxtaposition of seemingly unrelated objects that changed their meaning; as such, it set an important precedent for the Surrealists. Ducasse was second in importance as a precursor of Surrealism only to Arthur Rimbaud (1854–1891), whose work shares an equally hallucinatory style.

In the Monument series, Chase-Riboud is steeped in Surrealism in a way that one would hardly expect of someone who was trained in the strict discipline of the Bauhaus. Part of her master's thesis at Yale was a book of engravings illustrating Rimbaud's poems, *Une Saison en Enfer*, with an introduction by Henri Peyre. She was exposed intensively to the Surrealist tradition in Paris from 1961 on. Her first gallery, Cadran Solaire, was even named after its sundial, which was created by Salvador Dali. She came to know Man Ray (1890–1976) who, like her, was born in Philadelphia but resided in Paris, through her close friendship with the photographer Henri Cartier-Bresson, whose photography has strong Surrealist overtones. She cites Henri Michaux (1899–1984) as the most important influence on her thinking. He consistently followed the Surrealist doctrine of automatic handwriting that was the poet André Breton's ideal, and it has rightly been observed that Michaux's drawings are really another form of writing—a concept basic to the Monument series, even though they bear no direct stylistic relationship to his work. Michaux saw his drawings as "a new language, spurning the verbal, and so I see them as *liberators*" providing the artist "a writing unhoped for, affording relief . . . at last to express himself far from words, words, the words of others."[6] In a sense, Chase-Riboud does just the opposite of Michaux: she turns writing into drawing by making it a purely graphic gesture.

Chase-Riboud was also on intimate terms with the Chilean-born Roberto Matta Echaurren (b. 1911) and his wife, as well as the

Pushkin Monument, St. Petersburg

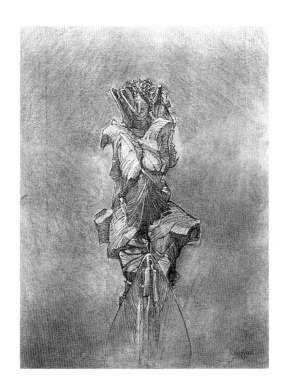

Romanian Victor Brauner (1903–1966) and the Cuban Wilfredo Lam (1902–1982). Lam was a great inspiration to African-American painters and sculptors coming up in the 1950s and 1960s, because he was one of the very few black artists of international stature. Chase-Riboud first saw Lam's work during her stay at the American Academy in Rome; she later met him through her brother-in-law, Jean Riboud, who was a major collector of his paintings. Hence, her affiliation with him falls not in the context of African-American studies but the international mainstream.

In true Surrealist fashion, the Monument drawings are spontaneous eruptions from the subconscious imagination. But rather than being jotted down hastily in automatic handwriting, these haunting visions are carefully worked up to make them as convincing as possible by giving them maximum concreteness. Despite the enigmatic imagery, each monument is visually more or less plausible, in part because it is so contemporary in the choice of materials and the treatment, which are related to what a number of other sculptors have been doing since the 1970s. For that very reason, these dreamscapes impress themselves on the viewer's imagination, disrupting it as if by a vague, eerie nightmare. In that respect, they are close to the "paranoid" hallucinations of Salvador Dali (1904–1989) but without his self-conscious gestures. For example, the desolate scene in the *Queen of Sheba Monument*, which revives a motif from an untitled drawing of 1973, conveys through its assemblage of forlorn artifacts a tragic vision reminiscent of Dali's *The Persistence of Memory. Pushkin's Monument* achieves a physically impossible feat, worthy of the Surrealist René Magritte by supporting an enormous boulder on a curtain of black ropes. In several instances (see *Hadrian's Monument* and *Francesco di Giorgio Monument,* for example), the monument is completed by architecture. The setting of *Émile Zola's Monument* in particular recalls the lonely piazzas depicted by Giorgio de Chirico (1888–1978); it is rendered even more melancholy by the base line hovering like a misplaced ribbon in the sky.

Chase-Riboud often adds pieces of human anatomy—a hand, an arm, a foot, a leg—studied with the precision of a nineteenth-century medical treatise yet constructed of pieces of tile, like those made to her specification by a French firm for her sculpture *Cleopatra's Chair.* In addition, the horizontal column of cords common to all the Monument drawings curiously recalls a piece of bone, and the resemblance is hardly coincidental. Chase-Riboud has a fascination with bones that is intimately related to her passion for unearthing the past. In advance of Nancy Graves and others, Chase-Riboud incorporated bones into her sculpture as a natural outgrowth of her major early works, such as *Walking Angel* of 1962 (page 25), which treated the human figure as an eviscerated skeleton. This interest came full circle in her monument to the African Americans buried beneath the Foley Square Federal Building.

Now, the use of bodily fragments was a favorite device of the

OPPOSITE:
*Pushkin's Monument,*
*St. Petersburg.* 1996

ABOVE:
*Untitled (Africa Rising).* 1997–99.
Chalk on Arches paper,
20 x 28″ (50.8 x 71.1 cm).
Collection of the artist

Surrealists, especially De Chirico and Max Ernst (1891–1976). Although Chase-Riboud regards her association with Man Ray as the least significant among the circle of Surrealists she knew in Paris, the apparent eclecticism of her work mirrors one of his chief traits: he worked in virtually every medium and style at one point or another during his long career, picking up whatever was useful along the way and transforming it for his own purposes. Both De Chirico and Magritte, for example, were important sources for him, as they were for Chase-Riboud.

In the Monument drawings, each object forms part of a cast of characters. Their interaction creates a quasi-narrative drama that in turn associates these tableaux with the shelf pieces. But what do they mean? Literally nothing—yet they suggest everything. With only a few exceptions, the titles were added *after* the drawings were finished. Hence, we must not seek a specific content on the basis of those titles. This is not to say, however, that the titles are irrelevant. They are, in fact, very meaningful, but their significance lies in their connection to the same chain of associations that engendered each work in the first place. One might argue that they are related through "elective affinity," to borrow a well-known eighteenth-century phrase. Chase-Riboud states, "The Zola drawing looked like Zola to me (like *Germinal,* his coal-mine novel)."[7]

Several of the Monument drawings received their titles through literary association: the French author Émile Zola (1840–1902); the Russian poet and prose writer Aleksandr Pushkin (1799–1837); the Austro-German novelist Robert Musil (1880–1942); and, above all, the Russian poet Anna Akhmatova (1889–1966). Née Gorenko, Akhmatova took her last name from the Akmeist group; like that of the rest of the avant-garde, her work was largely banned by the Soviet government after 1921. Chase-Riboud is a great admirer of Akhmatova as both a poet and a human being, and cites the kinship between them. Roberta Reeder's observation about Akhmatova applies equally to Chase-Riboud: she "hid her feelings behind a mask of restraint, but . . . shared . . . a profound love of European culture, a passionate attachment to her native land, and a strong attraction to the wisdom of the East."[8] The two finally met during Chase-Riboud's trip to Russia in 1963. Ironically, they could not exchange a single word. Chase-Riboud nonetheless paid homage to the Russian poet in her lithograph *Monument for Akhmatova,* created in 1995 upon receiving the James Van Der Zee Prize from the Brandywine Association, and in her 1973 poem "Akhmatova":

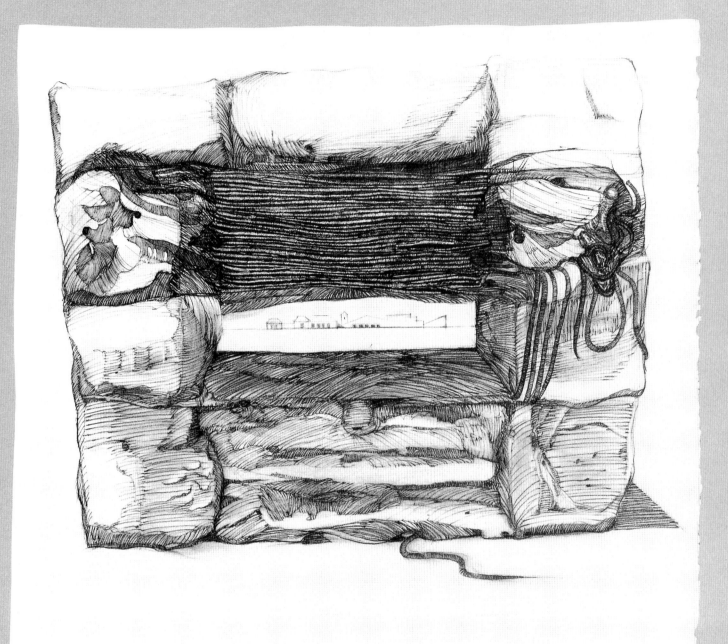

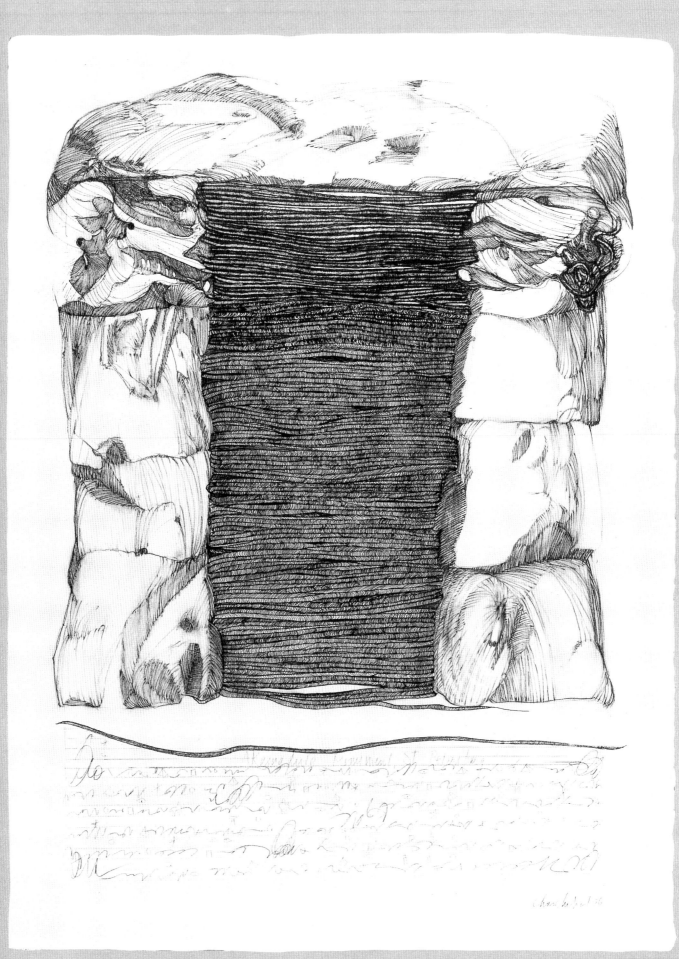

## AKHMATOVA

Akhmatova, Akhmatova,
What I mean is
Take care.
Don't fall, don't.
You are the brightest.
If you fall,
Who is there to tell
Of the bloody theft
That is a woman's life?
That we speak in fagged
And washed-gold icons because
We have no common language
Is nothing.
Your husband can only be just that,
But I read you like Braille,
A lesbian caress in that
Our sex knows
Where to touch.
Don't fall, don't.
Russian sister,
You drive me mad,
You drive too fast,
That sudden curve will get you yet.
And I'll find you
In a summer field in Georgia
Awash in apples pickled in blood.
No.
I won't have it.
Even if I have to come and get you,
Carry you on my back across that river
*Deep down in the valley of the Alazan*
And I can't swim.
My heart is not that flat, hard
Male heart to which we all cleave,
But I value yours.
Whispering through our carved ivory fans
As the house-lights dim,
Listening to our heart's murmurings . . .
Akhmatova,
If only you
Would turn in your pilot's license,
You must know by now
Russians shouldn't dive from *Drunken Boats*.

OPPOSITE:
*Akhmatova Monument,*
*St. Petersburg.* 1996

For Bella Akhmatova, October 12, 1973

The lithograph is a direct precursor of the Monument drawings; it is, however, utterly unlike the sheet in this series dedicated to Akhmatova. The sources of other titles are sometimes obscure, derived as they are mainly from the personal lives of the artist and her husband. For example, *Chevalier de Saint Georges Monument* is dedicated to a black French duelist who defeated an Italian fencing master and reigning European champion, thereby establishing himself as the first great black athlete. *Tommasi di Lampedusa* refers not to the well-known writer but to his ancestor, a saint of the same name, who is buried around the corner from Chase-Riboud's studio in Rome. He was canonized in 1992 on October 22, which is her husband's birthday; hence, they have adopted him as their patron saint. The studio itself is in a palazzo that was erected in 1599 by Cardinal Ricci (rather than the better-known Matteo Ricci, who went to China in 1585).

Chase-Riboud has a fascination with powerful female figures from history, but again her choices can be quite unusual. *Peter Paul Rubens's Mother's Monument*, the only sheet to bear a legible inscription (other than the title), commemorates a remarkable act of love and charity by incorporating a passage from the series of letters Dame Rubens wrote to the magistrate prosecuting her husband on the charge of adultery, which would have condemned him to death, and to her husband explaining why she did it, despite the fact that he was guilty. The world owes her a great debt: their son, the immortal artist Peter Paul Rubens, was born the following year. Hatshepsut in this case is not the ruler of Egypt during the height of Middle Kingdom who left behind the largest funerary monument ever created. She is instead the one who reigned during the black Napata Dynasty of 713–671 B.C. The Queen of Sheba, too, ruled a mighty realm, though she was so overwhelmed by the grandeur of Solomon's court that, according to the Bible, "there was no more spirit in her." I will leave it to others to analyze the sexual politics of these figures. Chase-Riboud is clearly a feminist but no theoretician. In her universe, erotic power virtually equates with worldly power.

The Monument series is suffused with an erotic content that, though it lies well hidden in most of the drawings, is unmistakable. The corded column is itself masculine in appearance and hardness, yet feminine in its silky softness. We need only cite as further evidence the phallic shape of *Pushkin's Monument* or the inverted vaginal form of *Shaka Zulu's Monument*. These are combined in the *Foley Square Monument* and, more subtly, in *Akhmatova Monument*. Any doubts concerning the import of the inverted triangle are dispelled by one of Chase-Riboud's sonnets about Cleopatra, who is for the artist the epitome of feminine sexuality and, with it, feminine power. Here the shape visually identified with Cleopatra is the same form as in *Shaka Zulu's Monument*.

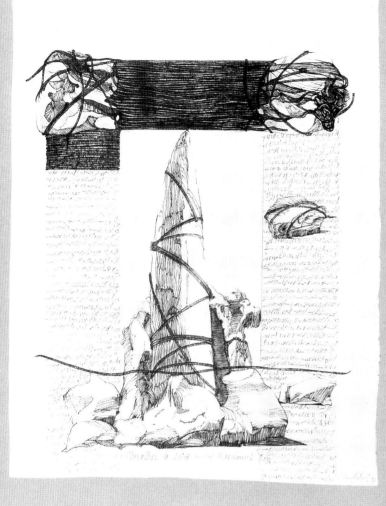

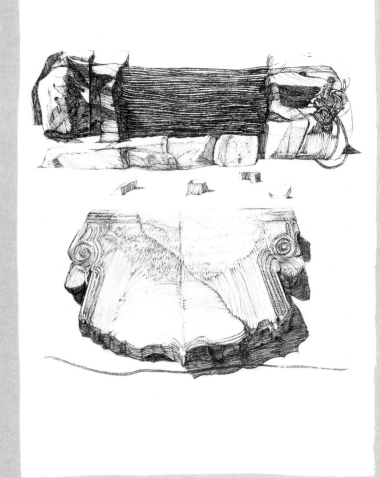

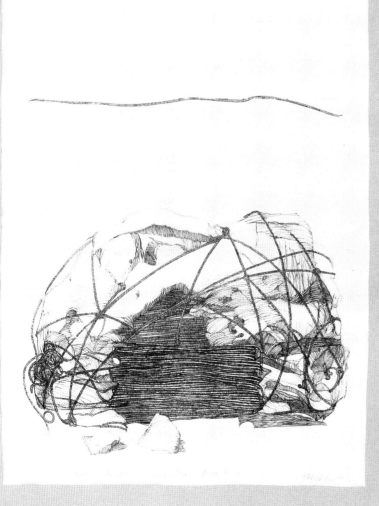

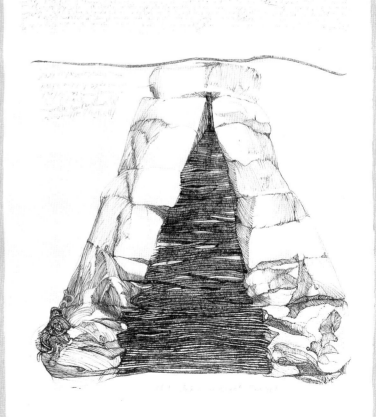

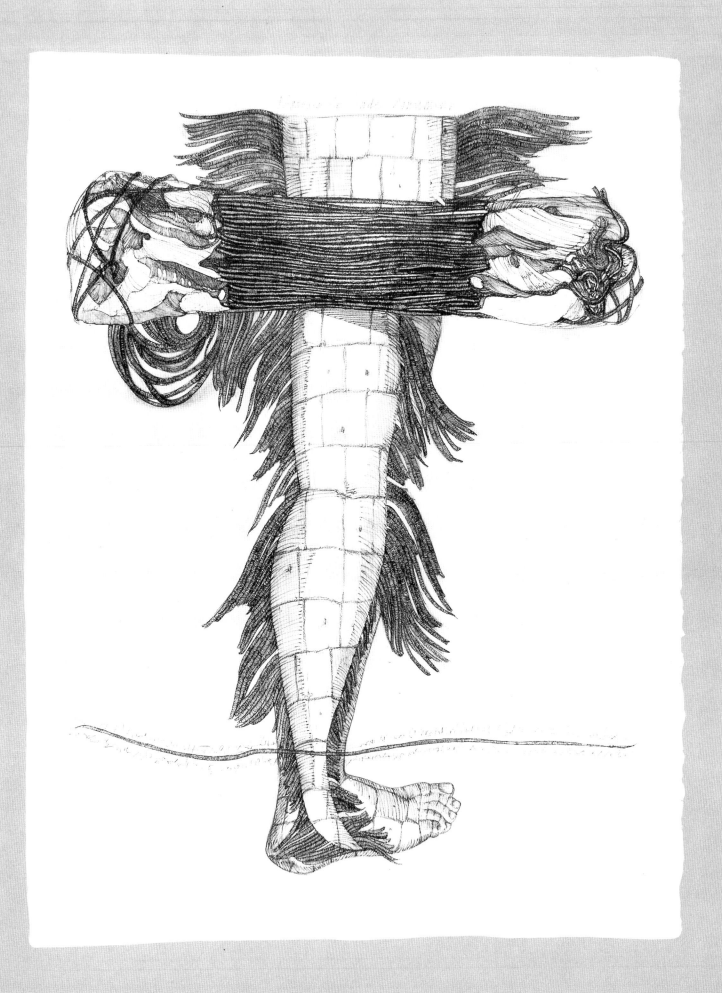

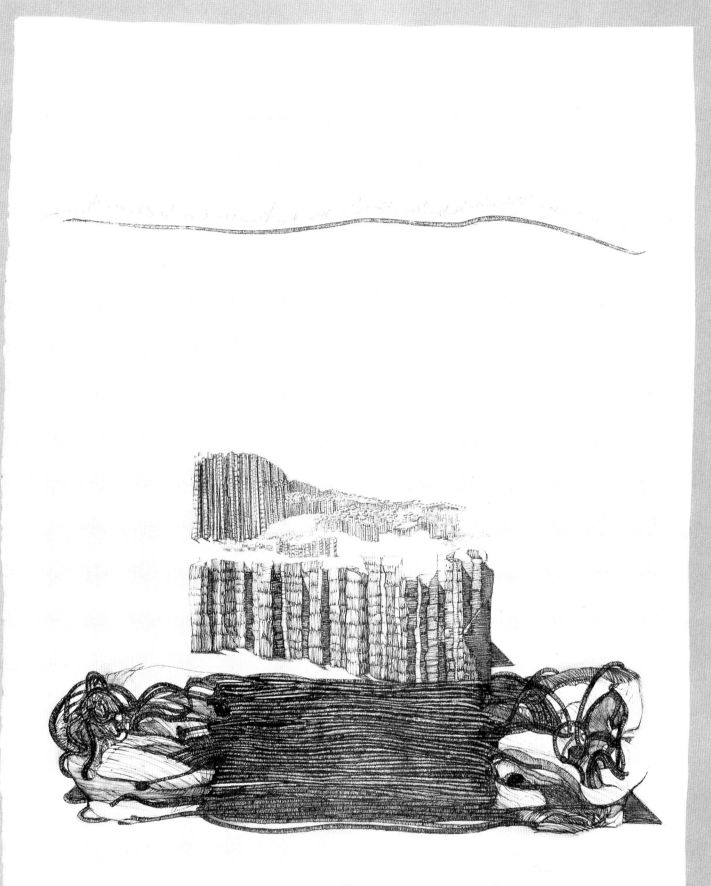

## CLEOPATRA II

In
Africa
The strange beasts
Wonder & worry at familiar
Lakes & watch reflections of
Egyptian Gods wade & speak to
Them in a meticulous tongue which is
Not our own nor any we have ever heard
But those who understand it say there is
No sound like their brilliant dialogues
Rustling savanna grass, composing mirage &
Miracles alike with bewildering urgency, as
Urgent as the pressed flesh of our own language
Which might be as beautiful if Caesar were in Africa.

Contrary to what one might expect, the triangle does not reference an Egyptian pyramid, which would be a conveniently easy read. Its erotic significance is made evident in a previous Cleopatra sonnet (excerpted here, with italics added by the author).

## CLEOPATRA I

Winged by my multifeathered flexed knees,
Soft down'd in peacock colors,
*My triangle pressed against your chest,*
*Connecting the three points*
Of your flesh's compass,
A nude woman flies South towards Summer—
As the swallow flies,
By degree and nature
Crowned and earring'd by love,
*My hair a ragged river flowing*
*Towards your sea—black tributaries*
*Raking your beaches,* where in the
Turquoise-veined granite of Hammamet
*I build my monument.*

This poem also clarifies the role of the black rope in the Monument drawings. The rope evokes the braids of silk in the Malcolm X sculptures, which, like the hair in "Cleopatra #1," have a distinctly fetishistic quality to them. In the Monument drawings, these tightly braided ropes often assume surprising, even paradoxical, guises. Rather than hanging in luxuriant cascades, as in *Confessions for Myself,* they typically appear

OPPOSITE:

*Hadrian's Monument,
Rome.* 1996

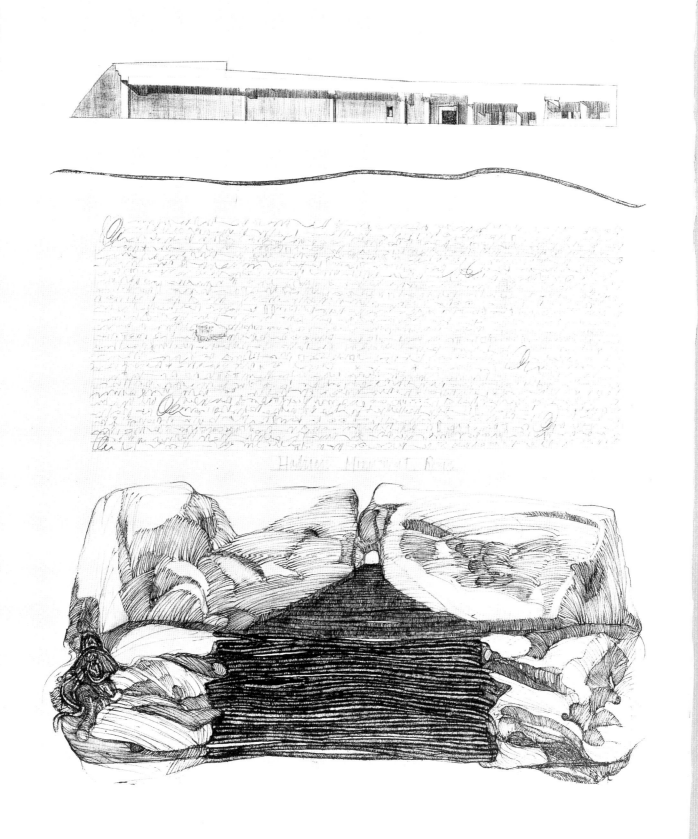

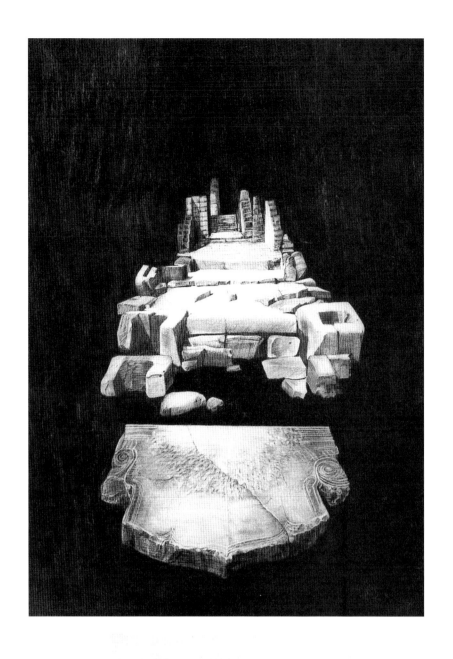

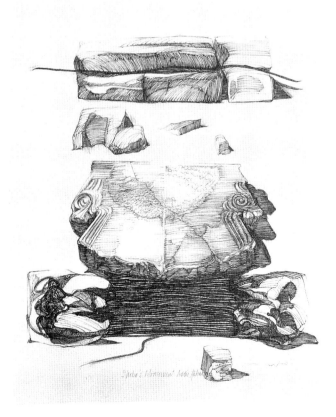

ABOVE:
*Untitled.* 1973.
Charcoal on Arches paper,
28 x 20″ (50.8 x 71.1 cm).
Collection of the artist

BELOW:
*Queen of Sheba Monument,*
*Addis Ababa.* 1997

OPPOSITE:
*Middle Passage Monument,*
*Washington.* 1997

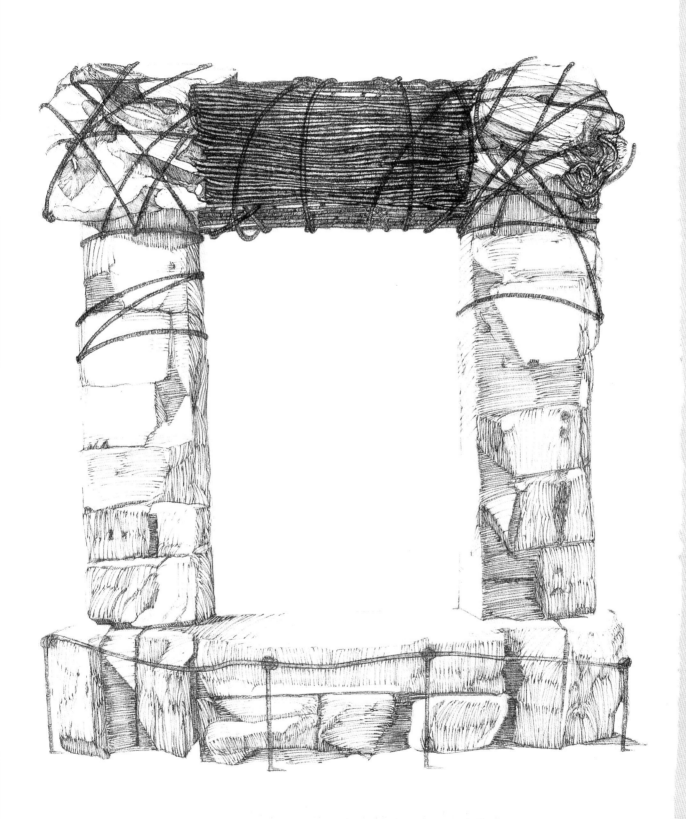

to span vast distances between vertical elements, yet provide no visible support. Though tautly stretched, they retain their identity as rope, sagging under their great weight to reveal gaps opening to the sky behind them. In *Foley Square*, *Akhmatova*, and *Shaka Zulu's Monument*, they form a nearly impenetrable barrier. Sometimes they hover like a mirage in midair, supported in the *Musil Monument* (page 95) by an implied prop resting on a foot or in the *Saint Georges Monument* by a needle-shaped stone fulcrum and two pillars of runic inscriptions. At other times (as *Hatshepsut's Monument*), they lie almost limply on the ground, like the carcass of some ancient creature (compare the *Queen of Sheba Monument* and *Tommasi di Lampedusa Monument*). Only in *Pushkin's Monument* do these ropes hold up anything. Most intriguingly, the rope may be tied around rock forms, as if holding them in literal bondage. The allusion to bondage is especially piquant in the *Marquis de Sade Monument*. So is the prim, almost coquettish handling of anatomical fragments; though they are not necessarily suggestive in themselves, the fringes of flowing black hair are unquestionably erotic. In this drawing, the cold stone, the very antithesis of flesh, acquires amorous overtones. It was inspired in part by the jade sarcophagi of a royal couple from the Han dynasty (page 76), whose discovery in China fired Chase-Riboud's imagination in the poem "Han Shroud":

| | |
|---|---|
| Jade | Jade |
| God's juices | Love's juices |
| Solidified | Solidified |
| Shield against mortality | Sheathed in your own flesh |
| I drape you drop by drop | I drape you drop by drop |
| Like grains of rice | Like emerald perfume |
| Running from | Running from |
| The silos of my favorite | My favorite silver and sapphire |
| domain | gourd |
| I enfolding you as | Enfolding you as |
| I enfolded you in life | I enfolded you in life |
| With my body still warm | With my body still warm |
| From the hunt | From the sun of my terrace |
| Ardent heat | Ardent heat |
| Now | Now |
| As cold as | As cold as |
| These jade fragments | These jade fragments |
| I weave | I weave |
| With golden threads | With golden threads |
| Round you | Round you |
| Beloved wife | Beloved husband |
| Princess! | Prince! |

In reality, much of Chase-Riboud's work contains a powerful erotic sensibility that was no doubt enhanced through contact with the Surrealist tradition. We have noted it already in the drawing of a couple lying within the crumpled sheets of a bed, an image that gave rise to the sculptures of the early 1970s, which remain her signature pieces. One of the major sculptures Chase-Riboud produced in Rome in 1958 and exhibited at the Spoleto Art Festival that year was a statue of Adam and Eve (page 19) sheltered within a lunette shape that later reappeared in the wall piece *Tantra I* of 1994 (page 2). The initial interest in Tantrism came during the artist's first visit to China in 1965, when she was introduced to its Buddhist form in Mongolia. Later, she added the more explicitly sexual overtones familiar from Hinduism, whence Tantrism arose, although she otherwise feels little affinity with Indian religion and culture. Chase-Riboud subsequently had an intense Tantric experience that shaped her spirituality. Her poem "All Reverence to Her" from the early 1970s is based on a Tantric text.[9] Significantly, it makes use of an inverted triangle that both acts as a symbol of feminine sexuality and connotes the passage of time in an hourglass, as seen in the fourth and final stanza (italics are the poet's):

When the last kiss sates one last rapturous paroxysm
The Race spinning and burning in fear as much as
Lust: Life's last illustrations receding into
Time and space inventing pretensions with
The last mouthing of love's last word
I'll turn my head towards you and
Salute *that power that exists*
*In all of us in the form*
*Of Illusion Reverence*
*All Reverence to*
*Her Reverence to*
*Her all*
*Rever-*
*ence*
*to*
*H*
*e*
*r*
.

The fusion of sensuality and spirituality is made clear in the following passages from Chase-Riboud's poem "The Well of the Precious Concubine Pearl," which also generated the title of two of the Monument drawings.

## THE WELL OF THE CONCUBINE PEARL

Love rustles like gray silk in the palace,
Love rustles like gray silk in the palace.
The Palace of Buddha,
The Palace of Tranquillity and Quietude,
The Palace of Eternal Spring,
The Palace of Intellectual Refinement,
The Palace of Total Joy,
The Palace of Rare Sublimeness,
The Palace of Ultimate Elegance,
The Palace of The Certitude of Happiness.

And in the pavilion
Black hair shifts.
Black hair shifts in the pavilion,
And white porcelain shatters
In the Pavilion of the Purest Perfumes,
In the Pavilion of Melodious Sounds.
Black hair shifts,
And white porcelain shatters
On a red lacquered table,
Spilling tea leaves
Onto the eye of the world,
And the eye of the world is in
The Well of the Precious Concubine Pearl.

Sexuality and spirituality have been made to seem contradictory in Western thought, but both have their place in human development as conceived by the Swiss psychologist Carl Jung. In his theory, they are vital to the process of individuation, by which the person grows into a fully independent individual who is yet connected to others through a deep and fundamental sense of humanity that we all share. The Jungian concept of the collective subconscious was very much in the forefront of African-American thinking during the 1960s and early 1970s when Chase-Riboud was a young woman establishing her identity, although she does not believe in the myth of racial consciousness. More important, the ascendent from the sexual to the spiritual conforms very closely to a paradigm found in Jung's psychology. Essential to both Jung and Tantra is a fusion of the masculine and the feminine. This is exactly the same reconciliation between opposing identities—male and female, black and white, hard and soft—that Chase-Riboud has sought in her sculpture, drawings, poetry, and novels. It is hardly a coincidence that one of her major early sculptures (see page 45) carries the same title as her poem "The Albino" (page 117).

OPPOSITE:

*Well of the Precious Concubine
Pearl Monument, Shanghai.* 1997

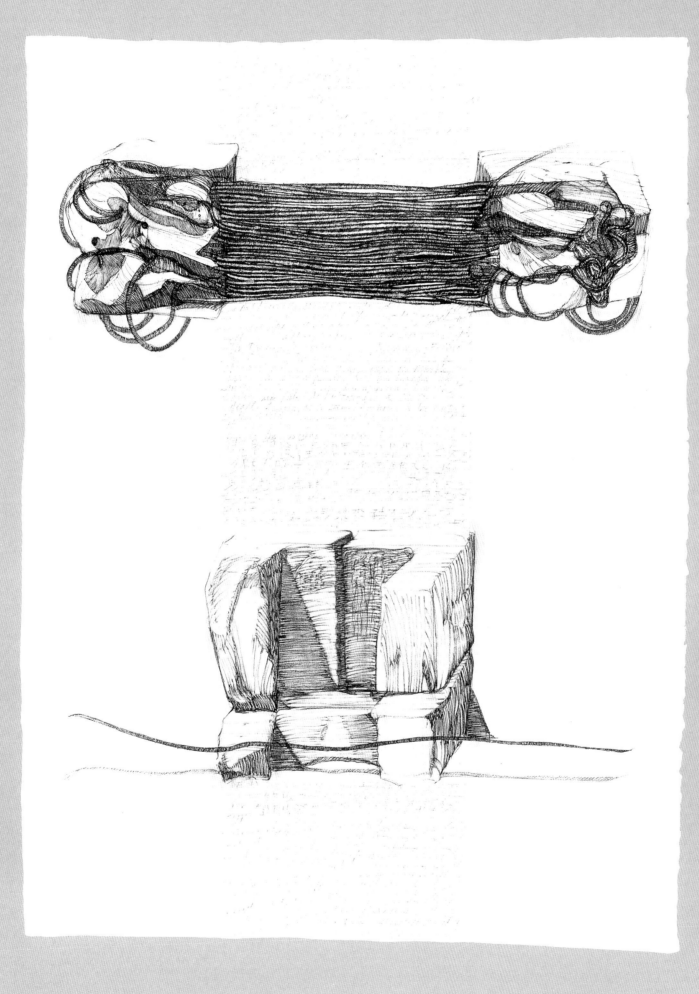

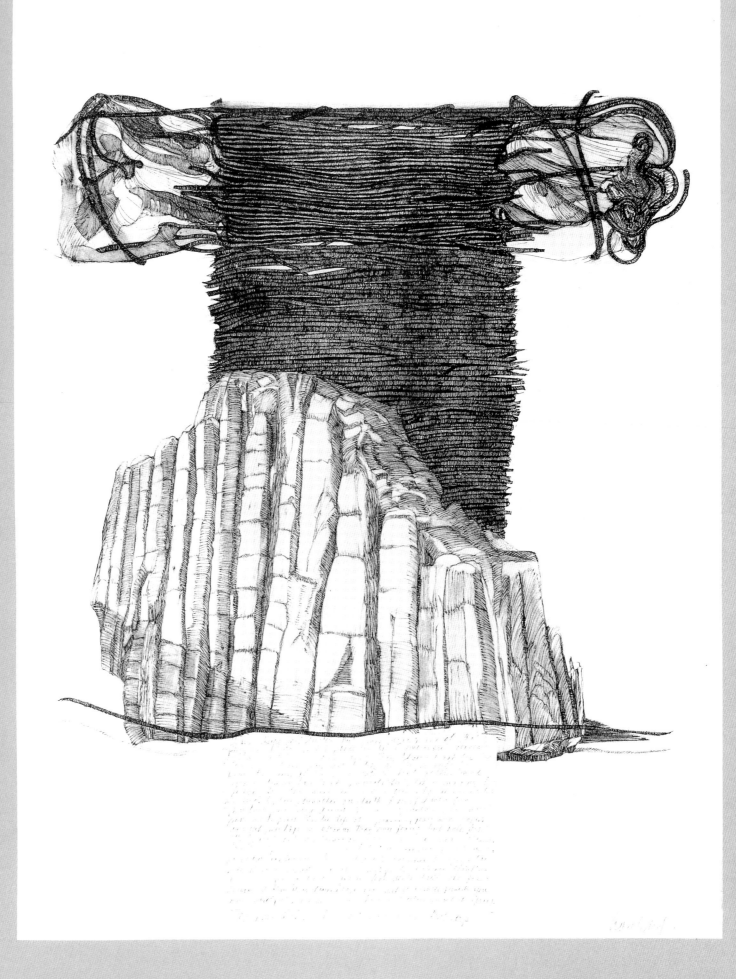

## THE ALBINO

The absence of color,

Is that the answer

To a moral question?

White African,

Walking negative,

Are you

Magic?

An ancestor called back

To prove the soul survives?

White African,

Walking negative,

Are you

Holy?

The sacred circle of the

Tantra?

White African,

Walking negative,

Are you

Proof?

Of the exception

Which proves the rule

Like the Hermaphrodite?

If color exists then

The absence of color must exist

As well

*As a single face becomes dual*

*In a mirror,*

*As a single body becomes dual*

*In a shadow,*

As a single thought becomes

Past and present

In the mind's eye,

As the only difference between

The seen and the unseen is

Love,

I am as male as I am female;

I am as white as I am black.

There is no difference

Between She and He,

Between You and Me.

You are as female as you are male;

You are as black as you are white.

Together we are

OPPOSITE:

*Peter Paul Rubens's*
*Mother's Monument,*
*Antwerp.* 1996

One,

Yet together

We are not

One,

But as love knows,

Only love knows

Our subtle differences.

Let there be

No doubt

About this.

The absence of color

Is that the answer

To a moral question?

In a larger sense, then, all of Chase-Riboud's work, artistic as well as literary, may be termed erotic. For her, the erotic is something that "one cannot escape. No woman. For a woman writer, painter, or sculptor, that is her obsession. Not simply 'evil' or pure 'eroticism' but a central condition, metaphysical, absurd, terrifying, fragile because it is mortal." Eros must also be understood here in the higher Greek meaning of the word as humanistic love. It is for this reason that the artist regards her works as religious statements, not in a sectarian sense but on a broad spiritual plane.

## Cleopatra's Chair

The Monument drawings fulfill Chase-Riboud's intent, announced in an interview with the filmmaker Chris Marker on the occasion of her first Paris exhibition at the Galerie Cadran Solaire in 1966, to make art that "unites opposing forces—male/female, negative/positive, black/white," while acknowledging its seeming impossibility. She would seek a combination of all these things, going beyond them individually to form "a new race destined to love more than we ever did," as she later wrote in a poem from her "White Porcelain" cycle. To a remarkable extent, she has succeeded in that goal. Chase-Riboud's work is "neither male nor female, neither black nor white, neither hard nor soft, neither European nor tribal, neither classic nor modern." Her achievement is all the more astonishing, given the almost irresistible urge among art critics to pigeonhole her as an African-American feminist. She has a well-founded aversion to all such categories, which seek to impose preexisting conditions on her art and limit how it is perceived. Not that she would deny either her color or her gender. On the contrary, she has often addressed both African-American and feminist issues in her art and writing. But rather than being limitations, these factors have proved to be sources of strength that provided the impetus for Chase-Riboud's quest for universality. As with all great artists, her work is a result of the

OPPOSITE:
*Émile Zola's Monument,
Paris,* 1997

complex interaction between personality, life experience, training, and that ineffable something known as creative talent, which she has in abundance.

Chase-Riboud's relation to American art is by no means simple. Among other African-American women artists, the nearest—indeed, the only—comparison is to Edmonia Lewis (1843–1900?), to whom she also feels the closest kinship. Chase-Riboud herself has remarked on the parallels between her sculpture *Cleopatra's Chair* and Lewis's recently rediscovered marble of *The Death of Cleopatra* (see page 49), which evokes a similar grandeur. Like Lewis's, her art is decidedly international, even eclectic, in its aesthetic while remaining essentially American in character.

Precisely because it resonates at so many levels, Chase-Riboud's work appeals to a wide range of audiences. For that reason, too, she has been championed by a long line of distinguished critics and curators on both sides of the Atlantic. Chase-Riboud participates in the mainstream of Western art. She consistently adheres to a mode of abstraction that is as exacting as it is personal. Her work nevertheless stands apart as a result of her interest in other cultures and civilizations. In fact, it looks alien in almost every context: American or European, black or white, male or female, for it partakes of all of these yet belongs solely to none. They have an extraordinary sophistication, polish, and scale, so that they tend to overwhelm everything around them. In fact, very few artists of any school can compete with Chase-Riboud in sheer power. She has adopted this cosmopolitan manner not to disavow gender, race, or nationality, but rather to transcend the limitations they impose in order to achieve a more personal expression. Hers remains a profoundly authentic voice by virtue of its commanding eloquence and encompassing vision, which strike a universal chord.

*I would like to thank Ren Brown, Director of the St. John's Museum of Art, Wilmington, North Carolina, who shares my passion for the art of Barbara Chase-Riboud, for making possible the exhibition of drawings that inspired this essay.*

### Notes

1. Ken Frampton to Mark Girouard, biographer of Sir James Stirling, in an interview in London, 1996. All uncited quotes are taken from conversations with the artist.
2. Quotation from the artist in Francoise Nora-Cachin, "Dialogue: Another Country," *Barbara Chase-Riboud* (Berkeley, 1973).
3. Ibid.
4. Ibid.
5. Quotation from the artist in ibid.
6. Henri Michaux, "Movements, 1950–51, in the Solomon R. Guggenheim," in *Henri Michaux* (Paris, 1978), 70, quoted in *Theories and Documents of Contemporary Art*, ed. K. Stiles and P. Selz (Berkeley, 1996), p. 47.
7. Letter to the author, December 13, 1998.
8. See Roberta Reeder, *Anna Akhmatova: Poet and Prophet* (New York: St. Martin's Press, 1994).
9. Friedrich W. Heckmanns in Berkeley catalogue, op. cit.

# Harrar/Africa Rising

Out of Omega we came,

Out of the womb of the world we came

All pleasure in feast and love forgotten

All rancor in feud and war forgotten

All joy in birth and circumcision forgotten

We came, Blackbodies: the negative of the light

The only merchandise that carries itself.

A column of jet quickening,

Gyrating in one celestial tribal dance

Spreading like a giant blastoma

Spinning itself into the fireball of a new planet.

In a season of stars, we came,

Out of Omega, rending the cosmos,

Groaning across deserts and the pyramids of Kush,

A lunar landscape of brimstone

Basalt and Obsidian, biotite and barium

Undergrounds pebbled with diamonds and gold scum

We came, into the Hell of deathly White.

In eclipsed sun, the negation of time,

Conned from every bankrupt and ravished kingdom,

Zeila & Somaliland, Galla & Abyssinia, Tigre & Shoa

Niger & Nile, Orange & Congo, Cubango & Kasai

We came, a stunned string of

Black pearls like a hundred year centipede: one thousand,

One thousand thousand, one million, three, six, nine, thirty million,

Torn from their roots, like belladonna lilies we came,

Death in every heart, sprawling over the badlands,

The red flag of slavery blotting out sky, hope and memory.

Lashing the hot sand of Ogaden

Fingers clutching a chilled sun in cyclone

Granite phalli marking graves strewn backwards,

While murder moved . . .

The Gods sit mute and horrified on their

Polished haunches, while we labor

Through petrified forests, an armour of glinting sweat

Our mouths stuffed with pebbles

Our savage wail whirling soundless on

Bloodied lips beaten back at every step by clouds

Of insects that cling to flesh like leeches in love.

Shackled hands and bent necks sway

In malignancy, oiled with tears

Their distant verse a children's chant in muffled

Barren dust that shifts and bursts underfoot

As light as charcoal, as deep as Genesis.

Outraged Spirits wheeze and groan, carried on slippery shoulders

Their godheads still roseate in the gathering dusk,

Magic is vanquished, no more will the Tribes prostrate themselves

Before Amon, Save, Seto & Whoot, Legba & Ogun,

No longer will the Nation swallow the burning sperm of warlocks

For they have allowed us to fall into this abomination.

The multi-colored powders of the Rites

Have blended into that which is all colors: Black

Boulders of our grief block our way like the

Palm of Shango and their weight undoes us all . . .

In the brazen glare of Africa's beach,

One collective scream rams the sullen sea

Vibrating the python of the continent

As tremors of our earthquake

Ripple back towards home and in that last moment,

With the sea and slavery before us,

The Race, resplendent unto itself dissolves and

All biographies become One.

Barbara Chase-Riboud (1994)

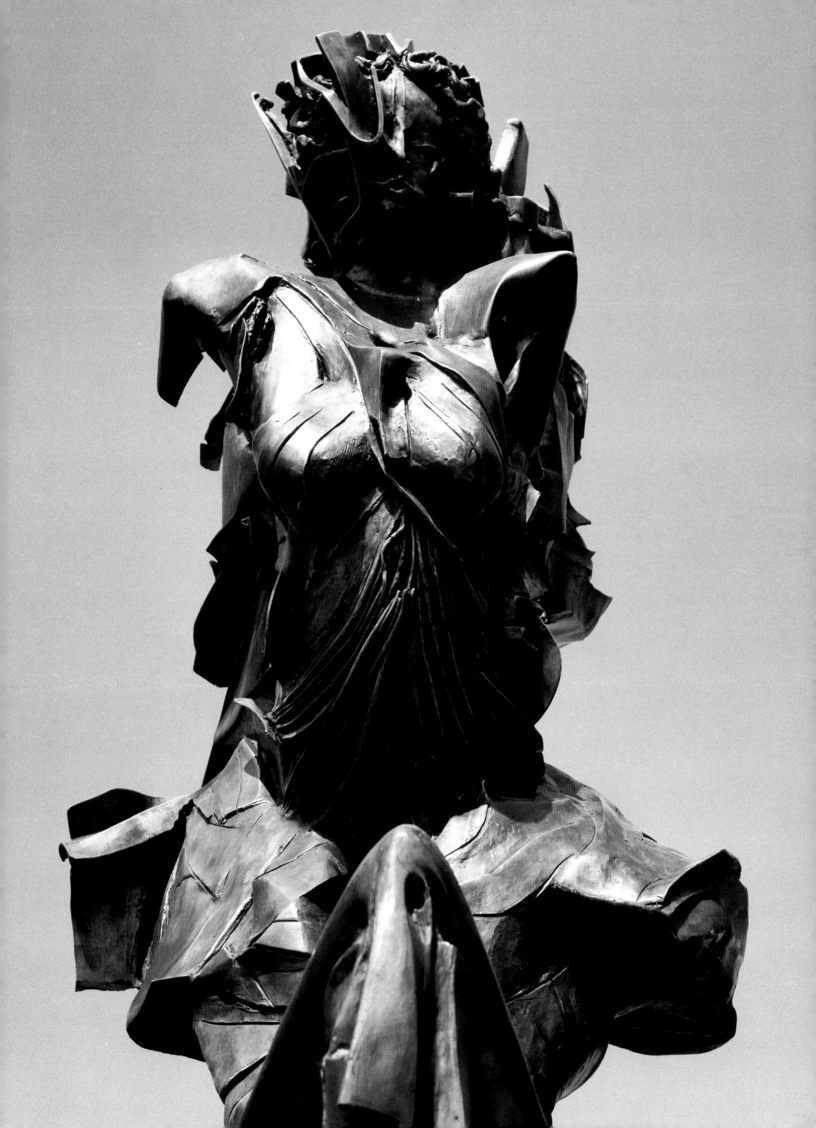

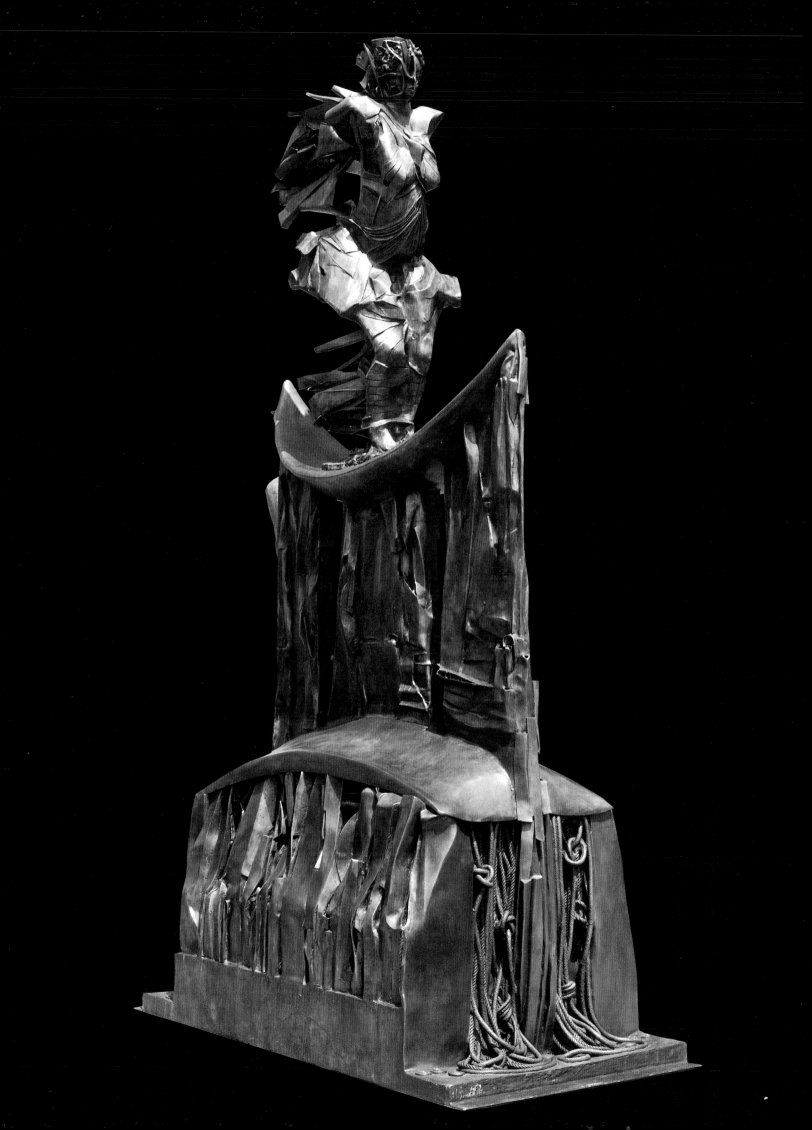

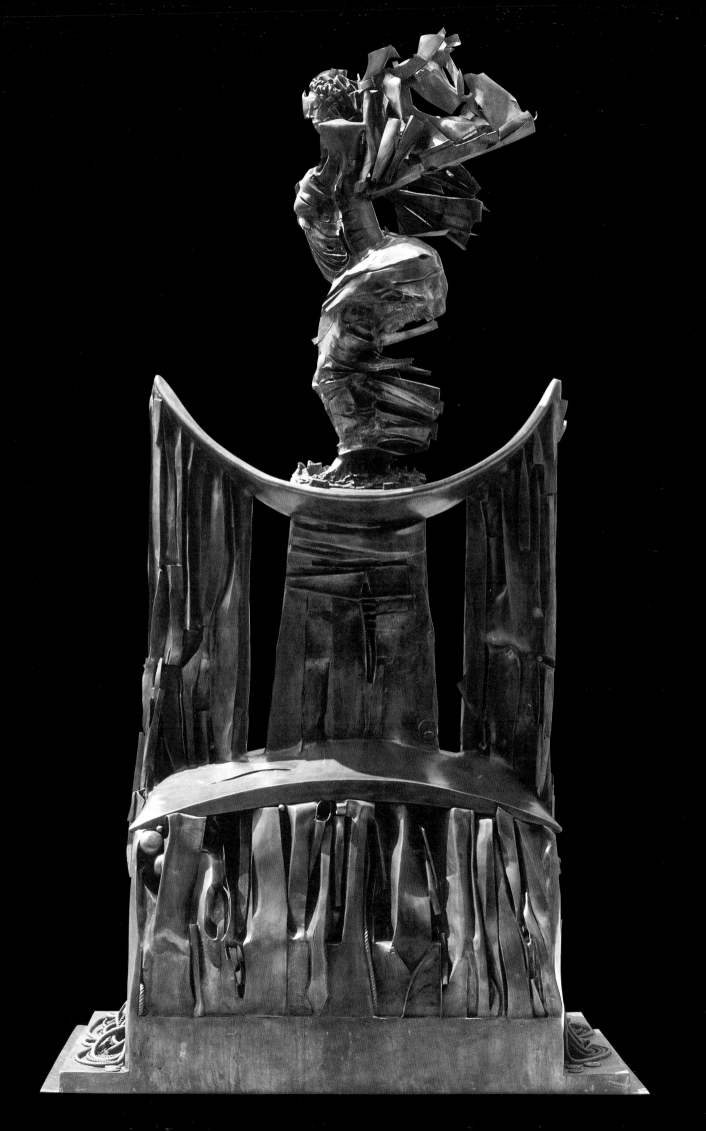

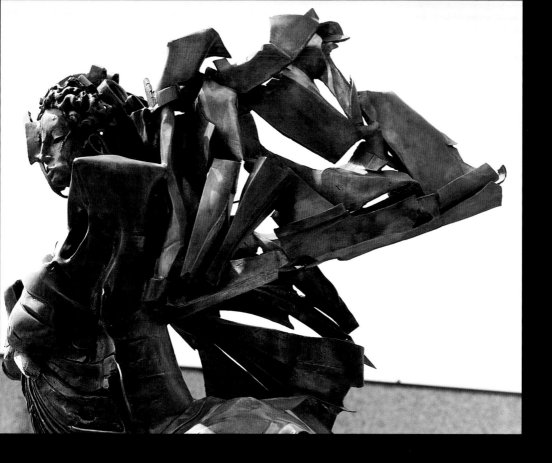

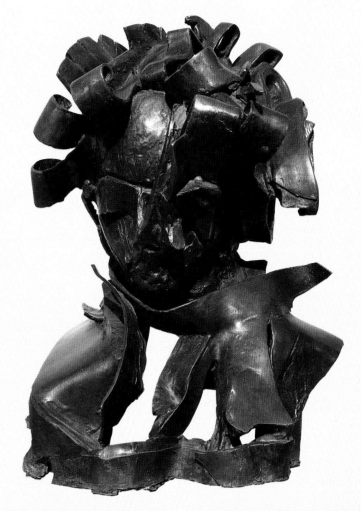

PAGES 123 TO TOP OF PAGE 126
AND PAGE 133:
*Africa Rising.* 1998.
Bronze with silver patina,
19′ 7″ x 9′ 2″ x 4′ 3″
(6 x 2.8 x 1.3 m).
Collection U.S. General Services
Administration

OPPOSITE, BELOW:
*Untitled (Africa Rising).* 1997–99.
Chalk on Arches paper, 20 x 28″
(50.8 x 71.1 cm).
Collection of the artist

ABOVE:
*Africa Rising* (cast of head)
Bronze with silver patina,
height 20 ½″ (52 cm).
Collection of the artist

BELOW:
*Untitled (Africa Rising).* 1997–99.
Chalk on Arches paper, 20 x 28″
(50.8 x 71.1 cm).
Collection of the artist

April 26, 1994

To the President
The White House
Washington, D.C.

Dear Mr. President,

Twenty-five years after the assassination of Martin Luther King, all recent polls and university studies confirm that more than half of your nation rated this country's race relations as poor, deeply divided, and, despite your promise, unhealed.

Two hundred and eighteen years ago, your namesake, Thomas Jefferson, attempted to prevent this fissure in our newly formed nation by condemning slavery, the basis of racism in America, in his Declaration of Independence. He wrote thus:

*He has waged cruel war against human nature itself, violating its most sacred rights of life & liberty in the persons of a distant people who never offended him, captivating & carrying them into slavery in another hemisphere, or to incur miserable death in their transportation hither. This piratical warfare, the opprobrium of INFIDEL powers, is the warfare of the CHRISTIAN king of Great Britain, determined to keep open a market where MEN should be bought and sold. He has prostituted his negative for suppressing every legislative attempt to prohibit or to restrain this execrable commerce, and that this assemblage of horrors might want no fact of distinguished die, he is now exciting those very people to rise in arms among us, and to purchasing that liberty of which he deprived them, by murdering the people of whom he also obstruded them; thus paying off former crimes committed against the LIBERTIES of one people, with crimes which he urges them to commit against the LIVES of another.*

—Thomas JEFFERSON
The Declaration of Independence, 1776 (excised from the final draft by consensus)

This memorable and pathetic attempt was excised from the final draft on the insistence of South Carolina and Georgia. But, as he wrote bitterly that year, "my anti-slavery expressions were immediately yielded by north *and* south." By not overthrowing slavery along with English rule, our nation therefore accepted responsibility for this crime which has haunted the United States and every American President, ever since. It has become the heart of darkness in our history.

We, your 30 million black citizens, and the nation as a whole feel that the time is now to issue an executive order to a confused and discouraged and divided nation, a Proclamation of Reconciliation in which the United States, for the first time, officially apologizes to the world and to the descendants of the African deportees who were incorporated into the institution of chattel slavery established on the soil of the United States for more than two hundred and fifty years, and to the 11 million victims of the Triangular Trade who perished in the Middle Passage, the voyage between the African coast and the Americas.

This apology and proclamation would challenge the Proclamation of Abraham Lincoln in historical importance, for it would recognize the crime committed, and thus begin the long-delayed process of healing a nation still racially divided one hundred and thirty years after the Civil War.

The United States has apologized to the Japanese, to the American Indians, even to the Queen of Hawaii; the Japanese have apologized to Southeast Asia, Korea, and China; the Germans have apologized to the Jews; de Klerk has apologized to black South Africans. But never has the United States government expressed one iota of regret for imposing the institution of slavery based solely upon race, on the ancestors of its fellow citizens, and on the United States itself.

There is no monument anywhere in the world at this moment dedicated to the memory of the 30 million deportees of the Triangular Trade—many of whom, from 1619 onward, ended up in this country—or to the 11 million victims on the bottom of the Atlantic Ocean.

A proclamation would merely say officially that the United States apologizes to its 30 million black citizens and regrets the crime of slavery perpetrated upon their ancestors by the United States. Remember this was not only an aberration of the South but also a national institution protected by the Constitution and existing from Boston to Florida.

To commemorate this Proclamation, which you as president can issue by executive order, without the advice or consent of anyone except your own humanity, morality, and conscience and in cognizance of your own place in history, we ask that a national monument, the plans of which we present to you today, be built on Theodore Roosevelt Island, Washington, D.C., a national park situated in front of Kennedy Center. Surrounded by water, this memorial would commemorate the 11 million victims of the Middle Passage.

We respectfully mandate as our memorial the historic conception and model of sculptor Barbara Chase-Riboud, which would represent this proclamation. This monument would in no way interfere or supplement other possible projects or commemorative proposals concerned with African-American history and the history of slavery. Like the Lincoln Memorial, the Holocaust Museum, and the Vietnam Veterans Memorial, the Middle Passage Monument would stand not only as a symbol of healing and reconciliation, but also as a memorial to human rights worldwide and to your own Proclamation. This symbol in which 11 million Americans, black and white, would participate, would inaugurate an unprecedented historical process and assure you a place in history as the redeemer of Jefferson's plea that never became part of his Declaration.

As his namesake, you owe him this.

As our President, you owe your fellow citizens this.

As a Southerner, you owe your own section of the country this by lifting the burden of guilt from *all* white people, by placing the burden where it rightfully belongs—with the United States of America.

By lifting this white guilt in an apology, which we assure you will be accepted by your African-American fellow citizens, you will begin a new era of historic perception, as significant as that of Martin Luther King Jr., of Abraham Lincoln, of Thomas Jefferson. You will have honored Thomas Jefferson's lost clause. And you will have freed, at last, a new United States and a united population (of which 3 million were black in 1776) from the guilt and shame of being either master or slave, of being either white or black.

We, of the United States, call on you, Mr. President, to fulfill your destiny with this historic, courageous gesture—now—not next month or next year.

This Proclamation could be drafted immediately, ready to be signed on the 4th of July 1994, the 218th anniversary of the birth of the nation and the 168th anniversary of the death of Thomas Jefferson. It could take effect on January 1, 1995, the 133rd anniversary of Abraham Lincoln's Emancipation Proclamation and 130 years after the Civil War. The memorial would be ready for its inauguration on the 4th of July 1996 in time for the opening of the Olympic Games in Atlanta, Georgia.

Take up your pen, Mr. President. We must never forget, nor allow our country to forget, that our country was conceived in liberty with slavery. That we overthrew colonialism but left 3 million Americans in a colonialism of the worst sort, which even the second American revolution, our Civil War, freed only in body, not in the spirit of our Declaration of Independence.

Do this for 30 million of your own countrymen—who have waited—who have loved and died for the country that enslaved them.

In the name of Thomas Jefferson's excised Declaration, we pray the President, William Jefferson Clinton.

Signed,
Barbara Chase-Riboud

Attachment: Proposal

April 1994

Proposal

The Middle Passage Monument is conceived in memory of the 11 million African victims on the bottom of the Atlantic Ocean who perished there through torture, disease, bestial confinement, inhumane treatment, and suicide, which occurred as a result of their enforced deportation into slavery. Their memories must be rehabilitated and honored in much the same way as the victims of the European Holocaust have been. It is absolutely necessary to integrate this experience into the warp and weave of American history for us to come to terms finally with this past crime against humanity. This is done not in the spirit of revindication, nor as a demand for reparation, but as an ultimate gesture of reconciliation and faith in America's common past.

The design of this sculpture is the result of more than ten years of reflection. It consists of two bronze-cast obelisk-shaped styles between which is suspended a wheel of bronze chain consisting of 11,000,000 links, each link representing one Middle Passage victim. The pillars and the suspended chain form an "H" shape, representing the ancient African city of Harrar. On the sculpted surface of the obelisks would be engraved the names of every nation, kingdom, clan, village, city, and river source from which the martyrs were taken.

Eventually, each link, which represents a nameless victim, will be claimed and sponsored by a living American—an individual, a wife, a husband, a group, a church, a city—so that the unknown victim becomes, in a sense, a real entity with a past, a future, a family, through his sponsor or contemporary namesake, who himself becomes a witness to that victim's martyrdom. The 11 million "sponsors" will create a permanent endowment and will form an international community in itself, equivalent to almost a third of the black population of the United States, and will bear witness to its collective past.

The Middle Passage Monument would be the first and, at present, only existing memorial in the world commemorating this part of world history. It could become a symbolic meeting place and means for all Americans to mourn this tremendous miscarriage of justice and inhumanity in a symbolic meeting place. A vast space of ignorance, anger, misunderstanding, and historical amnesia could be filled. In this way we, as a nation, can relegate a human catastrophe to the past and move forward.

The key concept here is "collective memory"—the event, or series of events which the memorial embodies, changed the history of the United States and of the entire New World from 1492 onward. Without a doubt, the Middle Passage was the greatest migration, forced or otherwise, in human history. This migration is a world-class manifestation that rivals and parallels the discovery of America itself. It is this cosmic and perfectly assimilative aspect of the Middle Passage which would be expressed in this memorial. The inscription would read:

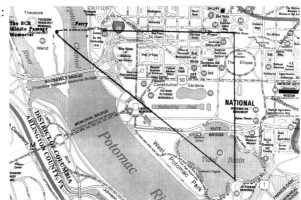

The Middle Passage Memorial
honors the 11,000,000 victims
and 30,000,000 deportees of
The African Diaspora
1492–1865–1888

ABOVE:
*Middle Passage II*. 1994.
Bronze and chalk on Cor-Ten steel,
42 x 48 x 11″ (106.7 x 121.9 x 27.9 cm).
Collection of the artist

OPPOSITE:
*Middle Passage Monument/Harrar*
(scale model). 1994. Cast bronze,
18 x 12 x 4″ (45.7 x 30.5 x 35.6 cm).
Collection of the artist

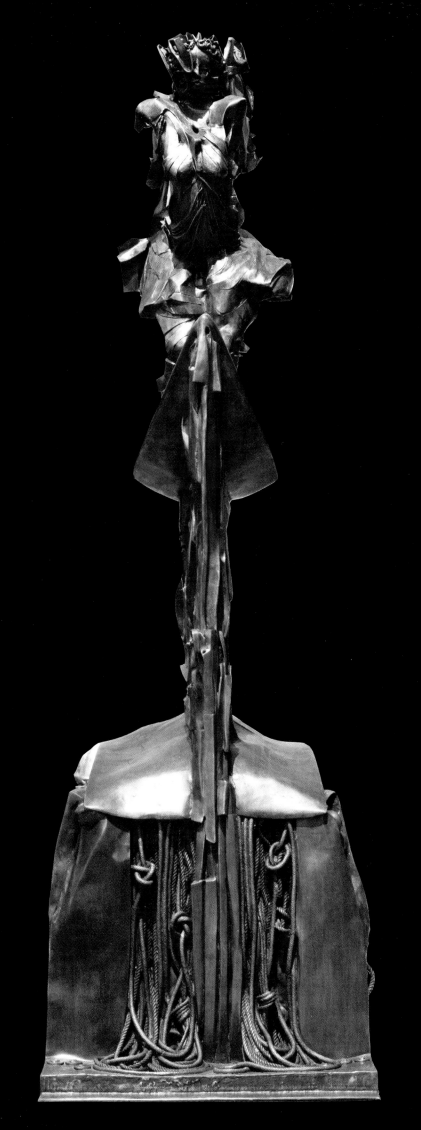

# Chronology

**1939** • Born June 26 in Philadelphia, only daughter of Charles Edward Chase and Vivian Braithwaite West.

**1946** • Begins classes at the Fletcher Memorial Art School in Philadelphia. Wins her first sculpture prize, a small Greek vase. Admitted to Philadelphia Museum of Art classes. Studies dance with Marion Cujet. Attends the Philadelphia Academy of Music's children's concerts.

**1950** • Begins to write poetry. After being falsely accused of plagiarism by a teacher, she is enrolled in the Philadelphia High School for Girls.

**1954** • Wins the National Scholastic Art Contest and, as a result, exhibits for the first time in New York at the ACA Gallery. Woodcut print *Reba* is purchased for The Museum of Modern Art, New York, by William Lieberman, then curator of prints and drawings. Graduates *summa cum laude* from the Philadelphia High School for Girls. Enrolls at Tyler School of Fine Arts in Elkins Park, Pennsylvania, affiliated with Temple University.

**1957** • Graduates from Tyler School. Wins *Mademoiselle Magazine* contest. Interviews with designer Leo Lionni, art director of *Fortune*, and upon his recommendation is awarded a John Hay Whitney Fellowship to study in Rome.

**1958** • Studies at American Academy in Rome. Meets Ralph Ellison. Spends three months traveling and studying art in Egypt. Visits Turkey and Greece. Begins to cast in bronze, utilizing the direct-wax method process and incorporating combustible materials like plants and bones to achieve her first mature style. Meets Richard Hunt. Exhibits at Spoleto Festival, where *Last Supper* is purchased by Ben Shahn. Exhibits at L'Obelisco Gallery, Rome. Returns to United States to attend Yale University on fellowship. Exhibits at Carnegie Institute International Exhibition of Paintings and Sculpture Biennale, Pittsburgh.

**1959** • At Yale University, studies design and architecture with Josef Albers, Vincent Scully, Philip Johnson, Louis Kahn, and Alvin Eisenman. Meets artist Sheila Hicks

*Barbara Chase with Leo Lionni, c. 1957*

*Barbara Chase in front of Castel Sant Angelo, Rome, 1958*

and architect James Stirling. Receives first public sculpture commission, to design and build *Wheaton Plaza Fountain*, Washington, D.C., which becomes the thesis for her master's degree along with book of engravings illustrating the poems of Arthur Rimbaud, *Une Saison en Enfer*, with introduction by Henri Peyre.

**1960** • Receives master's degree from Yale University. Engaged to marry James Stirling, moves to London.

**1961** • Leaves London for Paris, where she is hired by the *New York Times* as promotional art director. Meets photographer Marc Riboud, whom she marries on Christmas day in Talcapco, Mexico, at the ranch of Sheila Hicks.

**1962** • Two sculptures commissioned by Pierre Cardin. Travels in France, Greece, Morocco, and Spain, where she meets Salvador Dalí, James Baldwin, Henry Miller, and Jean Chalon.

**1963** • Travels for the first time to the Soviet Union, where she meets dissident painters. Discovers poet Anna Akhmatova. Purchases La Chenillère, an eighteenth-century farmhouse at Pontlevoy, in the Loire Valley, near Blois, where she establishes an atelier to accommodate large sculptures. Works at Bonvicini Brothers Foundry near Verona, where she perfects technique of making direct cut and folded wax models from sheet wax.

**1964** • Birth of first son, David Charles.

**1965** • Travels to the People's Republic of China, the first American woman invited to visit since the Cultural Revolution. Meets Chou En-lai. State dinner with Mao Tse-tung. Writes the "Chinese" poems.

**1966** • First exhibition in Paris at Cadran Solaire. Exhibits in Dakar, Senegal, at First African Festival of Arts; meets President Senghor. Attends Pan African Festival in Algiers. Meets Eldridge and Kathleen Cleaver, Huey Newton, and other high-ranking Black Panthers. Writes poem "Soledad."

**1967** • Birth of second son, Alexis Karol. Exhibits series of aluminum sculptures at Air France Gallery in New York.

**1970** • Exhibits memorial sculptures to Malcolm X at MIT's Hayden Gallery in Cambridge. First solo show in United States.
**1971** • Exhibits Malcolm X and Zanzibar series at Bertha Schaefer Gallery in New York. Meets Romare Bearden.
**1972** • Death of art dealer Bertha Schaefer. Second New York solo exhibit at Betty Parsons Gallery. *Five*, a documentary film on five black artists, including Barbara Chase-Riboud, premieres at Museum of Modern Art. Is profiled by Françoise Cachin in *ArtNews*. Receives National Endowment of the Arts fellowship. Included in Whitney Museum Annual. Invited by Friedrich Heckmanns to exhibit drawings at Düsseldorf Art Museum.
**1973** • Peter Selz organizes major exhibition at University Art Museum at Berkeley. Chase-Riboud spends summer in Greece on island Spetsia, where she finishes poems for *From Memphis & Peking*.
**1974** • Exhibits at Musée d'Art Moderne in Paris and, in Germany, at Kunstmuseum, Düsseldorf; Kunsthalle, Freiburg; Merian Gallery, Krefeld; Staatliche Kunsthalle, Baden Baden; and the Cologne Art Fair. Random House publishes *From Memphis & Peking* with Toni Morrison as editor.
**1975** • Exhibits throughout Africa for U.S. State Department. *Cleopatra's Cape* purchased by Lannan Foundation, Los Angeles. Death of art dealer Betty Parsons.
**1976** • Exhibits at Musée Réattu in Arles, Kunstverein in Freiburg, Germany. *Zanzibar/Gold* purchased by the French Ministry of Culture. Visits Jacqueline Onassis on Scorpios and expresses her desire to write about Thomas Jefferson and Sally Hemings. Begins to write the novel *Sally Hemings*.
**1977** • Exhibits at "Documenta VI" in Kassel, Germany. Exhibits jewelry at Ontario Museum of Art. Participates in international seminar on the role of art and the artist in society at Aspen Institute in Berlin.
**1978** • Writes "White Porcelain" and part of "Love Perfecting" poems and finishes *Sally Hemings*.
**1979** • Viking Press publishes *Sally Hemings* with Jacqueline Onassis as editor. The book becomes a best-seller and wins the Janet Heidinger Kafka prize for best novel written by an American woman.
**1980** • Divorces Marc Riboud. *Sally Hemings* is translated and published in nine

ABOVE: *Barbara Chase-Riboud in the gardens of the Forbidden City, Beijing, 1965*
BELOW: *The artist in her studio, c. 1969*

different countries. In New York, exhibits at Sergio Tosi's Stampatori Gallery, and at the Bronx Museum with Mel Edwards and Richard Hunt.

**1981** • Marries publisher and art expert Sergio Tosi in Switzerland. Receives honorary degree from Temple University. The Metropolitan Museum of Art acquires *All That Rises Must Converge/Gold*. Finishes most of "Love Perfecting" and "White Porcelain" poems.

**1983** • Exhibits at Rothschild Foundation, Paris.

**1984** • Establishes atelier in Rome in the Palazzo Ricci, former studio of Benvenuto Cellini.

**1986** • William Morrow, N.Y., publishes *Validé* in eight languages. *Validé* becomes Literary Guild Selection. Awarded Carl Sandburg Prize as best American poet.

**1988** • William Morrow, N.Y., publishes *Portrait of a Nude Woman as Cleopatra*.

**1989** • Publishes historical novel *Echo of Lions* concerning the first successful slave revolt (known as the Amistad revolt) and Civil Rights Supreme Court case. Awarded a citation from the Connecticut State Legislature and governor of Connecticut for outstanding contribution to state history for *Echo of Lions*, which also becomes Literary Guild Selection.

**1990** • Exhibits at Pasadena City College Art Gallery.

**1991** • Conceives *Middle Passage Monument*. Writes "Harrar" poem.

**1993** • Receives honorary degree from Muhlenberg College in Pennsylvania for contributions to the humanities.

**1994** • Exhibits at Espace Kiron Gallery, Paris. Editions Felin publishes novella *Roman Egyptien* in French. Publishes *The President's Daughter*, a Literary Guild Selection, with Random House. English composer Andrew Vores puts six Cleopatra poems to music in dramatic cantata form for soprano, performed in Boston by Dominique La Belle.

**1995** • Awarded VanDerZee Prize by Brandywine Association, Philadelphia. Receives commission from U.S. General Services Administration for African Burial Ground Memorial, Foley Square, New York. Establishes another atelier in Milan near her new Italian foundry, Artistica Mapelli. Bronze scale model of *Middle Passage Monument/Harrar* exhibited at Second Fujisankei Biennale in Japan.

**1996** • Named Knight of the Order of Arts and Letters by the French Minister of Culture. Exhibits at Studio Museum in Harlem, N.Y.; Chicago Cultural Center; Philadelphia

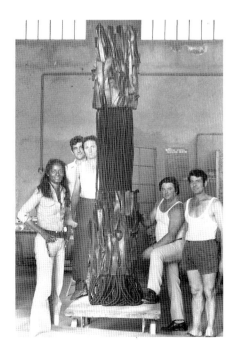

African-American Historical Museum; and The Equitable Gallery, N.Y. Receives honorary degree from the University of Connecticut.

**1997** • Exhibits at the Telfair Museum, Savannah, Georgia; Chicago Cultural Center; New Orleans Museum of Art; Seattle Art Museum; Modern Art Museum of Fort Worth; Fort Wayne Museum of Art, Indiana.

**1998** • Exhibits at St. Paul Museum of Art, St. Paul, Minnesota; Spellman Museum of Art, Atlanta; Gibbs Museum; Stella Jones Gallery, New Orleans; St. John's Museum, Wilmington, N.C.; Anthony F. Janson writes catalogue for St. John's Museum's Monument drawings exhibit. Installs *Africa Rising* at the Federal Building, 290 Broadway, N.Y. Vindication of *Sally Hemings* novel when DNA results prove Jefferson/Hemings liasion.

**1999** • Exhibits Monument drawings at The Metropolitan Museum of Art, N.Y. Is awarded Design Award from the U.S. General Services Administration in Washington, D.C., for *Africa Rising* as best public art 1993–98. Conference sponsored by Friends of Education at the Museum of Modern Art, N.Y. *Sally Hemings* republished by St. Martin's Press. Exhibition at Achim Moeller Gallery, N.Y.

ABOVE: *Barbara Chase-Riboud and Alexander Calder in Saché, France, c. late 1960s*
LEFT: *Barbara Chase-Riboud with* Confessions for Myself, *c. 1973*
BELOW: *Barbara Chase-Riboud and the Bonvicini brothers at their foundry, Verona, with* Black Column, *c. 1973*
OVERLEAF: *Barbara Chase-Riboud and colleagues at the Artistica Mapelli Foundry, Milan, with* Africa Rising, *1998. Sergio Tosi is in the back row, third from left.*

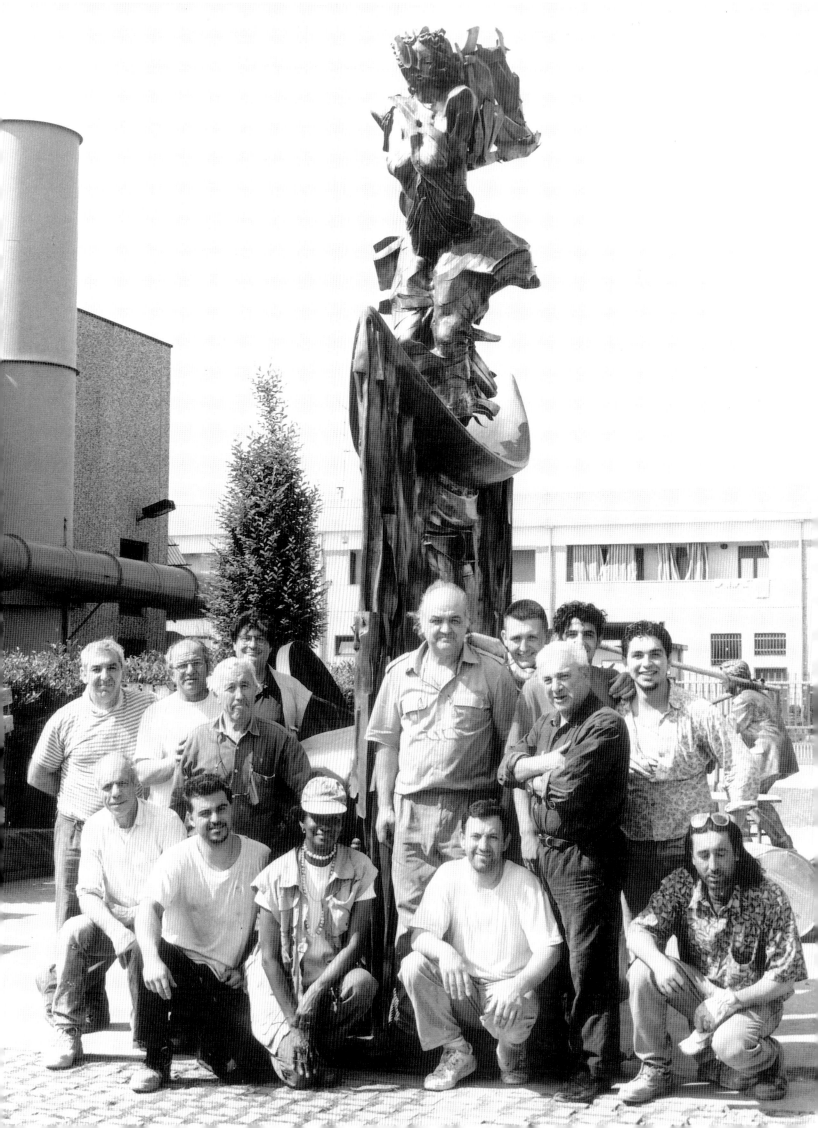

# Selected Solo Exhibitions

1958 • Galleria L'Obelisco, Rome, April.
  • American Academy in Rome, June.
  • Festival of Two Worlds, Spoleto, Italy, July.
1966 • Cadran Solaire, Paris, February.
1970 • Massachusetts Institute of Technology, Hayden Gallery, Cambridge, April.
1971 • Bertha Schaefer Gallery, New York, February.
1972 • Betty Parsons Gallery, New York, March–April.
1973 • Berkeley University Museum, Berkeley, California, January.
  • Leslie Tonkonow Gallery, New York, April.
  • The Detroit Institute of Arts, Michigan, May.
  • Indianapolis Art Museum, Indiana, May.
1974 • Musée d'Art Moderne de la Ville de Paris, Paris, April–June.

  • Staatliche Kunsthalle, Baden Baden, Germany, September.
  • Kunstmuseum, Düsseldorf, October.
  • Merian Gallery, Krefeld, Germany, November.
1975 • Betty Parsons Gallery, New York, February.
  • United States Cultural Center, Tunis, Tunisia, March.
  • United States Cultural Center, Bamako, Mali, March.
  • United States Cultural Center, Freetown, Sierra Leone, April.
  • United States Cultural Center, Accra, Ghana, April.
  • United States Cultural Center, Dakar, Senegal, April.
  • Musée d'Art Contemporain, Teheran, Iran, December.
1976 • Kunstverein, Freiburg, Germany, January.

  • Musée Reattu, Arles, France, July–September.
1977 • Documenta VI, Kassel, Germany, May.
1980 • Bronx Museum, New York, May.
1981 • Stampatori Gallery, New York, June–October.
1990 • Pasadena College Art Gallery, Pasadena, California, April.
  • Art for Architecture, New York, October.
1994 • Espace Kiron, Paris, April.
1998 • St. John's Museum of Art, Wilmington, North Carolina, January–April.
  • Stella Jones Gallery, New Orleans, January.
  • Bianca Pilat Gallery, Chicago, May–September.
1999 • The Metropolitan Museum of Art, New York, June–September.
  • Achim Moeller Gallery, New York, winter.

# Selected Group Exhibitions

1954 • New York, ACA Gallery: "Scholastic Art Awards."
1958 • Pittsburgh, Carnegie Institute: "International Exhibition of Painting and Sculpture Biennale."
1959 • Philadelphia, The Pennsylvania Academy of the Fine Arts: "National Painting and Drawing Exhibition."
1961 • Paris, Musée National d'Art Moderne, May: "Salon de Mai."
1965 • Philadelphia, Commercial Museum: "The New York Architectural League Selection."
1966 • Dakar, Senegal: "Premier Festival Mondial des Arts Nègres, 10 Artists des États-Unis."
1967 • New York, Galerie Air France, May: "7 Américains de Paris."
1969 • Avignon, Festival of Avignon, Musée Réatta: "L'Oeil Écoute."
1970 • Boston, Museum of Fine Arts: "Afro-American Artists New York/Boston."
1971 • Paris, Galeries Nationales d'Exposition du Grand Palais: "Salon des Nouvelles Réalités."
  • Newark, The Newark Museum of Art: "Two Generations."
  • Paris, Musée National d'Art Moderne: "Salon de la Jeune Sculpture."
  • Toronto, Ontario, Art Gallery of Ontario: "Contemporary Jewelry."
  • New York, Whitney Museum of American Art, April–May: "Contemporary Black Artists in America."
1971–73 • Ottawa, Ontario, National Gallery of Canada: "Jewelry as Sculpture as Jewelry." Traveled to Boston, Institute of Contemporary Art.
1972 • New York, The Metropolitan Museum of Art: "Gold." Traveled to Toronto Gallery of Art, New York, Whitney Museum of American Art: "Whitney Biennial."

1974 • New York, The Albright Knox Gallery: "Masterworks of the Seventies."
  • Philadelphia, Museum of the Civic Center: "Woman's Work—American Art '74."
1975 • Cologne Art Fair: "Merian Gallery Group Show."
1976 • Sydney, Australia: "The Sydney Biennial."
1977–80 • Art Gallery of Ontario: "European Drawings." Traveled to Sydney, Australia, Art Gallery of New South Wales; Adelaide, Australia, The Art Gallery of South Australia.
1977 • Washington, D.C., National Museum of American Art, Smithsonian Institution, Remwick Gallery: "The Object as Poet." Traveled to New York, American Craft Museum.
  • Paris, Centre Georges Pompidou: "Les Mains Regardant."
1979 • New York, The Studio Museum in Harlem, April: "Another Generation."
1980 • Brussels, Miroir d' Encre, April: "Group Show."
1980–81 • Long Island City, Queens, N.Y., P.S. 1. "African-American Abstraction." Traveled to Syracuse, N.Y., Everson Museum of Art.
1981–82 • Normal, Illinois, Center for Visual Arts Gallery: "Forever Free." Traveled to Montgomery Museum of Fine Art; Indianapolis Museum of Art.
1983 • Paris, F.N.A.P. Rothschild Museum, June–August: "Noeuds et Ligatures."
1984–85 • Los Angeles, California Afro-American Museum, July–January: "East/West Contemporary American Art."
1992 • San Francisco, Bomini Gallery, January–February: "Paris Connections."
1995 • Hakone, Japan: "The Second Fujisankei Biennale: International Exhibition for Contemporary Sculpture."

1995–96 • New York, The Studio Museum in Harlem: "The Listening Sky."
1996 • New York, The Museum of Modern Art: "The Grace Mayer Collection."
1996–98 • Philadelphia, African-American Historical and Cultural Museum: "Three Generations: A Study in Paradox." Traveled to New York, The Equitable Gallery; Savannah, Georgia, Telfair Museum; Los Angeles, Afro-American Museum. Washington, D.C., Smithsonian Institution.
  • New York, The Studio Museum in Harlem, January–June: "Explorations in the City of Light: African-American Artists in Paris, 1945–1965." Traveled to The Chicago Cultural Center; Fort Worth, Modern Art Museum of Fort Worth; New Orleans Museum of Art; Chicago Cultural Center; Milwaukee Art Museum; Seattle Art Museum.
1996–99 • Atlanta, Spellman College Museum of Art, May: "Bearing Witness, Contemporary African-American Women Artists." Traveled to Tuskegee, Alabama, Tuskegee University Art Gallery; Fort Wayne, Indiana, Fort Wayne Museum of Art; St. Paul, Minnesota, St. Paul Museum; Fort Worth, Texas, Museum of African-American Culture; Portland, Oregon, Portland Museum of Art; Houston, Texas, The Museum of Fine Arts.
1999 • Portland, Oregon, Portland Museum of Art: "Bearing Witness."
  • Washington, D.C. Building Museum, Smithsonian Institution: "Design Awards" [U.S. General Services Administration].
  • Houston, Texas, The Museum of Fine Arts: "Bearing Witness."

# Selected Bibliography

## Literary Works by the Artist
*The following are given in chronological order by publication date of the English-language edition, followed by translated editions.*

*From Memphis & Peking.* New York: Random House, Inc., 1974.
*Sally Hemings.* New York: Viking Press, 1979; New York: Ballantine Books, 1994; New York: St. Martin's Press, 1999.
  *La Virginienne.* Paris: Albin Michel, 1981, 1997.
  *Die Frau Aus Virginia.* Hamburg: Hoffmann und Campe, 1982.
  *La Virginiana.* Buenos Aires: Atlantida, 1982.
  *La Virginiana.* Milan: Rusconi Libri, 1982.
  *En Kvinde fra Virginia.* Copenhagen: Forum Publishers, Ltd., 1983.
  *Slavinnan.* Stockholm: Forum Publishers, 1984.
  *Zenska iz Virginije.* Trieste, Yugoslavia: ZTT EST, 1985.
  *Orjatar.* Helsinki: WSOY, 1986.
*Validé.* New York: William Morrow, 1986.
  *Haaremin Valtiatar.* Helsinki: WSO4, 1987.
  *La Grande Sultane.* Paris: Albin Michel, 1987.
  *La Sultana Bianca.* Milan: Rusconi Libri, 1987.
  *Naksh-i-dil Seraillets Dronning.* Copenhagen: Forum Publishers, Ltd., 1987.
  *Serail.* Hamburg: Hoffmann und Campe, 1988.
  *De Macht van een Sultane.* Amsterdam: Uniebolk, 1989.
  *Slovoch Härskarina.* Stockholm, Forum Publishers, Ltd., 1989.
*Portrait of a Nude Woman as Cleopatra.* New York: William Morrow, 1988.
*Echo of Lions.* New York: William Morrow, 1989.
  *L'Echo des Lions.* Paris: Nouveaux Horizons [U.S. Department of State, African Affairs], 1989.
  *Le Nègre de l'Amistad.* Paris: Albin Michel, 1989.
  *E Ruggivano Ancora.* Milan: Rusconi Libri, 1989. Out of print.
  *La Rivolta della Amistad.* Milan: Piemme, 1998.
*Roman Egyptien (Egypt's Nights).* Paris: Editions Félin, 1994.
*The President's Daughter.* New York: Crown Publishers Inc., 1994.
  *La Fille du Président.* Paris: Albin Michel, 1995.
  *Frei, Vogelfrei.* Munich: Europa Verlag, 1997.
*Cleopatra Cantata.* Words by Chase-Riboud, music by Andy Vores, Boston, Mass., April 1995.

## Monographs, Exhibition Catalogues, Films and Videos
Bontemps, Arna Alexander. *Forever Free.* Exhibition catalogue. New York: Stephenson Incorporated, 1980.
Cachin, Françoise, and Bury Pol. *Chase-Riboud.* Paris: Musée National d'Art Moderne, 1974.
Cachin, Françoise, F. Heckmanns, and G. Monnier. *Chase-Riboud.* Exhibition catalogue. Berkeley: University Museum at Berkeley, University of California. 1973.
*Chase-Riboud.* Exhibition catalogue. Kunstmuseum, Freiburg, Germany, 1974.
*Chase-Riboud.* Video by Dorothy Beskind, 1973.
*Conference.* Video, Minneapolis School of Design, 1973.
*Conversations with Barbara Chase-Riboud.* (French video). The United States Information Service Center in Tunisia, 1975.
Conwill, K., M. Fabre, C. Bernard, P. Selz, and V. Mercer. *Explorations in The City of Light: African-American Artists in Paris, 1945–1965.* Exhibition catalogue. New York: The Studio Museum in Harlem, 1996.
Dorsey, Hebe, and R. Doty. *Contemporary Black Artists in America.* Exhibition catalogue. New York: Whitney Museum of American Art, 1971.
*European Drawings, Montreal-Sydney-Berlin.* Exhibition catalogue. 1980.
Farley, Marilyn. *The 1998 Design Award, United States General Services Administration.* Catalogue. Washington, D.C., 1999.
*Five.* Documentary produced by Alvin Yudkoff and M. Meltzer for Seagram Company. Premiered at The Museum of Modern Art, New York, 19 August 1971.
Heckmanns, F. W. *Chase-Riboud—Zeichnungen.* Exhibition catalogue. Düsseldorf: Kunstmuseum, 1974.
——— . *Chase-Riboud–Calderara.* Exhibition catalogue. Krefeld, Germany: Merian Gallery, November 1973.
Hulten, P., and L. Waterlow. *European Dialogue, 3rd Biennale of Sydney.* Exhibition catalogue. Sydney, Australia, 1979.
Hunter, Sam. *The Second Fujisankei Biennale, International Exhibition for Contemporary Sculpture.* Exhibition catalogue. Japan: The Hakone Open-Air Museum, 1995.
*International Exhibition of Painting and Sculpture.* Exhibition catalogue. Pittsburgh: Carnegie Institute, 1958.
King-Hammond, Leslie, and Benjamin Tritobia Hayes. *Three Generations of African-American Sculptors: A Study in Paradox.* Exhibition catalogue. Philadelphia: The Afro-American Historical and Cultural Museum, 1996.
Kingsley, April. *Afro-American Abstraction.* Exhibition catalogue. New York: Menorah Printing, 1981.
Lascaulta, Gilbert. *Noeuds et Ligatures.* Exhibition catalogue. Paris: Centre National des Arts Plastiques, Rothschild Museum, June 1983.
*Like It Is.* Television documentary (featuring interview on the Malcolm X series), produced by Charles Hobson and Marguerite Jones for ABC, April 1970.
Lucas, Rolf. *Documenta VI, Vol. 3.* Exhibition catalogue. Kassel, Germany: Paul Dierichs KG & Co., 1977.
Patton, Sharan. *East/West Contemporary American Art.* Exhibition catalogue. Los Angeles: Afro-American Museum, 1984.
Pogach, Gerald. *VanDerZee Awards, An Appreciation.* [Brandywine Association]. Exhibition catalogue. Philadelphia: The University Museum, University of Pennsylvania, 1995.
Rubenstein, Charlotte Streifer. *Barbara Chase-Riboud.* Exhibition catalogue. Pasadena: Pasadena City College Art Gallery, April 1990.
Schmlea, Wieland. *European Drawings.* Exhibition catalogue. Sydney Biennale, 1979.
Selz, Peter. *Barbara Chase-Riboud.* Exhibition catalogue. University Art Museum at Berkeley, University of California, 1973.
Slivka, Rose. *The Object as Poet.* Exhibition catalogue. Washington, D.C.: Smithsonian Institution Press, 1977.
Tosi, Sergio G. *Chase-Riboud.* Exhibition catalogue. Espace Kiron, Palladium. Paris: Edition Selon Books, April 1994.
———. *Africa Rising.* Catalogue. New York: U.S. General Services Administration, 1998.
*Twentieth Century American Art.* [Sunrise Semester series] Documentary presented by Ruth Bowman and produced by Patricia Myers for CBS, 1972.
*The Object as Poet.* Washington, D.C.: Smithsonian Institution, 1977.
Veneciamo, Jorge Daniel. *The Listening Sky.* Exhibition catalogue. New York: The Studio Museum in Harlem, 1997.
*Whitney Annual*, Whitney Museum of American Art. Exhibition catalogue. New York 1972.

## Selected Articles Published in Periodicals or Newspapers
Alloway, Lawrence. "Afro-American Abstraction." *The Nation* (21 April 1980).
Beale, Lewis. "Monument to Slaves to Grace Schuylkill." *The Philadelphia Daily News*, 7 November 1980.
Béhar, Henri. "Explorations dans la Ville Lumiere." *Le Monde*, 2 May 1996.
Brierre, J. F. "Dakar." *L'Ouest African* (28 March 1975).
Brown, M. "Sculptor Barbara Chase-Riboud." *The New Orleans Tribune*, March 1998.
Cachin, Françoise (née Nora). "From Another Country." *ArtNews* (March 1972).
Cannon, Steve. "Gathering of the Tribes." Interview with Chase-Riboud. September 1999.
Chase-Riboud, Barbara. "Josephine Baker: Beyond Sequins." February 1976.
——— . "Le Plaîsir d' Etre Etranger." *Le Monde*, 23 January 1983.
——— . "Magnificent Métissage." January 1996.
——— . "Why Paris?" *Essence Magazine*, October 1987.
——— . "Wheaton Plaza Fountain." *Architectural Design* (January 1961).
——— . "Wheaton Plaza Fountain." *Bauw Magazine* (1961).
Crushshon, Theresa. "Barbara Chase-Riboud." *The New Orleans Tribune*, February 1998.
Dallier, Aline. "Soft Art." *Opus International* (September 1974).
David, Catherine. "Le Amérique, The Jefferson Syndrome." Supplement to *Le Nouvel Observateur*, 1989.
Dorsey, Hebe. "Cardin's Elysée-Palace Circus." *The International Herald Tribune.*
Driscoll, Edgar J. "Sculptors Three." *Boston Globe*, 19 April 1980.
——— . "Monuments to Malcolm X." Review of MIT exhibit in *The Boston Globe*, 6 April 1970.
"Monuments to Malcolm X Poster Exhibition, Awarded Advertising Directions Prize." *Art Direction Magazine* (September–October 1970).
"Barbara Chase Studies in Rome." *Ebony Magazine* [cover], April 1959.
Fine, Elsa H. "Mainstream, Blackstream, and the Black Art Movement." Spring 1971.
"The First World Festival of Negro Art." The Congressional Record, 89th Congress, Washington, D.C., May 1966.
Gandouet, Marielle. "Barbara Chase-Riboud." *Le Monde*, 17 May 1974.
——— . "Barbara Chase-Riboud." *Connaissance des Arts* (June 1974).
Gardner, Paul. "When France Was Home to African-American Artists." *Smithsonian Magazine* (March 1996).
Garmel, Marion. "Black Artists Show in Indy." *The Indianapolis News*, 7 April 1973.
Ghent, Henri. "A Threat to the Flag? Or Art?" *The New York Times* [Letters to the Editor], 19 April 1970.
Gifford, William. *Philadelphia Magazine* (August 1998).
Grafy, Dorothy. "Sculpture Venture in

Aluminum." *The Philadelphia Inquirer*, April 1961.

Grillo, Jean Bergantini. "Malcolm: Monuments in Bronze and Braid." *The Phoenix* (16 April 1970).

Hammel, Lisa. "A Show Where Literary Forms Imbue Crafts with Another Dimension." *The New York Times*, 17 December 1976.

Hansell, Betsey. "Chase-Riboud at the Institute." *Detroit Free Press*, 29 April 1973.

Henry, Susan. "Profile: Chase-Riboud." *Ms Magazine*, October 1980.

Hershman, Lynn Lester. "Sculpture as Beauty." *Art Week* (10 February 1973).

Hess, Thomas. "Reviews: Barbara Chase-Riboud." *ArtNews* (February 1970).

———. "The Object as Poet." *New York Magazine*, 1981.

Hughes, Robert. "Afro-American Abstraction." *Time Magazine*, 31 March 1980.

Johnson, Thomas A. "Paris: Negroes' Way Station." *The New York Times*, 19 March 1969.

Jones, Lisa. "A Most Dangerous Woman." *The Village Voice*, 9 February 1999.

Kibby, David. "MIT Press Release Bulletin." *Malcolm X Exhibit*, Hayden Gallery, April 1970.

Kimmelman, Michael. "Black Americans in Paris." *The International Herald Tribune*, 24 February 1996.

———. "Harlem Sculpture Garden, Turning an Alley into a Showcase for Sculpture." *The New York Times*, 22 September 1995.

———. "Black Artists at Home in Postwar Paris." *The New York Times*, 18 February 1996.

Kingsley, April. "Overcoming the Double Whammy." *The Village Voice*, 29 June 1979.

Kisselgorf, Anna. "Watching China from the Inside." *The New York Times*, 4 April 1967.

Klein, Julia. "Artist and Poet to Be Honored." *The Philadelphia Inquirer*, 26 September 1995.

Kramer, Hilton. "Black Experience and Modernist Art." *The New York Times*, February 1970.

Lansner, Faye. "Barbara Chase-Riboud." *Crafts Horizon* [cover], April 1972.

Last, Martin. "Previews & Reviews, Monuments to Malcolm X." *ArtNews* (March 1970).

Lewis, Flora. "An Author Ponders the Metaphysics of Race." *The New York Times*, 22 October 1979.

Levêque, Jean-Jacques. "Chase-Riboud." *Les Nouvelles Littéraires* (17 May 1974).

Lignères, Louis-Henri de. "Les Sculptures en Soie de Chase-Riboud." *Connaissance des Arts*.

Mallow, James R. "Barbara Chase-Riboud." *The New York Times*, 1 April 1972.

McFadden, Jerome. "B. C. R." *Sepia Magazine*, July 1977.

McLellan, Marian. *The New Orleans Art Review* (March–April 1998).

Newton, Edmund. "The Artist at Work." *The Los Angeles Times*, 3 May 1990.

Niesten, Joop. "Brief Aan Maria Over Barbara Chase-Riboud: Americans de Architet." *Bauw Magazine* (May 1986).

Palmer, A. "Jewelry Mirrors Her Sculpture." *The New York Times*, 29 April 1972.

Perreault, John. "Positively Black." *The Studio Weekly*, 27 February 1980.

———. "Afro-American Abstraction." *Soho Weekly News*, 27 February 1980.

Peyre, Henri. Introduction to "Une Saison en Enfer, 16 Engravings by Barbara Chase." [Master's thesis] New Haven: Carl Purington-Rollins Printing Office, Yale University Press, 1960.

Plazy, Gilles. "Chase-Riboud, Poli, Delay." *Le Quotidian de Paris*, 17 May 1974.

Ratcliff, Carter. "New York Letter." *Art International* (20 May 1970).

Reavis, Edward. "Tribute to an Artist." *Stars and Stripes* (29 July 1988).

Rickey, Carrie. "Afro-American Abstraction." *The Village Voice*, 3 March 1980.

Rose, Barbara. "Black Art in America." *Art in America* (July–December 1970).

Russell, John. "Barbara Chase-Riboud, Betty Parsons Gallery." Review, *The New York Times*, 12 April 1973.

———. "Art in Unexpected Places." *The New York Times*, 24 February 1980.

———. "Art Abstractions from Afro-America." *The New York Times*, 31 March 1980.

———. "Sally Hemings." *The New York Times*, April 1979.

Schwartz, Paul Waldo. "Two Americans." *The New York Times* [International Edition], 28 November 1966.

Smith, Elmer. "Triumphant Return for Author-Artist." *Philadelphia Daily News*, 22 September 1995.

Stalhy, François. "University Sculpture in Chicago." *Werk* (1960).

Terrell, Angela. "From Sculpture to Poetry." *The Washington Post*, 7 July 1974.

Tesseyre, Bernard. "Chase-Riboud." *Le Nouvel Observateur*, 29 April 1974.

———. "L'Image et la Mémoire." *Le Nouvel Observateur*, 12 May 1974.

"The 100 Most Influential Black Americans." *Ebony Magazine*, May 1986.

Vinson, R. J. "Art au Cou." *Connaissance des Arts* (May 1970).

Waddington, Chris. "Expatriate Gains." *The New Orleans Times-Picayune*, 14 February 1998.

———. "Color Them Modern." *The New Orleans Times-Picayune*, 20 September 1996.

———. "Sculpture: A World Between Abstract and Figurative Art." *The New Orleans Times-Picayune*, 20 February 1998.

Walters, Sheila. "Modern Primitivist." *Tuesday Magazine*, May 1974.

Warnod, Jeanine. "Quatre Franc Tireurs à L'A.R.C." *Le Figaro*, 7 May 1974.

White, Charles. "Barbara Chase-Riboud at Bertha Schaefer." *The Village Voice*, May 1971.

Wilson, Judith. "Afro-American Abstraction." *Art in America* (summer 1980).

## General References

*In addition to the following general sources given in alphabetical order by author, references to Barbara Chase-Riboud may be found on the Internet and in the following publications:* International Authors and Writers Who's Who, *[England: Melrose Press, 1973–99], Who's Who in American Art, [New York, London: R. R. Bowker Company, 1973–99], Encyclopedia of African-American Culture and History [New York: MacMillan, 1996], and Foremost Women of the 20th Century [Cambridge, England: Melrose UK, 1987].*

Attallah, Naim. *Women*. London: Quartet Books, 1987.

Barlow, Peggy. *Women Artists*. New York: Hugh L. Levin Assoc., 1999.

Bearden, Romare, and Harry Henderson. *A History of African-American Artists*. New York: Pantheon, 1990.

Bernheim, Nicole. *Voyage en Amérique*. Paris: Editions Stock, 1986.

Bevlin, Marjorie Elliott. *Design Through Discovery*. New York: Holt, Rinehart, Winston, 1977, 1981, 1986.

Bontemps, Jacqueline Fonvielle. *Forever Free, African-American Women*. Normal: Illinois State University Press, 1980.

Britton, Crystal A. *African-American Art*. New York: Smithmark, 1996.

DeCosta-Willis, Miriam, R. Martin, and R. Bell. *Erotique Noir/Black Erotica*. New York: Doubleday, 1992.

Doty, Robert. *Fine Arts and the Black American*. Indianapolis: Indiana University Press, 1970.

———. *The Afro-American Artist*. New York: Holt, Rinehart-Winston, 1972.

*Encyclopedia of Notable Black American Women*. London and Detroit: Gale Research, 1992.

Febre, Michel. *La Rive Noire*. Paris: Lieu Commun, 1985.

Fine, Elsa H. *Women & Art: History of Women Painters and Sculptors from the Renaissance to the 20th Century*. Montclair, New Jersey: Allanheld & Schram, 1978.

*Foremost Women of the Twentieth Century*. Cambridge: International Biographical Center, 1988.

Heller, Nancy G. *Women Artists: An Illustrated History*. New York: Abbeville Press, 1987.

Hunter, Sam. *American Sculpture and Painting*. New York: Harry N. Abrams, Inc., 1972.

Igoe, Lynn M. *250 Years of Afro-American Art*. New York: Bowker, 1961.

Janson, Anthony F. *A Basic History of Art*, 5th Edition. New York: Harry N. Abrams, Inc./Prentice Hall, 1997.

Janson, H. W. *History of Art*, 5th Edition, Revised. New York: Harry N. Abrams, Inc./Prentice Hall, 1997.

Leveeg, Christine. *Barbara Chase-Riboud: Critical Survey of Long Fiction*. Boston: Salem Press, in press.

Lewis, Samella. *Art: African-American*. New York: Harcourt, Brace, Jovanovich, 1978.

Munro, Eleanor. *The Originals: American Women Artists*. New York: Simon & Schuster, 1979.

Myers, Carol L. *Black Power in the Arts*. Flint: University of Michigan Press, 1970.

Naylor, Colin, and Genesis P-Orridge. *Contemporary Artists*. New York: St. Martin's Press, 1977.

Riggs, Thomas. *Black Artists*. Detroit: St. James Press, 1999.

Rubenstein, Charlotte Streifer. *American Women Sculptors: A History of Women Working in Three Dimensions*. Boston: G. K. Hall, 1991.

———. *Women in American Sculpture*. New York: Avon Books, 1988.

———. *American Women Artists: From Early Indian Times to the Present*. New York: Avon Books, 1982.

Smith, Jessie Carry. *Notable Black American Women*. Detroit and London: Gale Research, 1991.

Stofflet, Mary. *American Women Artists*. New York: Harper & Row, 1978.

Stovall, Tyler. *Paris Noir*. New York: Houghton Mifflin Co., 1996.

Walker, Roselyn. *A Resource Guide to the Visual Arts of Afro-Americans*. South Bend: University of Indiana Press, 1971.

Waller, Irene. *Design Sources for Fiber Artists*. Worcester, Mass: Davis Press, 1979.

———. *Textile Sculptures*. London: Studio Vista, 1977.

Watson-Jones, Virginia. *Contemporary American Women Sculptors*. New York: Oryx Press, 1986.

Wilcox, Michele. *Anthology of Contemporary African-American Women Artists: Gumbo Ya-Ya*. New York: Midmarch Art Books Press, 1995.

Witzling, Mara R. *Voicing Today's Visions*. New York: Universe Publishing, 1994.

Young, Bernard. *African American Artists and Cultures*. New York: Davis Publications, 1996.

# Index

# Photograph Credits

*The authors, artist, and publisher wish to thank the museums, galleries, and private collectors named in the illustration captions for supplying the necessary photographs. Other photograph credits are listed below.*

ABOVE: *Completed* Confessions for Myself *at the Bonvicini Foundry in Milan, c. 1973.*